50 ARTISTS
YOU SHOULD KNOW

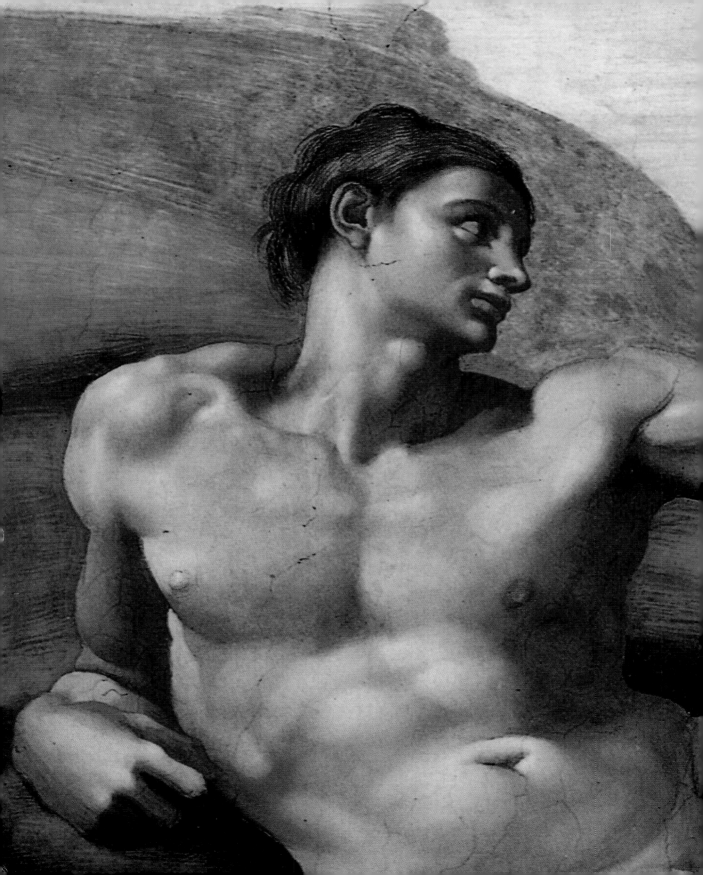

50 ARTISTS
YOU SHOULD KNOW

Thomas Köster

With contributions
by Lars Röper

Prestel
Munich · Berlin · London · New York

For Maja, who also paints beautiful pictures.
T.K.

Front cover from top to bottom:
Giotto di Bondone, detail from *Raising of Lazarus*, 1302–05. Fresco. Arena Chapel, Padua
Gustav Klimt, detail from *The Kiss*, 1907/08. Oil, silver and gold applied to canvas, 180 x 180 cm. Österreichische Galerie Belvedere, Vienna
Georges Seurat, detail from *Bathers at Asnières*, 1883/84. Oil on canvas, 201 x 300 cm. National Gallery, London
Claude Monet, detail from *Water Lilies*, 1916–19. Oil on canvas, 200 x 180 cm. Privately owned
Frontispiece: Michelangelo, detail from *The Creation of Adam*, Sistine Chapel Ceiling, 1508-12. Fresco. Vatican, Rome

Texts by Thomas Köster:
Pages 7, 9, 13, 17, 21, 25, 29, 31/32, 35, 39, 42, 47, 51, 59, 61, 65, 75–77, 81, 93, 97, 99–101, 103, 109, 113, 115, 119, 123/124, 127, 131, 133, 137, 139, 141, 147, 149, 153, 157, 161
Texts by Lars Röper:
Pages 55–57, 68/69, 71, 73, 78/79, 85, 89, 91, 107, 143, 145, 154/155
Time line by Edgar Kroll

Prestel Verlag
Königinstrasse 9, 80539 Munich
Tel. +49 (89) 38 17 09-0
Fax +49 (89) 38 17 09-35

Prestel Publishing Ltd.
4, Bloomsbury Place, London WC1A 2QA
Tel. +44 (20) 7323-5004
Fax +44 (20) 7636-8004

Prestel Publishing
900 Broadway, Suite 603
New York, N.Y. 10003
Tel. +1 (212) 995-2720
Fax +1 (212) 995-2733

www.prestel.com

Library of Congress Control Number: 2006929231

British Library Cataloguing-in-Publication Data
A catalogue record for this book is available from the British Library.
The Deutsche Bibliothek holds a record of this publication in the Deutsche Nationalbibliografie; detailed bibliographical data can be found under: http://dnb.ddb.de

Prestel books are available worldwide. Please contact your nearest bookseller or one of the above addresses for information concerning your local distributor.

Translated by Michael Robinson, London

Editorial direction by Katharina Haderer & Sandra Leitte
Copy-editing by Danko Szabo, Munich
Cover and design by Liquid, Augsburg
Layout und production by Rainald Schwarz, Munich
Origination by ReproLine Genceller, Munich
Printing and binding by MKT Print d.d., Ljubljana

Printed in Slovenia on acid-free paper

(German edition: ISBN 3-7913-3715-7)
ISBN 3-7913-3716-5
978-3-7913-3716-6

CONTENTS

1250 Democratic constitution for Florence

1256 Hundred Years' War between
Genoa and Venice

1268 Amiens cathedral
1268 End of German rule in Italy

1271 Marco Polo departs for the Mongol Empire

HIGH GOTHIC 1200–1350

1210 1215 1220 1225 1230 1235 1240 1245 1250 1255 1260 1265 1270 1275 1280 1285 1290 1295

Raising of Lazarus, 1302–05. Fresco.
Arena Chapel, Padua

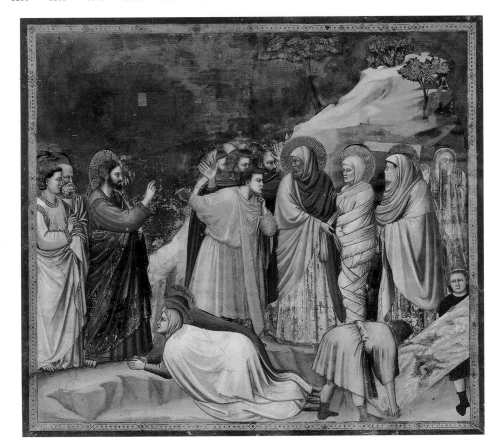

[left]
Madonna Ognissanti, 1310. Tempera on
wood, 325 x 204 cm. Uffizi, Florence

[right]
The Gift of the Cloak, second picture in
the legend of St. Francis, before 1300.
Fresco. San Francesco, Assisi

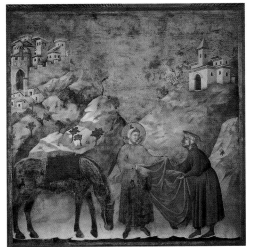

1307 Dante Aligh eri begins *The Divine Comedy*

1314 Palazzo Vecchio built in Florence

1355 Charles IV becomes Holy Roman Emperor

1200–1350 HIGH GOTHIC

| 1300 | 1305 | 1310 | 1315 | 1320 | 1325 | 1330 | 1335 | 1340 | 1345 | 1350 | 1355 | 1360 | 1365 | 1370 | 1375 | 1380 | 1385 |

GIOTTO DI BONDONE

The Italian painter and master builder Giotto di Bordone was a great storyteller. He used dramatic gestures and realistically-painted figures to illustrate Bible stories. He updated the fresco, an art form that had been known since antiquity, and impressed the early Italian Renaissance artists with his convincing presentation of spatial depth.

When Giotto was ten years old his father sent him out to look after the sheep in the fields. To pass the time, the shepherd boy picked up a flat stone and began to draw one of the animals on it. The famous painter Cimabue of Florence happened to pass by and asked the talented boy if he might like to work in his studio. So that is how Giotto became a painter, according to Giorgio Vasari, one of the first art historians, in his writings about the life and work of contemporary masters.

We cannot really be sure today whether Giotto actually became Cimabue's pupil. But it probably is true that he started to draw live from nature at a very early stage.

Medieval artists used to paint their religious pictures from standard versions in pattern books, or by copying from earlier works, but Giotto used the people around him as models. His *Madonna Ognissanti* is a proud and tender mother, holding her son on her lap. If viewed from close up one can even see two teeth sparkling between her lips. Giotto thus lent Biblical heroes lifelike features and personal gestures in his frescos.

Giotto's new fresco technique.
For frescos, the paint is applied to damp plaster made of lime, sand and marble dust. Cimabue always made his assistants plaster the whole area that could be reached from the painter's scaffold. If he didn't finish painting the plastered area in a day, he continued the next day on dry plaster, but the paint did not take as well on this. Giotto plastered only as much as he could paint in a day. This is why Giotto's frescos continue to survive in such good condition.

Picture stories on the church wall
Giotto's exciting new frescos soon became so well known beyond the boundaries of Florence that he needed assistants himself to meet the demand for his pictures. It was not just rich merchants and bankers who ordered his work, but the Pope, and the King of Naples, too. Giotto painted the ceiling and walls of the Franciscan monks' church in Assisi.

The rich and ambitious Enrico Scrovegni called Giotto to Padua to decorate his private chapel there with forty magnificent frescos. Painted in bright colours, Giotto's cycle tells the story of the lives of Jesus, Mary and other saints like a picture story that is easy to understand – even by people who cannot read. Gestures and expressions show rage, mourning and disappointment, but also happiness and faith in God's wondrous power. The frescos in the Scrovegni chapels made the shepherd boy Giotto the most important artist in Europe.

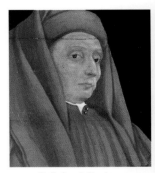

c. **1267** Giotto born in Vespignano near Florence
1290 Works in Assisi, presumably as assistant to the painter Cimabue
1300 Paints frescos in the Papal Palace
1302–05 Creates frescos for the Scrovegni Chapel in Padua
1309 Paints more frescos for the basilica in Assisi
1310 Works in the old St. Peter's in Rome
1325 Paints the Peruzzi Chapel in the Florentine church of Santa Croce
1328 King Robert of Anjou summons him to Naples
1334 Becomes cathedral architect in Florence
1337 Dies on 8 January in Florence

INTERNET TIP
The website www.giottoagliscrovegni.it offers a great deal of information about the frescos in the Scrovegni Chapel and its restoration, about the building and Giotto himself; an interactive tour of the chapel is also offered

[above]
Paolo Uccello (attributed), portrait of Giotto, detail from *Five Famous Men (The Fathers of Perspective)*, c. 1500–65. Tempera on wood, 42 x 210 cm. Musée du Louvre, Paris

FILIPPO BRUNELLESCHI

1355 Charles IV becomes Holy Roman Emperor

1378 Vatican papal residence

1400 Start of Humanism
in Germany

1200–1350 HIGH GOTHIC

EARLY RENAISSANCE 1400–1475

| 1325 | 1330 | 1335 | 1340 | 1345 | 1350 | 1355 | 1360 | 1365 | 1370 | 1375 | 1380 | 1385 | 1390 | 1395 | 1400 | 1405 | 1410 |

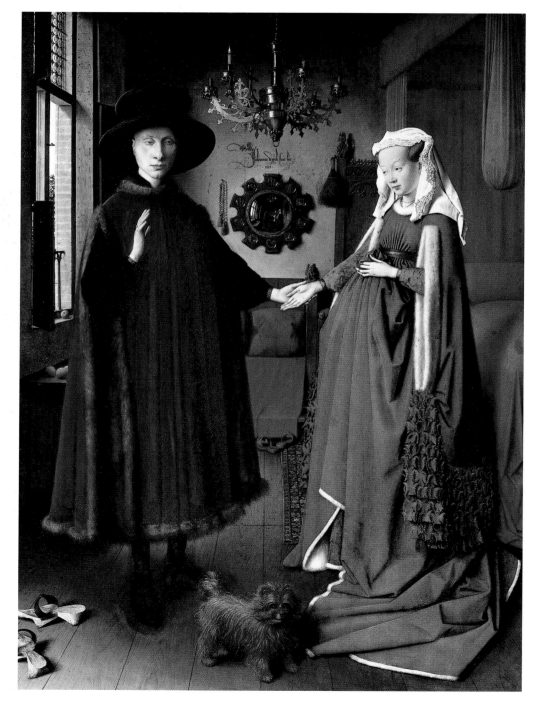

*Double Portrait of Arnolfini and his
Bride Giovanna Cenami,* 1434.
Oil on wood, 81.8 x 59.7 cm.
National Gallery, London

GIOVANNI BELLINI

c. **1412** Filippo Brunelleschi discovers central perspective

1453 Turks conquer Constantinople
1453 * Martin Luther
1455 Wars of the Roses break out in England
1455 Letterpress printing invented (Gutenberg)

1400–1475 EARLY RENAISSANCE

1415　　1420　　1425　　1430　　1435　　1440　　1445　　1450　　1455　　1460　　1465　　1470　　1475　　1480　　1485　　1490　　1495　　1500

JAN VAN EYCK

The Dutch painter Jan van Eyck achieved mastery in oil painting, a technique almost unknown until then, in his lifelike portraits and glowing images of Madonnas, and so for a long time he was considered to have invented it. He created the famous Ghent Altar with this brother Hubert.

As court painter to the Burgundian Duke Philip the Good, Jan van Eyck set off with a legation on the difficult journey to faraway Lisbon. The group was intended to prepare the ground for the duke's wedding to Isabella of Portugal. Van Eyck's task was to paint the bride, so that the duke would be able to form a picture of Isabella before the marriage.

The artist painted two unsparingly lifelike portraits of the young woman. The princess was probably not particularly attractive, and that is exactly how van Eyck painted her. He showed people with all their strengths and weaknesses: dignified, but with their big noses and bad skin, their wrinkles and sleepy eyes. Even so he was in demand as a portrait

painter, and many rulers and rich burghers commissioned him to paint them. And his pictures did not, after all impede Philip the Good's marriage to Isabella.

Brilliant oil painting

However, when Jan van Eyck painted the Madonna with her child, his brush brought out her purity and beauty above all. His images of Mary with their costly garments stand in Gothic churches, serious and lovely, or sit enthroned in lavishly decorated rooms, lit by the gentle sunlight. No one had been able to use colour so magically before van Eyck.

Previously, artists had used mainly dull tempera colours, which could not capture the waft of a transparent veil or the velvety glow of expensive fabrics. Van Eyck, however, used oil painting, a technique which was still new and which he mastered like no other. This enabled him to show fine transitions, to lend a glow to faces, velvety weight to fabrics and to make other textures shine transparently.

Jan's big brother

Jan van Eyck's brother Hubert was also a famous painter. In one of their joint major works, the *Ghent Altar*, it is agreed that he even surpassed his brother Jan. Hubert probably began painting the pictures on the polyptych, with Jan getting involved at a later stage. When the altar's side panels are closed, it shows a scene of the Annunciation; when open, it reveals the central picture with the Adoration of the Lamb. Jan completed the altar after his brother died and also painted over many of Hubert's ideas. Today, it is difficult to decide which of the music-making angels and saints, pilgrims and praying figures are by Jan and which by Hubert.

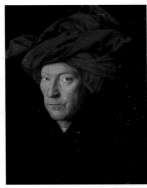

c. **1390**　Jan van Eyck born in Maaseyck near Maastricht
1422　Becomes court painter to Count Johann III of Holland in The Hague
1425　Duke Philip the Good of Burgundy employs him
1425　A secret diplomatic journey takes him to Italy
1426　His brother Hubert dies in Ghent
1428/29　Van Eyck travels to Lisbon, to paint a portrait of Princess Isabella
1430　Buys a house in Bruges
1436　Goes on a long journey, probably to the Holy Land
1441　Dies on 23 June in Bruges

READING TIP
Norbert Schneider, *Jan van Eyck*, Frankfurt 1997
Edwin Hall, *The Arnolfini Betrothal*, Berkeley 1997

[above]
Presumed self-portrait: *Man with Red Turban*, 1433. Oil on wood, 26 x 19 cm. National Gallery, London

[left]
Ghent Altar (closed), completed 1432. Tempera and oil on wood, approx. 335 x 229 cm. St. Bavo, Ghent

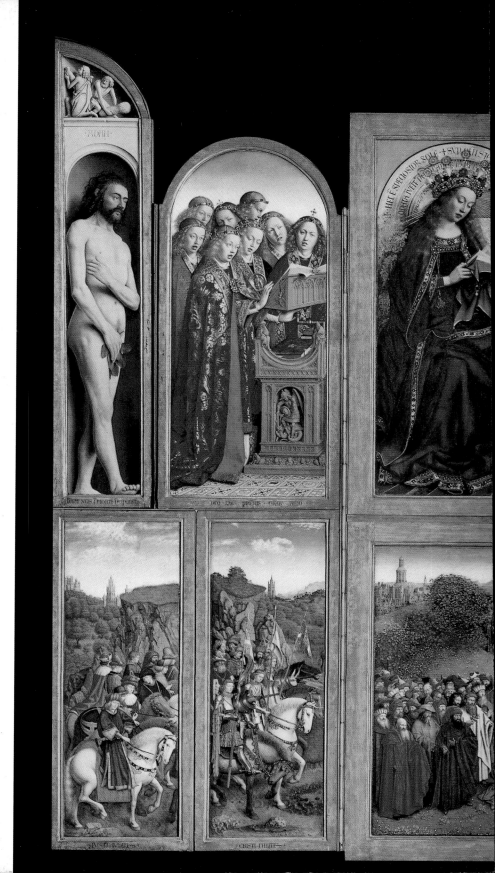

Ghent Altar (open), completed 1432.
Tempera and oil on wood, 335 x 229 cm.
St. Bavo, Ghent

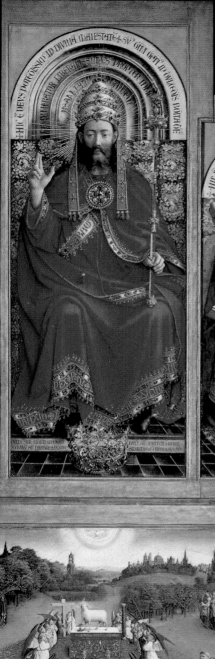
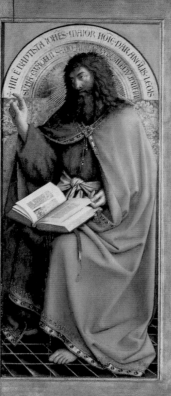
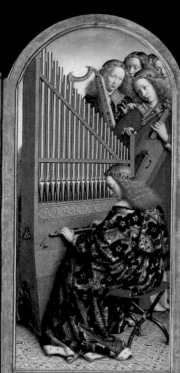
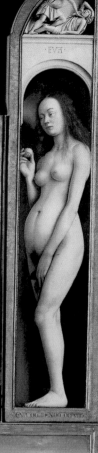
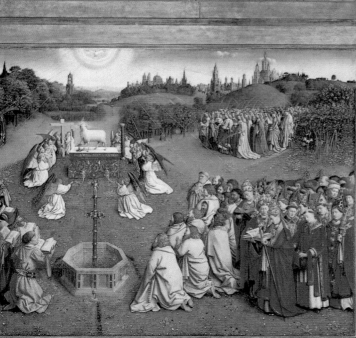

1453 Turks conquer Constantinople

1432 *Ghent Altar* (Jan van Eyck) **1455** Letterpress printing invented (Gutenberg) **1469–1492** Lorenzo de' Medici rules in Florence

EARLY RENAISSANCE 1400–1475 **1400–1475 EARLY RENAISSANCE**

| 1395 | 1400 | 1405 | 1410 | 1415 | 1420 | 1425 | 1430 | 1435 | 1440 | 1445 | 1450 | 1455 | 1460 | 1465 | 1470 | 1475 | 1480 |

[right]
Venus and Mars, Tempera and oil on wood, 70.6 x 176.8 cm. National Gallery, London

[below]
Birth of Venus, c. 1485. Tempera on canvas, 172 x 285 cm. Uffizi, Florence

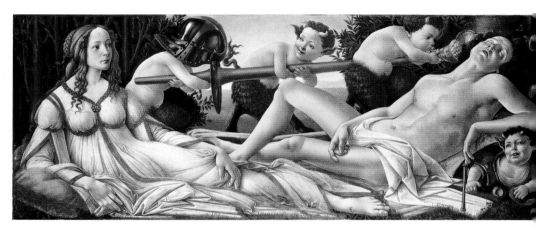

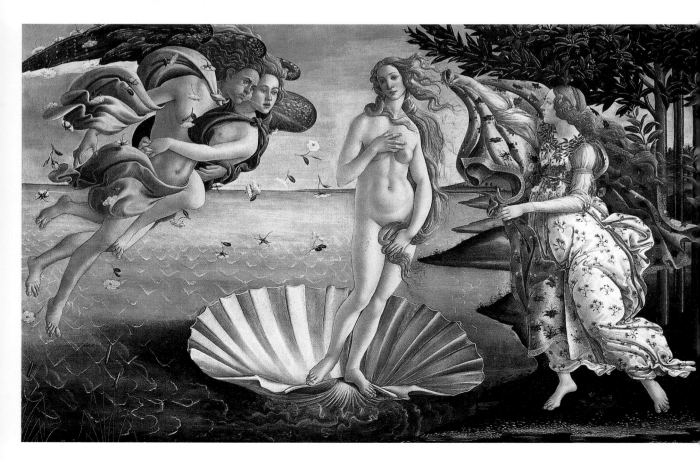

1503/06 *Mona Lisa*
(Leonardo)

1517 Start of the Reformation

1492 Columbus's voyage of
discovery to America

1529 Turks besiege Vienna

1508 Frescos in Sistine Chapel begun (Michelangelo)

HIGH RENAISSANCE 1475–1600

| 1485 | 1490 | 1495 | 1500 | 1505 | 1510 | 1515 | 1520 | 1525 | 1530 | 1535 | 1540 | 1545 | 1550 | 1555 | 1560 | 1565 | 1570 |

SANDRO BOTTICELLI

He is considered to be the most important Florentine painter of the early Italian Renaissance. In his large-format paintings, the Italian painter Sandro Botticelli captured the splendour of Florence's flowery meadows and the charms of heroes, gods and magical beings from the world of antique mythology — thus creating an oeuvre that links his home landscape with the legends of classical antiquity.

Actually, Botticelli's father intended his sickly son to become a goldsmith. Fortunately, the boy showed no talent for this, which was not the case with his drawing skills. Sandro was therefore apprenticed to the distinguished painter Filippo Lippi and soon surpassed his master in fame and skill. The Pope summoned the artist to Rome, where his wall frescos adorn the Sistine Chapel beneath Michelangelo's ceiling frescos. It was not until the end of his life, when the notorious Florentine preacher Savonarola began campaigning against joyful art, that Botticelli almost gave up painting altogether.

An illustrious patron

Florence was a rich city in those days, and the Medicis were one of its most influential families. Botticelli probably painted his famous *Birth of Venus* for them. The goddess of beauty is depicted emerging from the sea, standing on a shell, and is being wafted ashore amid a shower of roses by zephyrs, and on the shore a nymph awaits her with a purple mantle. Here, Botticelli painted the ancient myth of the birth of beauty in perfect harmony.

The most colourful scion of the Medici clan was Lorenzo, whom everyone admiringly called 'the Magnificent' ('il Magnifico' in Italian). He commissioned Botticelli to paint a wedding picture for Semiramide Appiani, whom Lorenzo wanted to marry to his ward Lorenzo di Pierfrancesco di Medici. Such wedding gifts were customary at the time, and it was not unusual for painters to decorate the wooden chests the brides brought to the marriage as part of their dowry with Biblical motifs and scenes of hunting and love.

Spring in Florence

Botticelli saw marriage as the start of a new life. In his picture *Primavera* (Spring) he placed the Roman gods in the middle of an Italian landscape. Mercury, the messenger of the gods, is driving the last dark clouds away with his staff, and the goddess Flora is strewing flowers into the fertile landscape from her floral garment.

The marriage of Semiramide and Lorenzo was intended to bind the ruling houses of Appiani and Medici together more closely. Love was probably not involved; on the contrary, Semiramide hardly knew her future husband before she married him. In Botticelli's picture, therefore, Mercury, who is waving his herald's staff in the sky, is perhaps also supposed to be driving away the clouds of anxiety from above the bride's head.

1444 or **1445** Sandro Botticelli born in Florence
1465–67 Works in the studio of the famous painter Filippo Lippi
1470 Founds his own workshop
1472 Becomes a member of the Compagnia di San Luca brotherhood of painters
1475 The rich Medici family becomes his most important patron
1480 Pope Sixtus IV summons the painter to Rome
1492 Death of Lorenzo de' Medici; Botticelli begins to be influenced by the fanatical Dominican monk Savonarola
1510 Botticelli dies on 17 May in his native town, Florence

READING TIP
Frank Zöllner, *Botticelli*, Munich 2005

[above]
Self-portrait, detail from the *Adoration of the Magi*, c. 1477/78. Tempera on wood, 111 x 134 cm. Uffizi, Florence

[next double page]
Primavera (detail), c. 1478. Tempera on wood, 203 x 314 cm. Uffizi, Florence

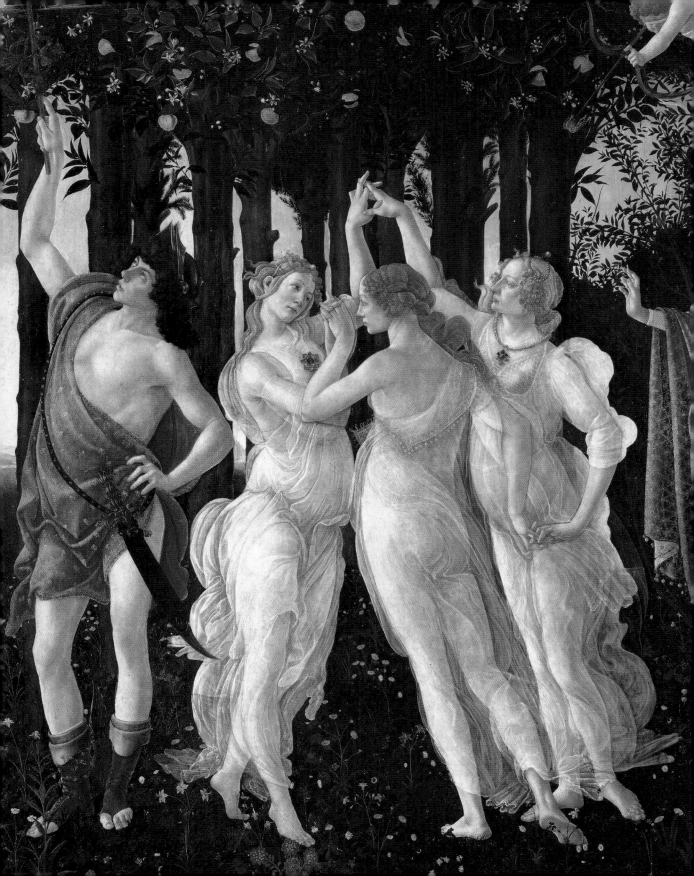

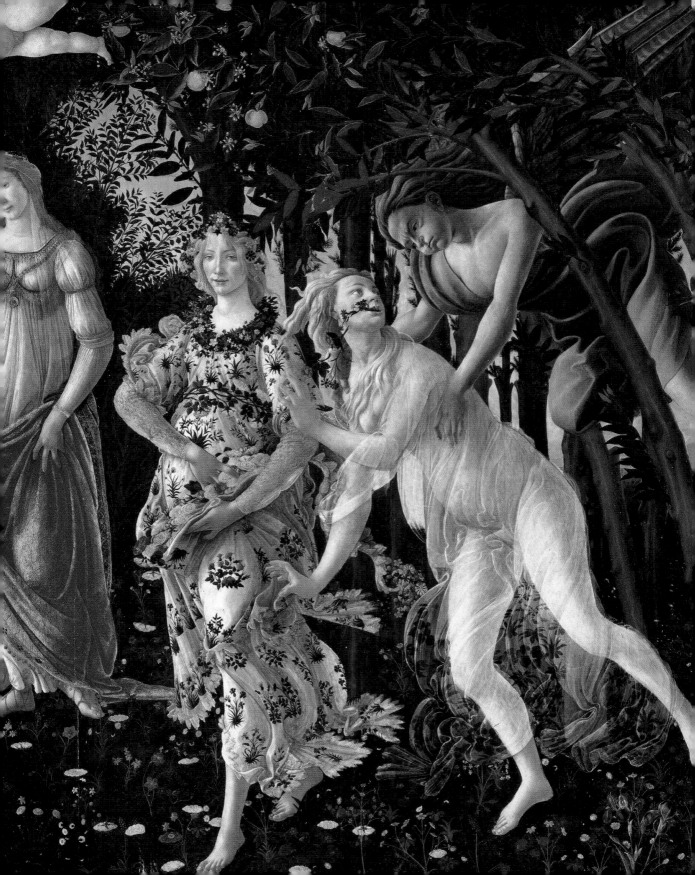

ALBRECHT DÜRER

MICHELANGELO BUONARROTI

1432 *Ghent Altar* (Jan van Eyck) **1453** Turks conquer Constantinople

1455 Letterpress printing invented (Gutenberg)

EARLY RENAISSANCE 1400–1475 1400–1475 EARLY RENAISSANCE HIGH RENAISSANCE

| 1395 | 1400 | 1405 | 1410 | 1415 | 1420 | 1425 | 1430 | 1435 | 1440 | 1445 | 1450 | 1455 | 1460 | 1465 | 1470 | 1475 | 1480 |

The Hay Wagon, c. 1500. Oil on panel,
135 x 100 cm. Museo Nacional del Prado,
Madrid

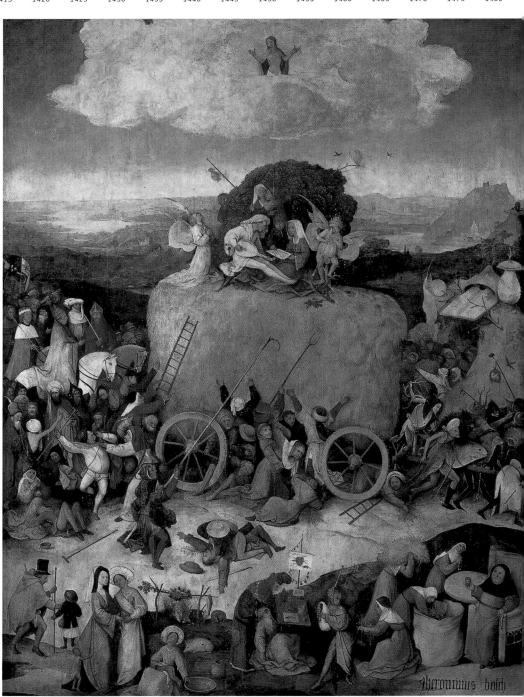

1475–1600

| 1485 *Birth of Venus* (Botticelli) | 1503/06 *Mona Lisa* (Leonardo) | 1529 Turks besiege Vienna |

1492 Columbus's voyage of discovery to America

1517 Start of the Reformation
1519 Charles V becomes Holy Roman Emperor

| 1485 | 1490 | 1495 | 1500 | 1505 | 1510 | 1515 | 1520 | 1525 | 1530 | 1535 | 1540 | 1545 | 1550 | 1555 | 1560 | 1565 | 1570 |

HIERONYMUS BOSCH

The Dutch painter Hieronymus Bosch amazed his fellow men with his mysterious, often gloomy pictures full of remarkable events and horrifying monsters. The triptych of the Garden of Delights *is considered his masterpiece.*

Little is known of the life of Hieronymus Bosch. He was christened Jheronimus Anthonissen van Aken, and later chose his birthplace of 's-Hertogenbosch as his working name. After his wedding, Bosch moved to the exclusive north side of the market place of the then prosperous commercial centre. He was a member of the Brotherhood of Mary, a community of faithful followers of Mary, famous for its lavish banquets and Marian processions, in which actors often appeared as devils. In those days, people's belief in God and the Devil was very vivid. Bosch's own belief in heaven, hell and purgatory is reflected in many of his pictures.

Fantastic creatures

Information on Bosch's life may be thin on the ground, but his paintings are fantastic and varied. This is true above all of his triptych of *The Garden of Earthly Delights*, which celebrates life as its theme. Unicorns and other fabulous creatures live there in harmony with elephants and larger-than-life birds. People are fed by ducks, others are crawling into eggshells, walking on their hands or flying around in amniotic sacks. Fish have wings or are being used as lances by naked riders; cats have horns; dogs walk on two legs through a strange landscape. But monsters and devilish creatures, cruelty and torment are also to be seen, sending a shudder down the viewer's spine.

Pictures like this had never been seen before, and so even rulers and cardinals sent their ambassadors to North Brabant to commission work from the painter. A 'genuine Bosch' was an adornment to any art collection.

A painting full of surprises

On the outside, the tripartite *Garden of Earthly Delights* shows the creation of the world, painted entirely in shades of grey. When the panels are opened the picture becomes surprisingly bright, magnificent and full of life. Hieronymus Bosch created three different ideas of the world in his *Garden of Earthly Delights*. On the left-hand panel he painted paradise, with God bringing Adam and Eve together in the foreground. The gigantic central section is simply teeming with naked people and exotic animals.

The right-hand wooden panel shows hell, where people have turned to vice, houses burn and wars rage.

That fact that many artists faked Bosch's paintings shows just how popular his works were at the time. Some forgers hung their imitations in a fireplace to make them look darker and thus older. Now that it is possible to determine the age of the wood artists painted their pictures on, we know fairly precisely which paintings are by Bosch and which are not.

c. 1450 Hieronymus Bosch born in 's-Hertogenbosch near Eindhoven
1481 Marries Aleyt van de Mervenne, a patrician's daughter
1486 Becomes a member of the Brotherhood of Mary
1516 Is buried on 9 August in his birthplace, 's-Hertogenbosch

READING AND INTERNET TIPS
Informative and exciting to read:
Hans Belting, *Hieronymus Bosch. Garden of Earthly Delights*, Munich 2002
www.boschuniverse.org offers a wide range of information, pictures and games.

[above]
Self-portrait, detail from the left-hand inner panel of the triptych *The Temptation of St. Anthony*, c. 1500. Oil on wood, side panels each 131.5 x 53 cm. National Museum of Old Art, Lisbon

[left]
The Garden of Earthly Delights, c. 1510. Oil on wood, outer panels each 220 x 97 cm. Museo del Prado, Madrid

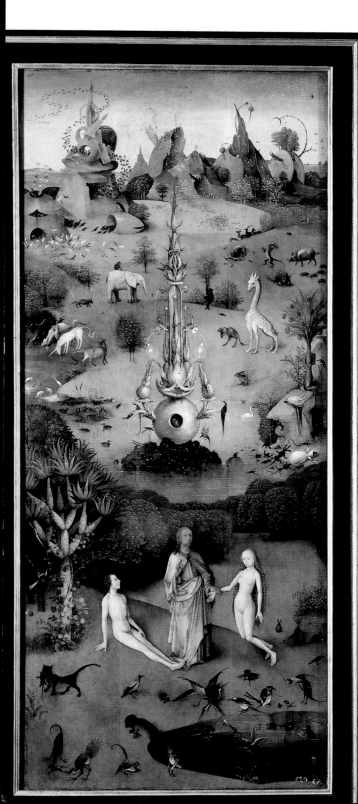
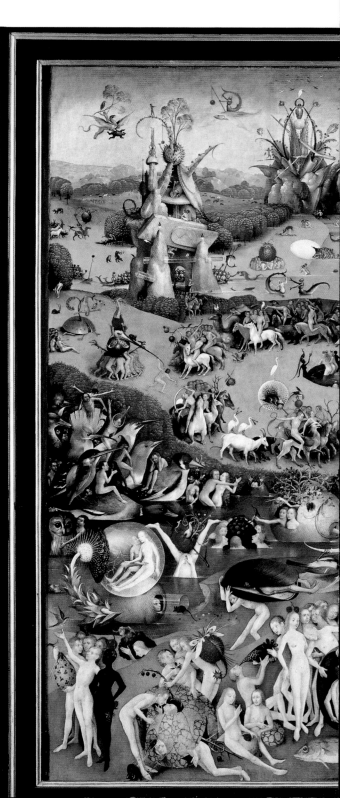

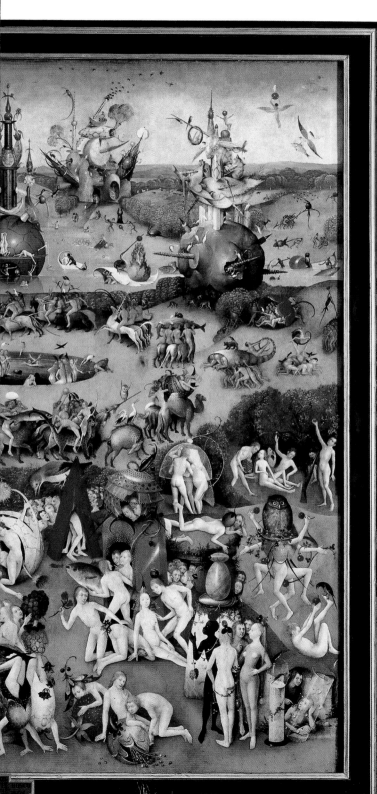

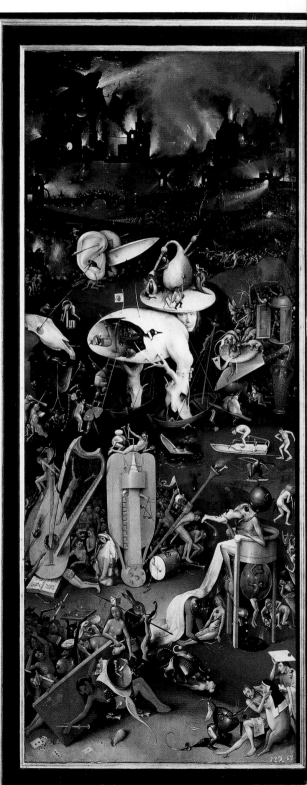

1432 *Ghent Altar* (Jan van Eyck) **1453** Turks conquer Constantinople

1434–1464 Cosimo de' Medici rules
in Florence

1469–1492 Lorenzo de' Medici rules
in Florence

EARLY RENAISSANCE 1400–1475

1400–1475 EARLY RENAISSANCE HIGH RENAISSANCE 1475–1600

1400 1405 1410 1415 1420 1425 1430 1435 1440 1445 1450 1455 1460 1465 1470 1475 1480 1485

Mona Lisa, 1503–06. Oil on wood,
77 x 53 cm. Musée du Louvre, Paris

1490 1495 1500 1505 1510 1515 1520 1525 1530 1535 1540 1545 1550 1555 1560 1565 1570 1575

LEONARDO DA VINCI

No one had such a wide range of interests and invented and studied so many things as the Italian Renaissance artist Leonardo from the little village of Vinci. His Mona Lisa is the most famous painting in the world.

When Leonardo was strolling around the market place in Florence with his pupils he liked to visit the bird dealers. He would buy a few birds, then take them out of their cages and set them free. It was one of Leonardo's most heartfelt desires to lift himself into the air some day. He drew a parachute, a glider and a helicopter in his sketchbook.

Leonardo wrote down his observations on birds in mirror writing, so that he would not smudge the ink as he wrote left-handed, and scribbled pictures alongside them, intended to show how birds move their wings. Leonardo regarded the observation of nature and painting as one and the same thing: art was intended to provide a better understanding of the world.

The most famous smile in the world

After training under the sculptor Andrea del Verrochio in Florence, Leonardo became a member of the city's renowned Gild of St. Luke, an association named after the patron saint of painters. Leonardo soon became famous as a painter, but also as an architect and engineer. Prince Lodovico Sforza brought him to Milan to build bridges, catapults and cannons for him, and Pope Leo X invited him to Rome. He later worked for the French king François I, who appointed him 'first painter, architect and mechanic to the king'. Leonardo painted *The Last Supper* in Milan, and the *Mona Lisa*, the most famous painting in the world, after his return to Florence. The subject is presumed to be the wife of a Florentine merchant. Leonardo himself came to love the picture so much that he even took it with him on his travels. The landscape elements in the background of the painting are not clearly demarcated from each other, but seem to blend together in a mist. This painting technique is called 'sfumato', from the Italian word for smoke ('fumo').

Discoveries and setbacks

But Leonardo also had to put up with some setbacks among his many experiments. For example, when mixing the paints for his *Last Supper* he tried to devise a new technique. But the paint peeled off while he was still painting, which is why the painting had to be elaborately restored some time ago. Flying turned out to be difficult as well: Leonardo's helicopter would not lift off; and when Leonardo's pupil Salai tried to soar into the air with a glider from a hill near Florence, he crashed and injured himself. After this, Leonardo never tried to build a flying machine again. He can, nonetheless, be considered a true universal genius. He could not only draw, paint and make music, he also made some earth-shaking discoveries. He observed, for example, that the sun did not move in the firmament in the way people thought it did at the time.

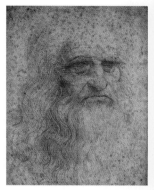

1452 Leonardo da Vinci born on 15 April in the village of Vinci near Florence
1469 Trains at the workshop of Andrea del Verrochio
1472 Becomes master of the Guild of St. Luke in Florence
1482 Prince Lodovico Sforza summons him to Milan
1500 Leonardo returns to Florence
1513 Pope Leo X invites him to Rome
1516 Leonardo visits François I in France
1519 Dies on 2 May at the Château de Cloux near Amboise

MUSEUM AND INTERNET TIPS
Leonardo's home town celebrates its famous son in its own museum:
www.leonet.it/comuni/vinci
Leonardo's inventions can be admired from close up in the Boston Museum of Science: www.mos.org/leonardo

[above]
Self-portrait, c. 1516. Red chalk drawing, 33.2 x 21.2 cm. Biblioteca Reale, Turin

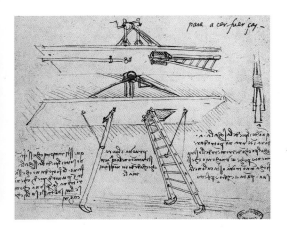

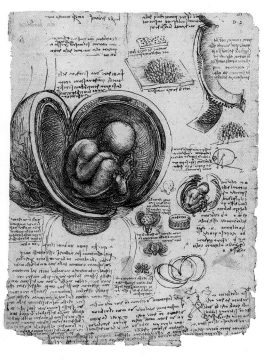

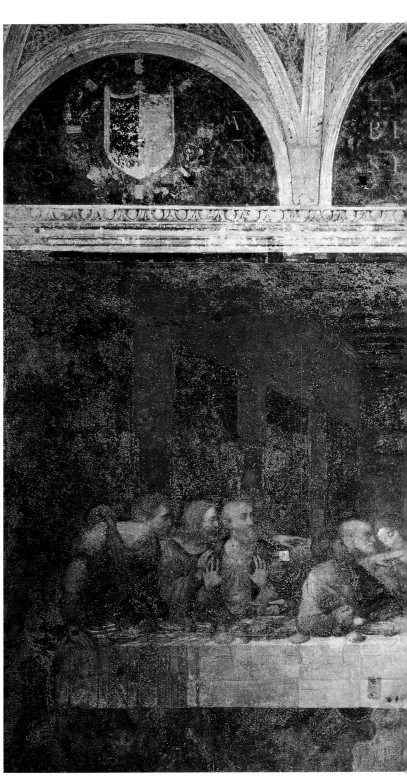

[above]
Aircraft with ladders for landing.
Manuscript D. Institut de France,
Paris

[below]
Human foetus in open womb,
1511–13. Royal Collection,
Windsor Castle

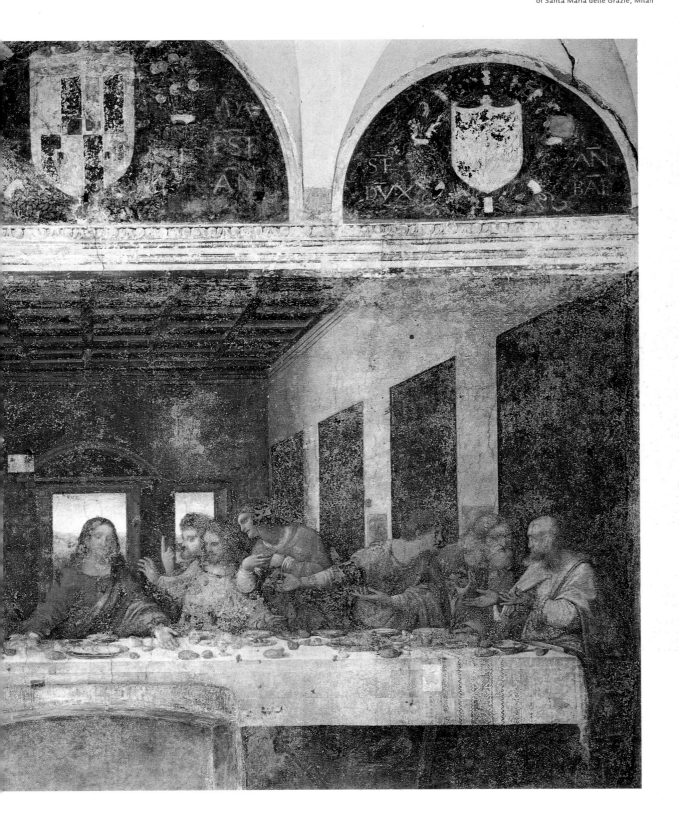

The Last Supper, 1495–97. Tempera and oil on plaster, 460 x 880 cm. Monastery of Santa Maria delle Grazie, Milan

1455 Letterpress printing invented
(Gutenberg)

1485 *Birth of Venus*
(Botticelli)

1473 * Nicolaus Copernicus

HIGH RENAISSANCE 1475–1600

1410 1415 1420 1425 1430 1435 1440 1445 1450 1455 1460 1465 1470 1475 1480 1485 1490 1495

Hare, 1502. Watercolour, opaque paints
and ink on paper, 25 x 25 cm. Albertina,
Vienna

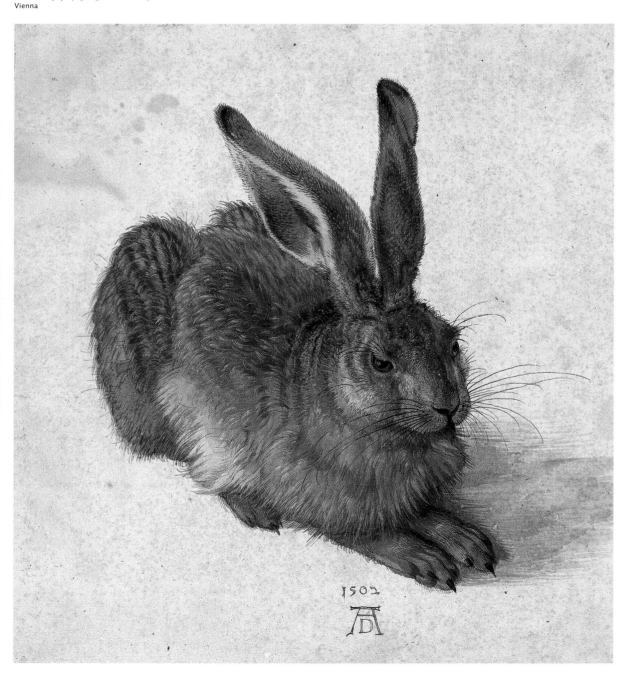

1503/06 *Mona Lisa* (Leonardo) 1529 Turks besiege Vienna 1546 High point of Fuggers' financial empire

1512–1514 *Sistine Madonna* (Raphael)

1517 Start of the Reformation 1534 Henry VIII founds the Anglican Church

| 1500 | 1505 | 1510 | 1515 | 1520 | 1525 | 1530 | 1535 | 1540 | 1545 | 1550 | 1555 | 1560 | 1565 | 1570 | 1575 | 1580 | 1585 |

ALBRECHT DÜRER

The German painter, draughtsman and graphic artist Albrecht Dürer was a self-assured man. No other artist of his day created so many self-portraits. And no painter north of the Alps understood how to show the new ideas of the Italian Renaissance so independently in paintings, woodcuts and copperplate engravings.

Dürer's first self-portrait shows him at the age of thirteen, when he was still an apprentice in his father's distinguished goldsmith's shop in Nuremberg. "I made the likeness in a mirror from my own self," he later wrote proudly next to the picture, "when I was yet a child."

At the age of twenty-nine, Dürer captured himself looking fairly vain and self-adoring in the *Self-portrait in a Fur-collared Robe*. In the meantime he had married Agnes Frey, the daughter of a rich merchant, had travelled to Venice and was running his own painter's studio in Nuremberg.

New self-confidence

Artists in the Middle Ages still saw themselves as simple craftsmen, but Dürer's colleagues in Venice, Rome and Florence already perceived themselves to be the creators of an art that was on the same plane as the works of the great poets and philosophers. Thanks to Dürer and other peripatetic artists, it was not just Renaissance art that came over the Alps

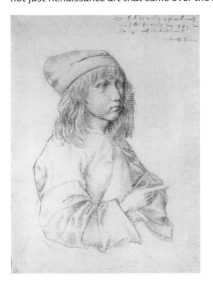

from Italy, but also this new sense of themselves. It is eloquently present in the *Self-portrait in a Fur-collared Robe*: Dürer the craftsman had turned into an artist. The Elector of Saxony and the burghers of Nuremberg provided the painter with commissions, and he worked for Emperor Maximilian. Dürer soon became a 'Member of the Grand Council' in his home town and thus one of its most highly-esteemed citizens.

The laws of beauty

Dürer was a critical and curious contemporary. He learned the laws of perspective in Italy in order to give his pictures the illusion of spatial depth. He invented a painting aid, used different kinds of paper to create unusual effects and brought to perfection the difficult arts of woodcut and copperplate engraving. The teachings of the Reformation, with which Dürer sympathised, also found their way into his pictures. As commissions for religious pictures became rarer in the Reformation period, many Renaissance artists in Germany turned to painting mainly landscapes and portraits.

Dürer was a close observer of the nature around him, as well as of himself. No one else could paint a tiny piece of turf so convincingly, and no one could make a hare look so deceptively realistic as the Nuremberg artist. Dürer spent a great deal of time studying the perfect proportions the human body should possess if it was to be considered perfectly beautiful. He later wrote down these laws of beauty in his *Theory of Proportion*.

Dürer also captured the beauty of the landscape in watercolours: they show the environs of Nuremberg in particular, and views from his first journey to Italy, like the little town of Arco in the midst of olive groves. "For man's most noble sense of all", he once wrote, "is sight." And that is why the artist should capture what his eye sees.

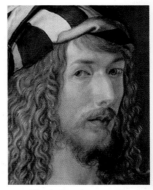

1471 Albrecht Dürer born on 21 May in Nuremberg
1484 Draws a self-portrait at the age of thirteen
1486 Apprenticed to the best painter in Nuremberg, Michael Wolgemut
1490–94 Dürer travels to Colmar and Basel
1494 Marries Agnes Frey and visits Italy for the first time in 1495
1500 Paints the famous *Self-portrait in a Fur-collared Robe*
1505–06 Travels to Italy again
1509 Becomes a councillor in Nuremberg and acquires the 'Dürerhaus'
1520 Travels to the Netherlands with Agnes
1528 Publishes his *Theory of Proportion*
1528 Dies on 6 April in his native town, Nuremberg

MUSEUM AND INTERNET TIPS
Dürer's house can be visited in Nuremberg. It now accommodates a museum of the master's life and work:
www.museen.nuernberg.de/duerer

[above]
Self-portrait at 26 (Detail), 1498. Oil on panel, 52 x 41 cm. Museo Nacional del Prado, Madrid

[left]
Self-portrait as 13-year-old boy, 1484. Silverpoint drawing, 27.5 x 19.6 cm. Albertina, Vienna

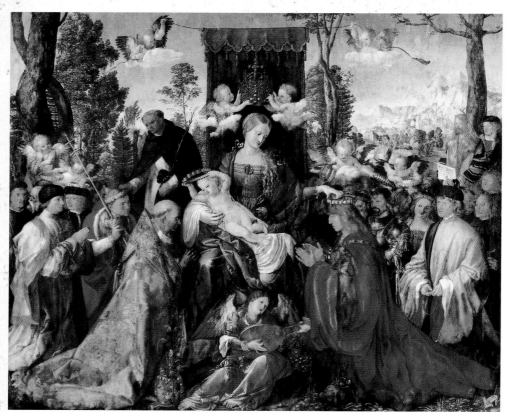

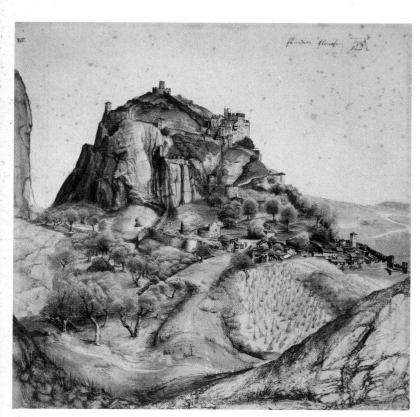

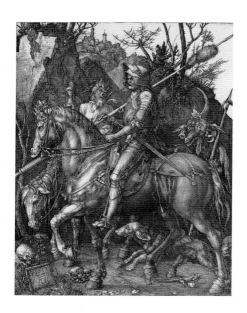

[left]
The Festival of the Rosary, 1506. Oil on wood, 162 x 194.5 cm. National Gallery Prague

[below left]
Arco, 1495. Watercolour and opaque paints on paper, 22.1 x 22.1 cm. Musée du Louvre, Paris

[below right]
Knight, Death and Devil, 1513. Copperplate engraving, 24.5 x 18.8 cm

[right side]
Self-portrait in a Fur-collared Robe, 1500. Oil on wood, 67 x 49 cm. Alte Pinakothek, Munich

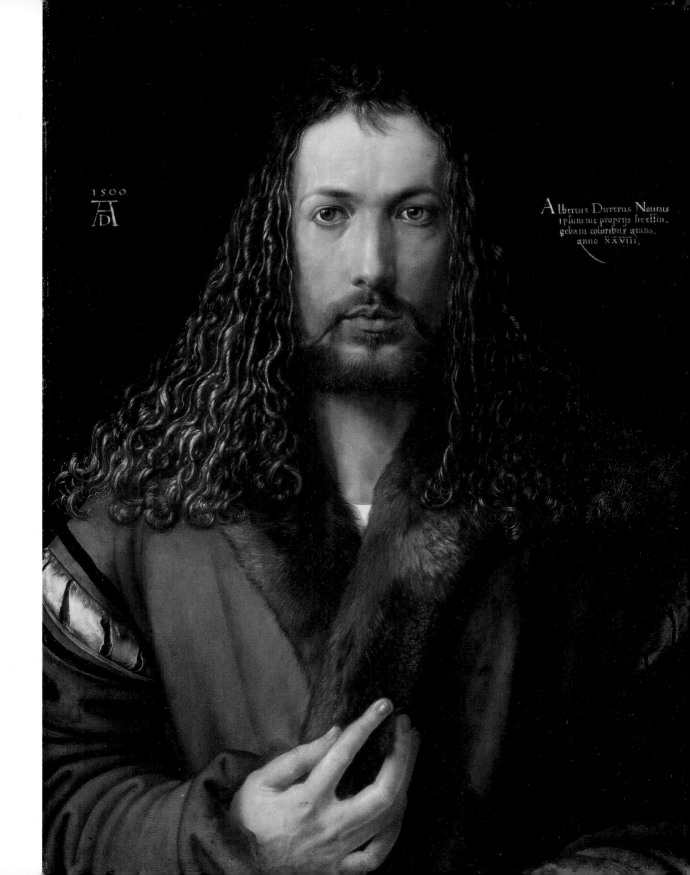

LUCAS CRANACH THE ELDER ══════════════════════════════
ALBRECHT DÜRER ═══════════════════════════════════
MICHELANGELO BUONARROTI ═══════════════════════════════

1503/06 *Mona Lisa*
(Leonardo)

1455 Letterpress printing invented
(Gutenberg)

1485 *Birth of Venus* (Botticelli)

HIGH RENAISSANCE 1475–1600

| 1430 | 1435 | 1440 | 1445 | 1450 | 1455 | 1460 | 1465 | 1470 | 1475 | 1480 | 1485 | 1490 | 1495 | 1500 | 1505 | 1510 | 1515 |

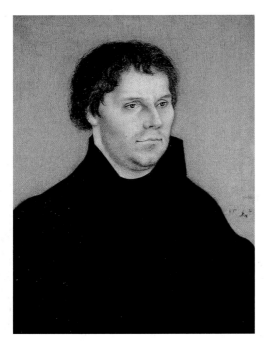

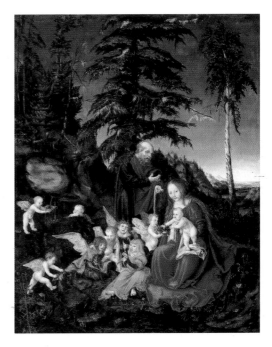

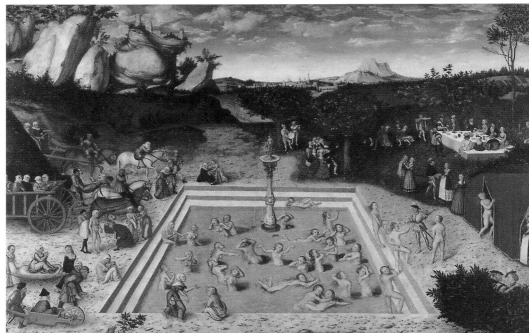

[above left]
Martin Luther, 1553. Wood,
20.5 x 145 cm. Herzog
Anton Ulrich Museum,
Braunschweig

[above right]
Rest on the Flight to Egypt,
1504. Oil and tempera on
wood, 69 x 51 cm. Gemälde-
galerie, Staatliche Museen
zu Berlin, Berlin

[right]
The Fountain of Youth, 1546.
On wood, 121 x 184 cm.
Gemäldegalerie, Staatliche
Museen zu Berlin, Berlin

1517 Start of the Reformation

1529 Turks besiege Vienna

1519 Charles V becomes Holy Roman Emperor

1546 High point of Fuggers' financial empire

1564 * William Shakespeare

1571 Naval Battle of Lepanto: end of Turks' marine dominance

1475–1600 HIGH RENAISSANCE

1520 1525 1530 1535 1540 1545 1550 1555 1560 1565 1570 1575 1580 1585 1590 1595 1600 1605

LUCAS CRANACH THE ELDER

In his youth, the German painter, draughtsman and copperplate engraver Lucas Cranach established the style of the so-called Danube school. He became famous for his depictions of beautiful, naked women and his portraits of Martin Luther.

Cranach's father was a painter, and as he obviously wanted his son to follow in his footsteps he named him after St. Luke, the patron saint of painters. The artist himself later chose the name of his birthplace, Kronach, as a surname. The Cranach painting dynasty lasted over a hundred years in all.

Lucas Cranach was a very good businessman. He owned a chemist's shop, his own printing press and a licensed inn. But his greatest passion was for art. In Vienna, where he lived from 1500 to 1504, he painted some portraits of scholars and their wives that caused a stir, but also pictures of Biblical scenes. Unlike the painters of the Middle Ages, who were not interested in depicting landscape, Cranach painted nature in rich colours, showing people as part of the mighty, divine creation. Other artists in the Danube area, like Albrecht Altdorfer, were seized by a similar feeling for nature, and they became known collectively as the Danube School.

A many-sided artist

Cranach liked depicting saints in fashionable garments. He was particularly good at images of lovely young women, often dressed only in transparent veils or elegant hats, looking seductively back at the viewer: he painted Eve, the goddess Venus, or water-nymphs in this fashion. But anyone who looked carefully could recognise the face of the daughter, spouse or lover of the burgher who had commissioned the picture.

The artist's fame also reached Elector Frederick the Wise of Saxony, who made him court painter at Wittenberg for life. Cranach soon became known as the 'fastest painter' in the area. He and his assistants produced paintings, watercolours or copperplate engravings to order, as if on a conveyor belt.

Cranach also had to decorate the Elector's palaces, accompany him on hunts and in battle, paint furniture and create horse-blankets for tournaments. And when his sovereign ended up in captivity, Cranach had to follow him and cheer him up with pictures.

Luther's first portraitist

But the most important man in Cranach's pictures was not an elector but the famous ecclesiastical reformer Martin Luther. Luther was the godfather of Cranach's daughter Anna, and the painter was best man at Luther's wedding. Cranach printed Luther's translation of the Bible, for which he also created the woodcuts, and painted numerous portraits of his friend, showing Luther as a strong-willed and uncompromising thinker. Luther has survived to this day in the form painted by Cranach. All later artists copied their pictures of Luther from Cranach.

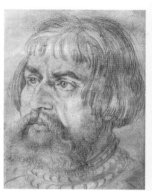

1472 Lucas Cranach born in Kronach in October

1500–04 Works in Vienna

1505 Moves to Wittenberg as court painter to Frederick the Wise

1520 Martin Luther becomes godfather to Cranach's daughter Anna

1523 Cranach opens a printing press in Wittenberg

1525 Is best man at Luther's marriage to Katharina von Bora

1528 Cranach is the second-richest citizen of Wittenberg

1547 The office of court painter is suspended for three years

1550 Hands over the painting workshop to his son Lucas Cranach the Younger

1553 Cranach dies on 16 October in Weimar

INTERNET TIP
There are links to Lucas Cranach's work at www.cranach.de

Reformation

The Reformation triggered by Martin Luther split European Christendom into Catholics and Protestants. Luther protested against the Catholic Church's practice of 'forgiving' sins by selling so-called indulgences. He was convinced that Man could be redeemed only through God's grace, and rejected the Catholic idea of Hell, whereupon many artists stopped painting it. Large numbers of paintings and sculptures were removed from churches and destroyed during the Reformation. "Thou shalt not make to thyself any graven image" is one of the Ten Commandments, and some of the reformers took it all too seriously. Luther turned against the 'iconoclasts', thus taking the side of his friend Cranach – who had painted altars himself – and of art.

[above]
Albrecht Dürer, *Lucas Cranach*, 1525. Silver pencil drawing, 16.2 x 11 cm. Musée Bonnat, Bayonne

MICHELANGELO BUONARROTI

TITIAN

RAPHAEL

1469–1492 Lorenzo de' Medici
rules in Florence

1506 Work begins on rebuilding
St. Peter's in the Vatican

1503/06 *Mona Lisa* (Leonardo)

1512–1514 *Sistine Madonna*
(Raphael)

HIGH RENAISSANCE 1475–1600

| 1430 | 1435 | 1440 | 1445 | 1450 | 1455 | 1460 | 1465 | 1470 | 1475 | 1480 | 1485 | 1490 | 1495 | 1500 | 1505 | 1510 | 1515 |

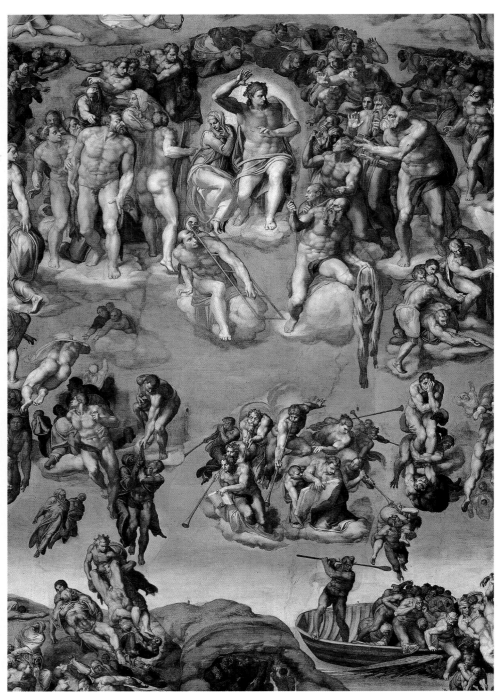

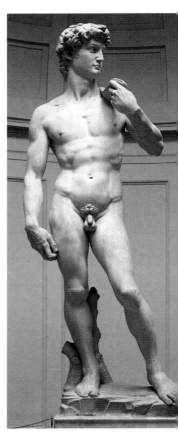

[left]
The Last Judgement, 1535–41. Fresco,
c. 17 x 13 m. Sistine Chapel, Vatican, Rome

[right]
David, 1501–04. Marble, height 550 cm.
Galleria dell'Accademia, Florence

1520/21 Magellan circumnavigates the globe
1529 Turks besiege Vienna
1514 Niccolo Machiavelli's *Il Principe* published
1541 Spain conquers the Mayan Empire in Central America
1571 Naval Battle of Lepanto: end of Turks' marine dominance

1475–1600 HIGH RENAISSANCE

1520 1525 1530 1535 1540 1545 1550 1555 1560 1565 1570 1575 1580 1585 1590 1595 1600 1605

MICHELANGELO

The Italian sculptor, painter, master builder and poet Michelangelo Buonarroti was the greatest genius of the Renaissance, alongside Leonardo da Vinci. He was called 'The Divine Michelangelo' by his contemporaries because his art was so perfect. His sculptures and frescos are among the most magnificent works of art in the world.

Michelangelo did not have a good word to say about painting. In his opinion, brushes and paint were a pastime for lazy artists; only imbeciles and stupid women could take any pleasure in paintings. He wanted to create great works as a sculptor. As his nurse's husband was a stonemason, Michelangelo had learned how to handle a hammer and chisel from the cradle. Later, at the academy of the rich and learned Lorenzo de' Medici, he was able to marvel at the sculptures of antiquity. Michelangelo even dissected corpses and studied their anatomy in order to be able to depict muscles, veins and limbs as accurately as possible. His graceful figures are realised so perfectly that not a single chisel mark is to be seen on the smooth surface of these beautifully proportioned bodies. The artist sometimes insisted philosophically that his sculptures were already captive in the marble as an idea: all he had to do was carve them out. One can get a sense of what he meant by this from a group of slave sculptures: they almost look as if they had previously been imprisoned in stone and would now have to struggle desperately, with the artist's help, to free themselves from their heavy encasement.

Seven badminton courts full of painting
In 1518, Pope Julius II summoned Michelangelo to Rome. At the time the artist was still hoping to be able to continue working on a massive tomb with forty sculptures that the Pope had commissioned. But Julius II had something else in mind: Michelangelo was to paint the ceiling of the chapel in the Papal Palace. Wicked tongues suggested that powerful Italian sculptors had planted this idea in the Pope's mind in order to rid themselves of a tiresome competitor by getting him bogged down in painting.

Michelangelo resisted for a while, then finally accepted the challenge. After all, the walls of the Sistine Chapel already had frescos painted by Botticelli, by Michelangelo's teacher Ghirlandaio and other famous early Renaissance artists – works that Michelangelo intended to surpass. The chapel ceiling was huge, and the task seemed almost superhuman. Nevertheless, Michelangelo wanted to succeed by himself, not trusting journeymen or assistants to contribute a single brushstroke. Italy's sculptors rubbed their hands in satisfaction: Raphael was considered to be the greatest painter of the day, so the arrogant Michelangelo could only make a fool of himself.

An impatient patron
For four years Michelangelo had to adopt an uncomfortable position, with his arms outstretched, a lonely figure on wooden scaffolding he had built himself. Fresco work required haste, for the paint dried quickly on the wet plaster. Every stroke had to be in place by evening. The paint constantly dripped onto his face, as he described in one of his sonnets. Despite considerable pain, Michelangelo had no intention of giving up.

The impatient Pope could scarcely believe his ears: Michelangelo had at last completed the gigantic work with its teeming mass of almost 300 figures and the Biblical stories of the Creation, the Great Flood and the Fall of Man. It was the largest ceiling fresco in the world at the time, and had been created by a single artist!

Julius II died shortly afterwards. It almost seems as though he had been holding on just to be able to admire this magnificent work. Michelangelo's bitterest opponents had to agree that Michelangelo had indeed surpassed even Raphael.

The Last Judgement
Years later, Michelangelo came back to the Sistine Chapel to decorate the massive wall behind the altar with a fresco. He chose the Last Judgement as the theme. The papal chamberlain Biagio da Cesena and the Pope himself blushed with shame when they saw that Michelangelo had painted the blessed and the damned naked, as God had created

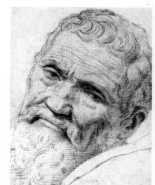

1475 Michelangelo Buonarroti born on 6 March in Caprese near Florence
1488 Trains with the famous Renaissance artist Ghirlandaio
1489 Lorenzo de' Medici takes him into his Academy
1505 Pope Julius II commissions his own tomb from Michelangelo
1508 Michelangelo begins painting the Sistine chapel
1529 Is appointed military architect to Florence and has to go into exile in Venice
1535 Pope Paul III appoints him chief Vatican sculptor, painter and architect
1541 *The Last Judgement* is unveiled
1546 Becomes architect for St. Peter's
1564 Michelangelo Buonarroti dies on 18 February in Rome

READING, MUSEUM AND INTERNET TIPS
Irving Stone's novel *The Agony and the Ecstasy* is already a classic, London 2000.
Georgia Illetschko, I, *Michelangelo*, Munich 2003, offers attractive pictures and entertaining information.
You can pay a virtual visit to the Sistine Chapel in the Vatican: www.mv.vatican.va
Michelangelo's finest sculptures are to be found in the Galleria dell'Accademia in Florence.

[above]
Daniele da Volterra, *Michelangelo Buonarroti*, c. 1548–53. Black chalk, 29.5 x 21.8 cm. Tylers Museum, Haarlem

High Renaissance

The early Renaissance began in Florence, and the High Renaissance found a new centre in Rome in the early 16th century. The popes in the Vatican in particular brought many important artists to the city. Building St. Peter's was the largest project. Art was intended to represent divine harmony in the well-thought-out order of buildings, sculptures and paintings, in the beauty of human faces and gracefully curving bodies. The important painters, sculptors and architects of the High Renaissance – alongside Michelangelo – were Leonardo da Vinci, Giorgione, Raphael, Correggio and Titian. The High Renaissance ended with the sack of Rome by Emperor Charles V's troops on 6 May 1527.

Sistine Chapel ceiling, 1508–12. Fresco, 13.7 x 39 m. Vatican, Rome

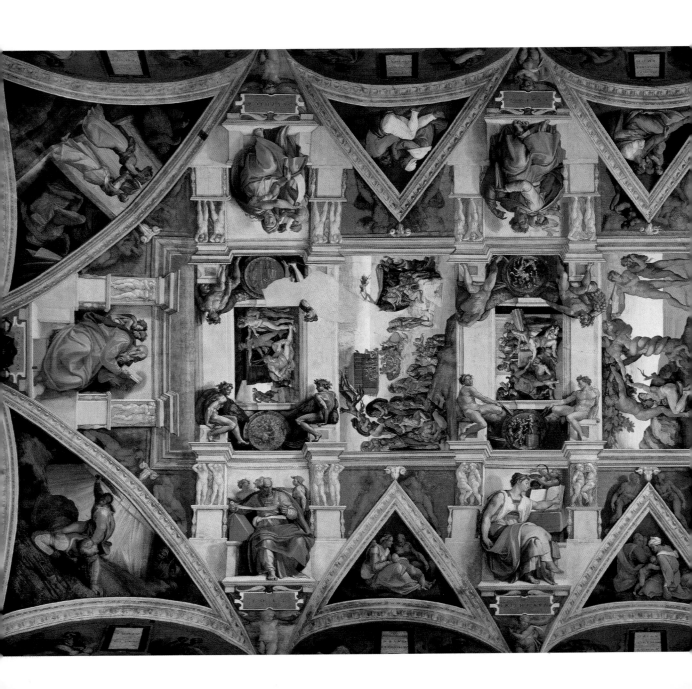

them. Cesena was not the only person to fulminate against the painting, which he felt was more suitable for a bathhouse than a chapel. Pope Pius V subsequently commissioned another painter to clothe the imposing figures in seemly garments. Michelangelo took bitter revenge on Biagio da Cesena by later painting him in hell at the Last Judgement.

Best painter whether he liked it or not
Throughout his long life, Michelangelo created many more paintings and sculptures in addition to the Sistine Chapel, constantly enhancing his reputation as the greatest artist of the High Renaissance. He worked for Pope Leo X and the rich Medici banking family, created façades for churches and, as an architect, redesigned St. Peter's in Rome. Even though Michelangelo never wanted to be anything but a sculptor, he nevertheless also became one of the best painters and architects in the world.

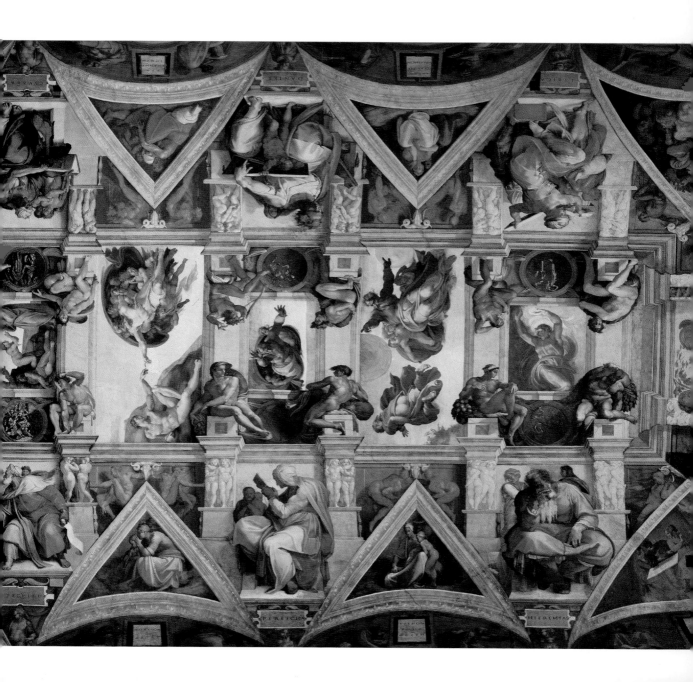

1503/06 *Mona Lisa* (Leonardo)

1453 Turks conquer Constantinople

1492 Columbus's voyage of discovery to America

1512–1514 *Sistine Madonna* (Raphael)

HIGH RENAISSANCE 1475–1600

| 1430 | 1435 | 1440 | 1445 | 1450 | 1455 | 1460 | 1465 | 1470 | 1475 | 1480 | 1485 | 1490 | 1495 | 1500 | 1505 | 1510 | 1515 |

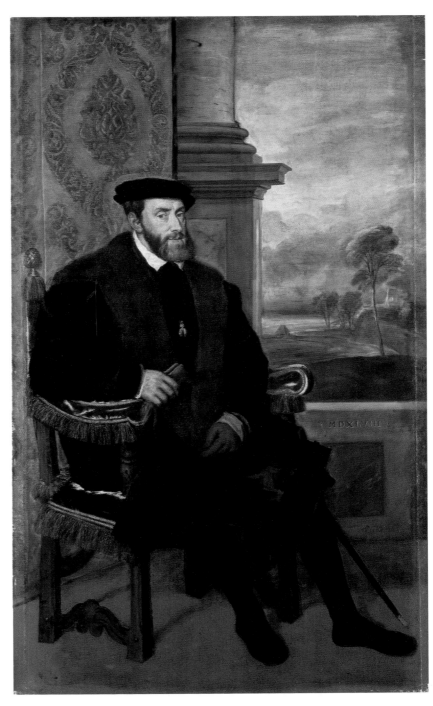

Emperor Charles V Seated, 1548.
Oil on canvas, 205 x 122 cm.
Alte Pinakothek, Munich

PIETER BRUEGEL
THE ELDER

1529 Turks besiege Vienna

1541 Sistine Chapel frescos completed
(Michelangelo)

1567 * Claudio Monteverdi

1588 Defeat of the Spanish Armada

1590 Dome of St. Peter's completed

1475–1600 HIGH RENAISSANCE

1520 1525 1530 1535 1540 1545 1550 1555 1560 1565 1570 1575 1580 1585 1590 1595 1600 1605

TITIAN

No one knew how to paint the Biblical saints and heroes of ancient mythology as luminously and with such life as the Italian artist Titian. His portraits lent magnificent lustre to emperors and popes. Many of Titian's sophisticated ideas about painting were imitated in the Baroque period. He was one of the most important painters of the Venetian High Renaissance.

In his younger years, Titian was commissioned to decorate the altar of the church of Santa Maria Gloriosa dei Frari in Venice with a picture of the Assumption. At that time, many artists were brooding about what painting tricks they could use to simulate dramatic movement in a rigid image. Titian found a convincing solution: the application of glowing colours – with brilliant yellow and a red whose velvety tones would make him famous – and by using innovative gestures and spiral twists in the figures.

In his painting of the Assumption, which is almost seven metres high, angels are carrying Mary up from the darkness of earth to the radiant firmament. This vigorous image, bursting with power, was as much a miracle to his amazed colleagues as the Mother of God's Assumption itself.

In demand as a portraitist

Titian's *Assumption* made him the most sought-after painter in the wealthy city of Venice almost overnight. His portraits in particular were much in demand. Here, too, the colour magician invented his own technique: first, he painted the faces as he saw them; then he applied a veil of milder tones over them, beneath which crooked noses, deep wrinkles and dark rings under the eyes disappeared in a wondrous fashion. In the flattering light of Titian's beauty cure, his satisfied clients looked much more dignified, younger and more beautiful, despite the obvious resemblance.

Pope Paul III was so besotted by the sensual luminosity of these pictures that the artist had to paint the whole papal family in Rome, "including the cats". Titian's rival Michelangelo was very jealous of this favour and is said to have been utterly delighted when Titian left Rome.

Court painter to the emperor

Charles V was also a great admirer of Titian's art, and valued it very highly. When he was crowned Holy Roman Emperor, the Venetian was allowed to paint a picture of the magnificent coronation. The ruler was so delighted with Titian that he appointed him a count palatine and made him his personal painter. Titian painted portraits of the emperor sometimes as a radiant warrior, and sometimes slumped exhausted in a chair. Despite his office at the imperial court, Titian did not have to live there, a particularly important concession for the artist, who was reluctant to leave his home city. Venice had made him a great painter, and that was where he wanted to be.

Titian grew less fond of portraiture as he grew older, sometimes merely sketching the outlines of his patron, and then letting a long time elapse before returning to the pictures. Months could pass in this way before a picture was completed.

c. **1477** or **1488** Titian born as Tiziano Vecellio in Pieve di Cadore
1508 Works with the painter Giorgione in Venice
1513 Pope Leo X invites him to Rome; Titian declines with thanks
1530 Titian is permitted to paint Charles V's coronation picture
1533 The emperor appoints Titian to be his personal painter and ennobles him
1541 Titian receives an imperial pension
1545 Works for Pope Paul III in Rome
1548 Karl V takes him to the parliament in Augsburg
1553 Titian works for Charles's successor Philip II
1576 Titian dies on 27 August in Venice

[above]
Self-portrait, c. 1550. Oil on canvas, 96 x 75 cm. Gemäldegalerie, Staatliche Museen zu Berlin, Berlin

[left]
Portrait of Pope Paul III, 1543. Oil on canvas, 106 x 85 cm. Museo e Gallerie Nazionali di Capodimonte

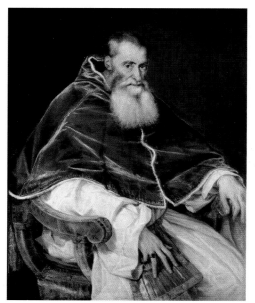

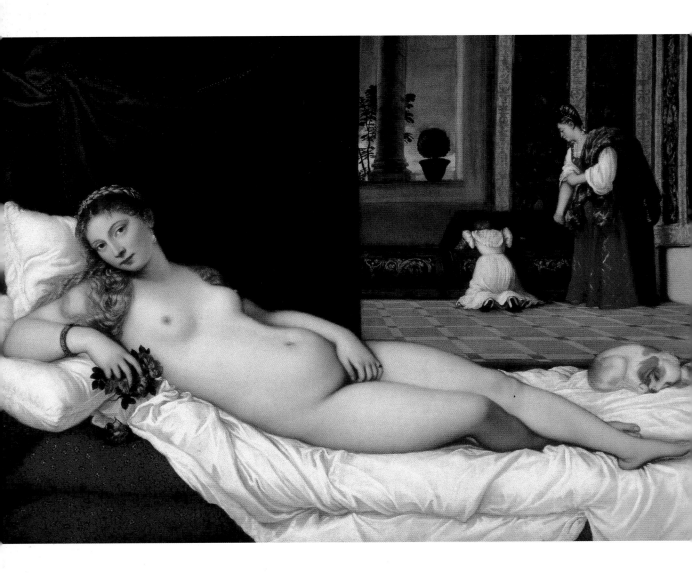

Venus of Urbino, 1538. Oil on canvas,
119 x 165 cm. Uffizi, Florence

[right]
Assumption of the Virgin (Assunta),
1516–18. Oil on wood, 690 x 360 cm.
Santa Maria Gloriosa dei Frari, Venice

LEONARDO DA VINCI

RAPHAEL

MICHELANGELO BUONARROTI

1469–1492 Lorenzo de' Medici
rules in Florence

1485 *Birth of Venus*
(Botticelli)

1506 Work begins on rebuilding
St. Peter's in the Vatican

1503/06 *Mona Lisa* (Leonardo)

HIGH RENAISSANCE 1475–1600

| 1430 | 1435 | 1440 | 1445 | 1450 | 1455 | 1460 | 1465 | 1470 | 1475 | 1480 | 1485 | 1490 | 1495 | 1500 | 1505 | 1510 | 1515 |

Sistine Madonna, 1512–14. Oil on canvas,
265 x 196 cm. Gemäldegalerie Alte
Meister, Dresden

1541 Sistine Chapel frescos completed
(Michelangelo)

1529 Turks besiege Vienna

1588 Defeat of the Spanish Armada

1475–1600 HIGH RENAISSANCE

1520 1525 1530 1535 1540 1545 1550 1555 1560 1565 1570 1575 1580 1585 1590 1595 1600 1605

RAPHAEL

The Italian painter and architect Raphael influenced subsequent images of Mary for a long time with his graceful pictures of the Madonna. His frescos for Pope Julius II made him one of the most famous painters of his age. His painting was considered an unattainable pinnacle of art for almost 400 years. Along with Leonardo, Michelangelo and Titian, Raphael was the most important Italian artist of the High Renaissance.

Raphael's father was a mediocre painter. When he could teach his son nothing more, he sent him to Perugia to train in the workshop of his famous colleague Pietro Perugino. Soon no one could tell the master's and pupil's work apart. Raphael had a great talent for appropriating the artistic skills of other painters. He took over Leonardo's compositional idea of arranging figures in the shape of a triangle. He learned to handle delicate colouring from the Venetian masters. And when he was in Rome, a friend is said to have opened the Sistine Chapel door behind which Michelangelo was secretly painting his frescos, so that Raphael was able to amaze people with figures à la Michelangelo even before the chapel was officially opened.

Raphael, the prince of painters

Raphael surpassed most of his models in versatility, perfection and refinement. His reputation soon spread all over Italy. He was just twenty-five years old when Pope Julius II, who wanted to revive the splendours of Roman antiquity, summoned the painter to Rome. He commissioned him to decorate a room in his new residence in the Vatican, one of the so-called Stanze, with frescos. Raphael had until then painted only one wall painting in his own right.

Julius was so enthusiastic about the young painter's proposals that he unceremoniously had frescos by other famous painters hacked off the walls in the other rooms. Now, Raphael and his assistants were able to adorn the Stanze completely with a teeming mass of heroes from the Bible and mythology, with saints and philosophers. Raphael assembled the most famous philosophers of antiquity in the School of Athens. He gave some of them the features of his contemporaries: the pessimistic philosopher Heraclitus, leaning on a marble block and writing on a sheet of paper, is a portrait of Michelangelo. Raphael painted himself in a black cap on the far right.

Many painters despaired at Raphael's talent; he was able to execute his depictions of the Madonna and other female portraits with tenderness, warmth and elegance. This is why Giorgio Vasari, author of the famous *The Lives of the Artists* – and whom we have to thank for many truths, as well as many rumours, about Raphael's life – said that Raphael "painted not with paint, but with flesh".

1483 Raffaello Santi born in Urbino, presumably on 6 April
1500 Is apprenticed to the painter Pietro Perugino in Perugia
1504 Moves to Florence, the heart of the Renaissance
1508 Pope Julius II summons the painter to Rome and gives him important commissions
1513 Raphael works for Julius's successor, Leo X
1514 Leo X appoints Raphael as architect and building director for St. Peter's
1520 Raphael dies on 6 April in Rome

INTERNET TIP
Raphael's *Stanze* (rooms), the Sistine and other Vatican museums can be visited online: www.mv.vatican.va

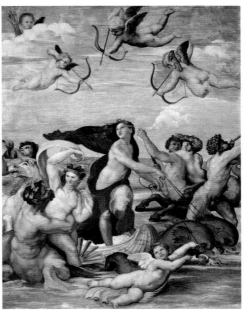

[above]
Self-portrait (detail), 1509. Oil on wood, 45 x 35 cm. Uffizi, Florence

[left]
Triumph of Galatea, 1512. Fresco, 295 x 225 cm. Villa Farnesina, Rome

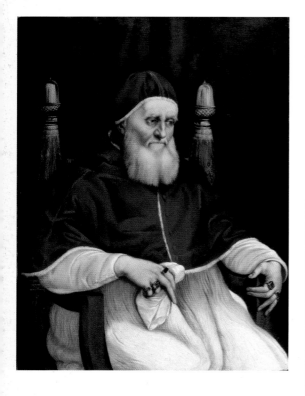

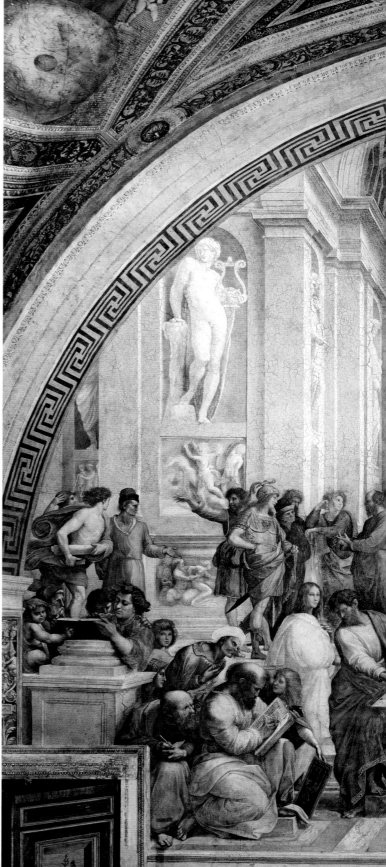

[abvove]
Pope Julius II, 1511. Oil on wood,
108 x 80 cm. Uffizi, Florence

[right]
The School of Athens, 1510/11. Fresco,
base length approx. 770 cm. Stanza
della Segnatura, Vatican

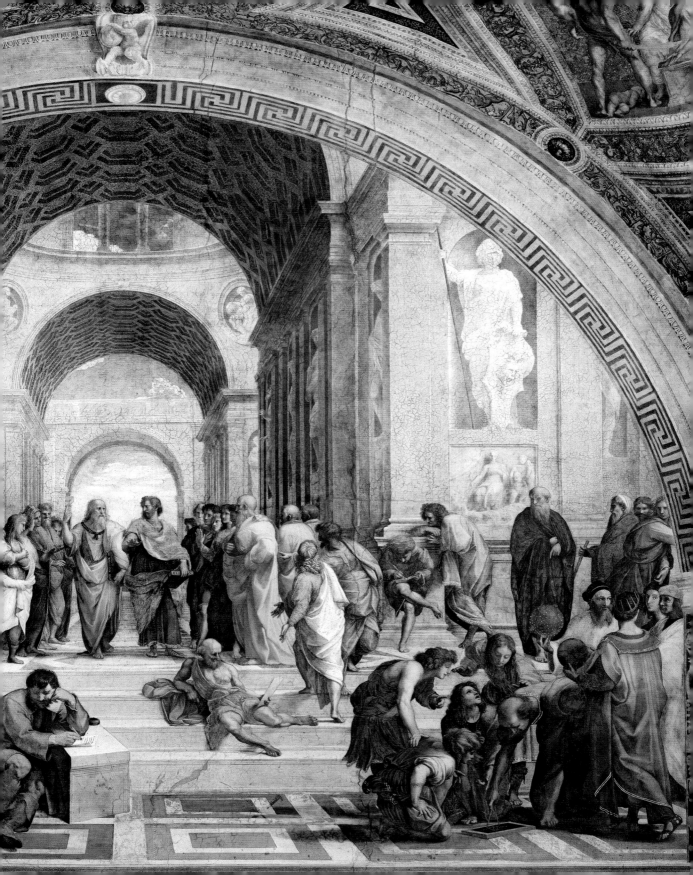

1473 * Nicolaus Copernicus

1503/06 *Mona Lisa* (Leonardo)

1491 * Henry VIII king of England

1509 * John Calvin

HIGH RENAISSANCE 1475–1600

1430 1435 1440 1445 1450 1455 1460 1465 1470 1475 1480 1485 1490 1495 1500 1505 1510 1515

The Ambassadors, 1533. Oil on wood,
207 x 209.5 cm. National Gallery, London

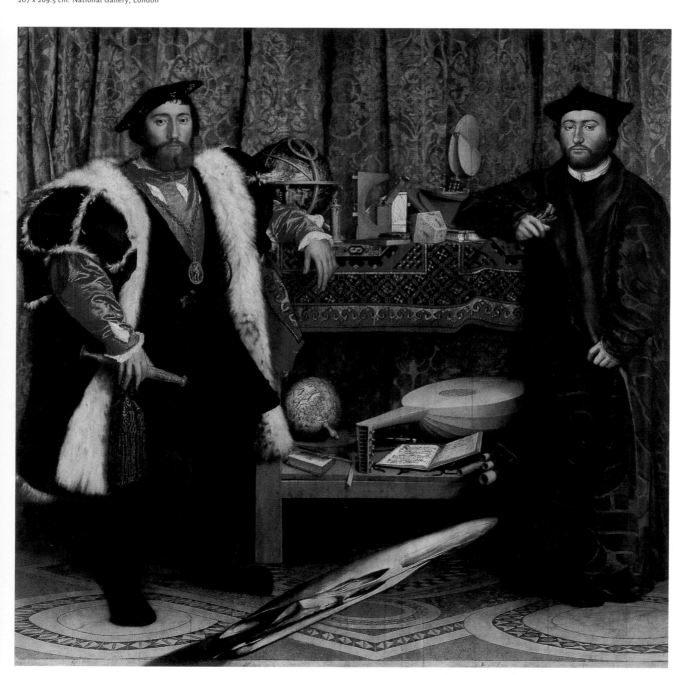

PIETER BRUEGEL
THE ELDER

1534 Henry VIII founds the Anglican Church

5 Hampton Court Palace near London

517 Start of the Reformation

1558 Elizabeth I becomes queen of England

1564 * William Shakespeare

1475–1600 HIGH RENAISSANCE

1520	1525	1530	1535	1540	1545	1550	1555	1560	1565	1570	1575	1580	1585	1590	1595	1600	1605

HANS HOLBEIN THE YOUNGER

The artist Hans Holbein the Younger, who came from Augsburg, painted Renaissance merchants, noblemen, church dignitaries, scholars and scientists in Basel. Reformation iconoclasm drove him to England, where he painted his most important picture, The Ambassadors. *But he also witnessed religious conflict as court painter to Henry VIII.*

Viewing the world scientifically, and the unique qualities of individual human beings, were important themes in Holbein's day, the age of humanism. Holbein, too, wanted to show the world as precisely as possible, and always captured the characteristics of his subjects accurately.

Portrait of a marriage-mad ruler
Holbein showed his patron, England's King Henry VIII, as a strong-willed man with broad shoulders. The king sent his painter to foreign courts to paint portraits of possible candidates for marriage. Henry VIII had six wives in all and was far from squeamish in the way he treated them.

Henry's divorce from his first wife and subsequent remarriage took place in secret because the pope had forbidden him to do so. Later, the marriage-crazed king simply founded his own church,

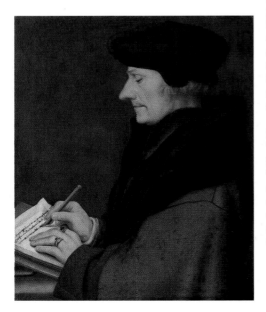

the Anglican Church. Bishop Georges de Selve was appointed by the king of France to smooth the waters between the pope and the English monarch. The bishop took the opportunity to look in on his friend the French ambassador, Jean de Dinteville. No one was to know anything about Selve's secret mission. But Dinteville wanted something to remember this meeting with his friend by. So the learned nobleman commissioned the double portrait called *The Ambassadors* from Holbein, showing Dinteville and Selve life-size in magnificent garments in front of a lavishly decorated table.

Death as a companion
In the foreground of *The Ambassadors*, Holbein painted a strange object that cannot be properly identified when viewed from the front. Only when the viewer is really close to the canvas and looks at the object obliquely from above does that patch of paint change into a grinning skull! The death's head is a reminder of death, a 'memento mori'. The idea of death was always present for Holbein. He repeatedly depicted death, to show that the clock of life starts ticking away inexorably from the day of our birth. In some of the artist's woodcuts, therefore, a rattling skeleton follows politicians, doctors, nuns, old women and monks alike, at every turn.

Holbein's hidden death's head also shows that he had mastered every trick of painting perfectly. This technique for showing objects in distorted form is called anamorphosis, from the Greek word for 'transformation'. Even Leonardo da Vinci had recommended anamorphosis as an exercise for artists who wanted to show that they could play tricks with perspective. The death's head is, to a certain extent, also Holbein's signature: in his day, a skull was also called a 'hohles Gebein' (hollow bone).

c. **1497/98** Hans Holbein the Younger born in Augsburg
1516 After being apprenticed as a painter to his father, Hans Holbein the Elder, he goes to Switzerland. Works for a number of book printers there as an illustrator and paints many murals
1519 Is accepted into the painters' guild in Basel as a master
1532 Moves to England during the Reformation
1536 Henry VIII appoints him royal painter
1538 Holbein paints possible future wives for Henry while journeying
1543 Hans Holbein the Younger dies of the plague in London and is buried on 29 November

[above]
Self-portrait (detail), c. 1542/43. Pastel on paper, 32 x 26 cm. Uffizi, Florence

[left]
Erasmus of Rotterdam Writing, 1523. Paper, glued onto wood, 37 x 30.5 cm. Kunstmuseum, Basel

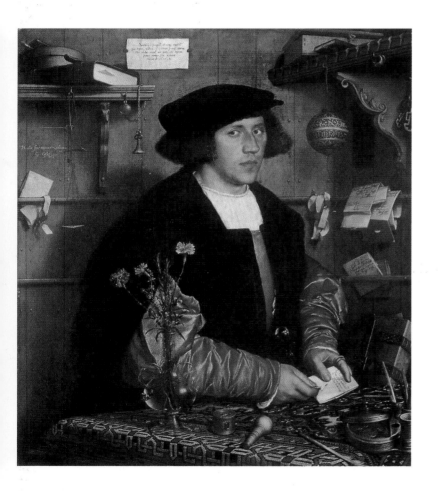

[left]
Portrait of the Merchant Georg Gisze,
1532. Oil on oak, 96.3 x 85.7 cm.
Gemäldegalerie, Staatliche Museen
zu Berlin, Berlin

[below]
The Body of Christ in the Tomb, 1521/22.
Tempera on wood, 30.5 x 200 cm.
Kunstmuseum, Basel

[right]
Henry VIII, c. 1540. Oil on wood,
88 x 75 cm. Gallerie Nazionale d'Arte
Antica, Rome

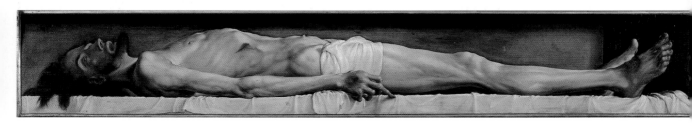

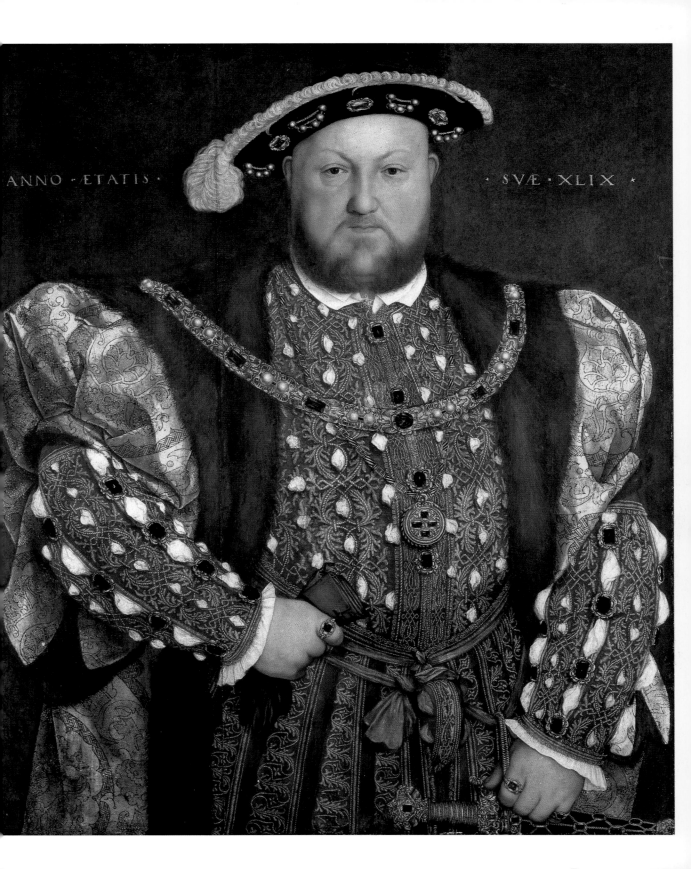

ANNO · ÆTATIS · · SVÆ · XLIX ·

1519 Charles V becomes Holy Roman Emperor

1520/21 Magellan circumnavigates the globe

1541 Spain conquers the Mayan Empire in Central America

HIGH RENAISSANCE 1475–1600

1475 1480 1485 1490 1495 1500 1505 1510 1515 1520 1525 1530 1535 1540 1545 1550 1555 1560

[right]
Hunters in the Snow, 1565. Oil on wood, 117 x 162 cm. Kunsthistorisches Museum, Vienna

[below]
The Tower of Babel, 1563. Oil on wood, 114 x 155 cm. Kunsthistorisches Museum, Vienna

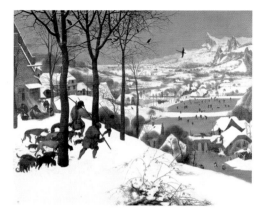

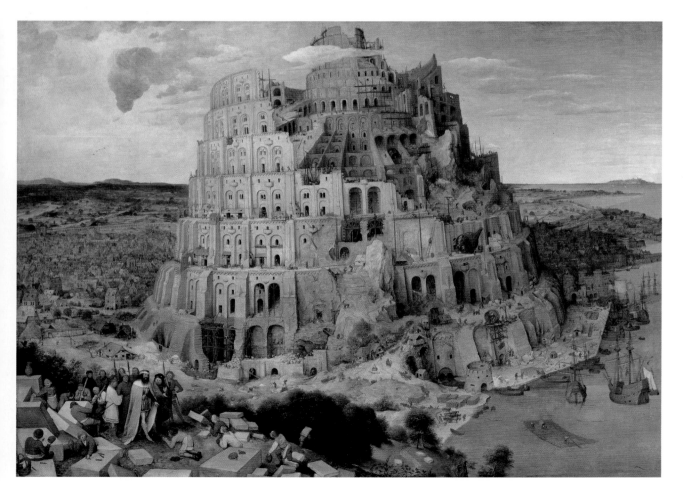

1588 Defeat of the Spanish Armada

1571 Naval Battle of Lepanto: **1590** Dome of St. Peter's completed
 end of Turks' marine dominance

62 Huguenot wars in France **1601** *Hamlet* (William Shakespeare)

 1602 Dutch found Cape Colony in South Africa

1475–1600 HIGH RENAISSANCE

| 1565 | 1570 | 1575 | 1580 | 1585 | 1590 | 1595 | 1600 | 1605 | 1610 | 1615 | 1620 | 1625 | 1630 | 1635 | 1640 | 1645 | 1650 |

PIETER BRUEGEL THE ELDER

The Dutch painter Pieter Bruegel painted landscapes, giving us a bird's-eye view of the everyday life of simple country people or stories from the Bible. His entertaining depictions of peasant life earned him the nickname 'peasant Bruegel'. Breugel left behind only about forty pictures overall.

Bruegel liked going to village weddings. Dressed like a peasant, he sat with the guests, flirted with the women, laughed and crank with the men. Carel van Mander, who wrote a ife of the painter, tells us: "Here, Bruegel much enjoyed observing how the peasants ate, drank, danced, jumped about, courted each other, and other amusing things."

One can tell how precisely Bruegel observed everyday village life just by looking at his colourful, detailed paintings. He painted withy-cutting on a stormy spring day, the sweaty hay harvest in summer, the driving of the cows from the meadows to the cowshed in the autumn, or huntsmen coming home through deep snow. But he also painted the picnic break in the fields, fun at carnival time and a game of ice-hockey on a frozen lake. His pictures of peasant life were popular with rich burghers, royal advisors and ministers.

Fantasy landscapes

We do not know whether Bruegel himself came from a peasant family. What is certain is that he was friendly with many of the scholars of his day, and that he painted religious pictures. Both of these facts suggest that he was educated, which would have been unlikley for a simple peasant's son. On his journey to France and Italy, Bruegel saw the hills and mountains he later combined in his paintings with the meadows and pastures of his flat homeland to make fantasy landscapes that were all his own, teeming with people. For this reason it almost seemed to Carel van Mander as though Bruegel, on his travels, had "swallowed all the mountains and rocks and spewed them out again as a painting-board, so close to nature could he come."

Painter of peasant life

In Bruegel's pictures, Nature offers people rich nourishment in the form of cereals, fruit, cows, stags or foxes, but she is also full of dangers. In one of his pictures, therefore, sailors are seen being shipwrecked in a rough sea. Besides, Bruegel did not depict only the work and pleasures of peasants, but also the large and small misfortunes and mishaps of daily life. In the painting *Huntsmen in the Snow*, for example, a house is on fire and some of the skaters are taking a tumble.

Towards the end of his life, Bruegel no longer allowed his figures to disappear in an overwhelming landscape, but moved them more into the foreground of his pictures. Here, they can feast, drink, dance, laugh and celebrate – all things Bruegel liked to share with them. Regardless of whether the painter was a peasant himself or not: no other painter has given us such a vivid and precise image of their life in those days.

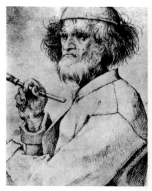

c. **1526/30** Pieter Bruegel the Elder born in Brabant
1551 Joins the St. Luke painters' guild in Antwerp
1552–54 Travels via France to Italy
1563 Marries Maiken Coecke, the daughter of his painting teacher
1563 The couple moves to Brussels
1564 His son Pieter is born
1565 Bruegel paints his pictures of the seasons
1568 His son Jan is born
1569 Pieter Bruegel the Elder dies on 9 September in Brussels

The Bruegel family

Pieter Bruegel the Elder was the most important son of an extremely productive family of painters. His sons, Pieter the Younger and Jan, emulated 'Peasant Bruegel' powerfully with their own paintings of village life. To help tell the difference between the Bruegels, they have been given nicknames derived from their preferences: Pieter's son Jan is known as 'Velvet Bruegel' or 'Flower Bruegel' because of his fondness for still lifes featuring lavish bouquets of flowers. Pieter the Younger loved gloomy pictures full of devilish torments and ghostly figures in the manner of Hieronymus Bosch, which is why he is also called 'Hell Bruegel'. However, neither of the sons could compete with Bruegel the Elder as painters.

[above]
Self-portrait (detail), c. 1565. Drawing, 25 x 21.6 cm. Albertina, Vienna

[next double page]
The Peasants' Wedding, c. 1568. Oil on wood, 114 x 163 cm. Kunsthistorisches Museum, Vienna

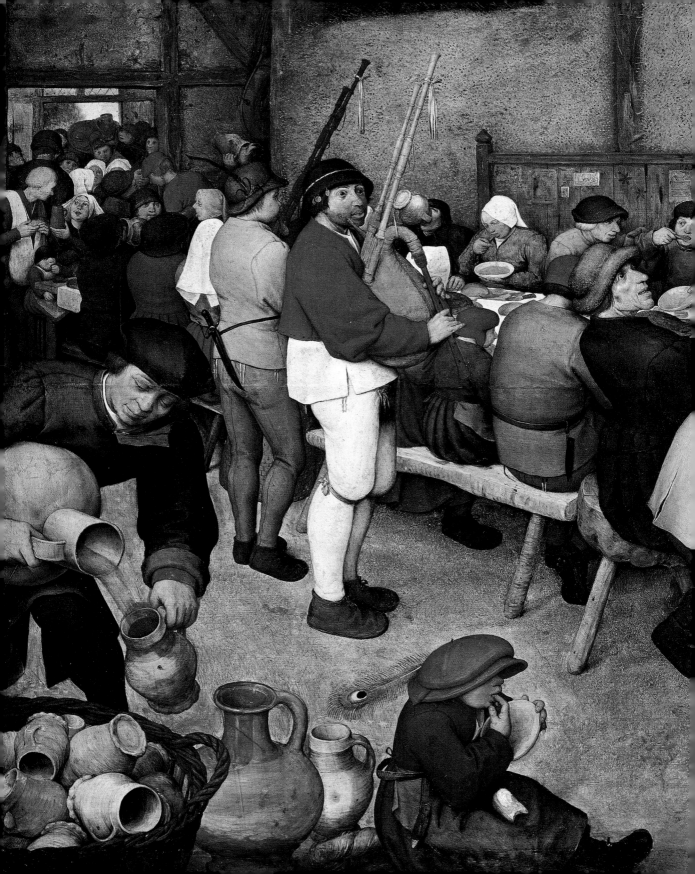

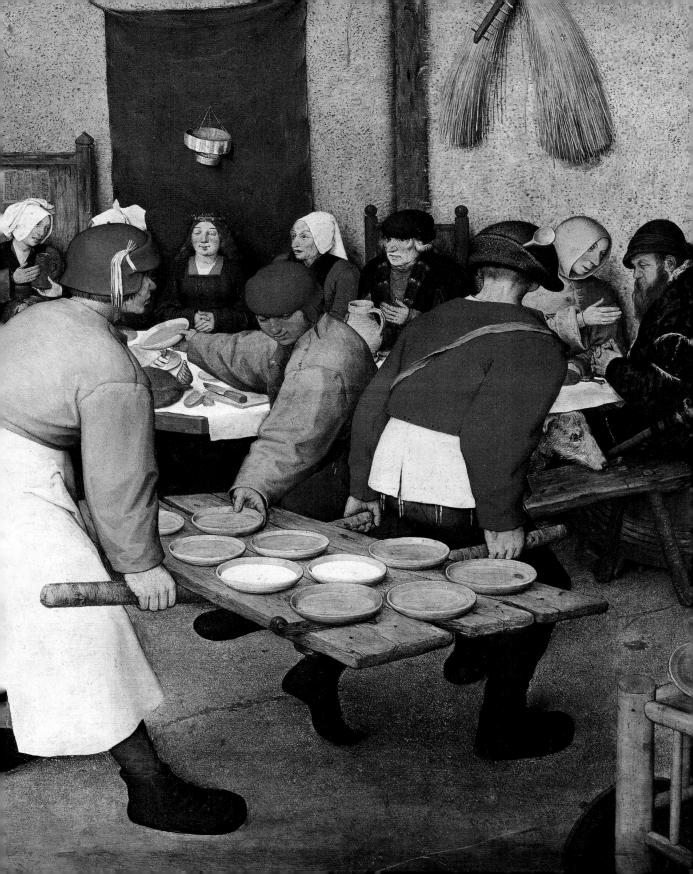

1541 Sistine Chapel frescos
completed (Michelangelo)

1567 * Claudio Monteverdi

1571 Naval Battle of Lepanto:
end of Turks' marine dominance

1500 1505 1510 1515 1520 1525 1530 1535 1540 1545 1550 1555 1560 1565 1570 1575 1580 1585

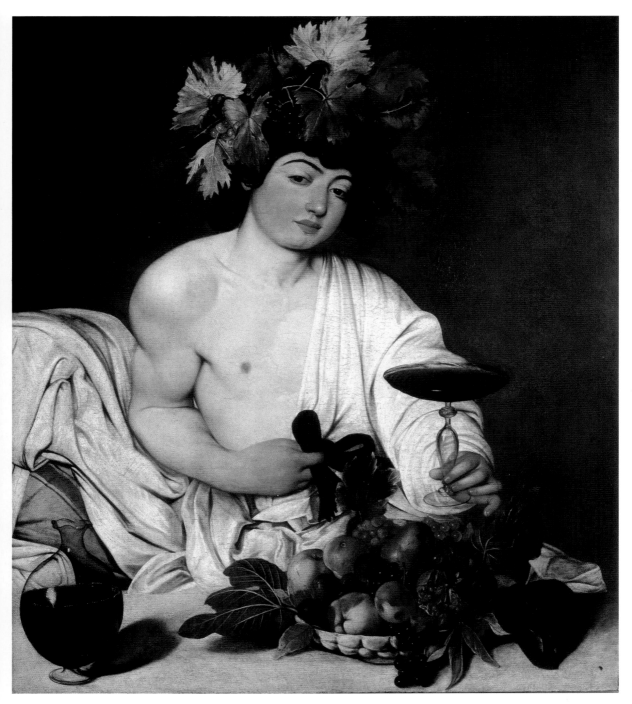

DIEGO VELÁZQUEZ

1609 Moors driven out of Spain **1630** Building begins on Taj Mahal, India

1590 Dome of St. Peter's completed **1618** Thirty Years' War begins

1601 Hamlet (William Shakespeare) **1620** Mayflower lands in America

1475–1600 HIGH RENAISSANCE BAROQUE 1600–1700

| 1590 | 1595 | 1600 | 1605 | 1610 | 1615 | 1620 | 1625 | 1630 | 1635 | 1640 | 1645 | 1650 | 1655 | 1660 | 1665 | 1670 | 1675 |

CARAVAGGIO

The Italian painter Michelangelo Merisi, later called Caravaggio, invented chiaroscuro painting, a completely new way of depicting Biblical scenes dramatically. His realistic still lifes show even the worm-holes in the apple and the discoloration of the leaves, and in his pictures of saints even the dirty soles of the praying figures' feet can be made out. Caravaggio is an important figure in the early Baroque period, and one of painting's major innovators.

While most of his contemporaries were discussing how to depict saints particularly gracefully, Caravaggio also wanted to show ordinary and ugly aspects in his pictures. Handsome lute players, beautiful women and naked angels appear alongside thieving fortune-tellers, card cheats or a painful bite from a lizard. The painter sometimes brought in ordinary people from the street to sit as models for his saints, and dressed numerous figures from Biblical stories in the fashionable clothes of his day. And Caravaggio always paid as much attention to painting dewdrops on fruit in his work as he did to the details of a historical picture. "When I paint a picture of a flower", he once said, "I take as much trouble as when depicting human figures."

A pugnacious painter

This almost makes Caravaggio sound like an amiable contemporary. In fact, he was probably a shady character and a bad-tempered fellow who enjoyed gambling as much as wine. Armed with his sword he roamed from one inn to the next, drinking and gambling, always ready to draw his weapon or use his fists – he was for ever being taken to court by fellow drinkers he had beaten up. Almost everything we know about Caravaggio's life comes from trial documents and indictments, for he spent almost as much time in court as in his studio. He was arrested several times and managed to escape from jail on one occasion. After killing a man in one of his fits of rage, Caravaggio fled to Naples to escape punishment, and from there to Malta and Sicily. It is not clear whether he died of natural causes.

Murder and manslaughter, light and dark

There is plenty of murder and manslaughter in Caravaggio's pictures as well. He liked to choose tension-filled Biblical scenes as his subject matter. To make his pictures all the more dramatic he placed the brightly-lit protagonists against an almost black background. While important details appear to be under a spotlight, less important features disappear into the darkness.

Chiaroscuro painting was soon so famous that many artists copied Caravaggio's pictures. Other painters, such as Dutch painter Rembrandt, picked up the idea and developed their own style from it. In this way the ruffian Caravaggio and his wonderful painting were able to point art in a completely new direction.

Caravaggio's influence

Caravaggio became a model for enthusiastic painters all over Europe with his dramatic use of contrasting light and darkness, called chiaroscuro. His style was imitated in the Baroque period above all in the Netherlands, France, Spain and Germany. Important imitators of Caravaggio who usually positioned their brightly-lit figures against a very dark background include the Italians Orazio Gentileschi and Giovanni Battista Caracciolo, the Spaniards Francisco Ribalta and Jusepe de Ribera, as well as Hendrick Terbrugghen, Gerrit van Honthorst and other painters from Utrecht in Holland, and the French artist Georges de la Tour.

1571 Caravaggio born as Michelangelo Merisi on 28 September in Caravaggio near Milan
1592 Goes to Rome
1595 Cardinal Francesco Maria del Monte obtains commissions for him
1600 Two paintings for the chapel of Cardinal Matteo Contarelli make him famous
1603 Caravaggio imprisoned for insulting a colleague
1606 Flees to Naples after committing manslaughter, then in 1607 to Malta and in 1608 to Sicily
1607 Becomes a member of the Order of the Knights of Malta, is later excluded
1608 Escapes from prison
1610 Caravaggio dies on 18 July in Porto d'Ercole.

READING TIPS
The painter's eventful life has provided material for many novels, for example: Atle Naess, *Doubting Thomas*, London 2000.
Christopher Peachment, *Caravaggio*, New York 2003

[above]
Ottavio Leoni, *Portrait of Caravaggio* (detail), c. 1621–25. Drawing. Biblioteca Marucelliana, Florence

[left page]
Bacchus, c. 1597. Oil on canvas, 95 x 85 cm. Uffizi, Florence

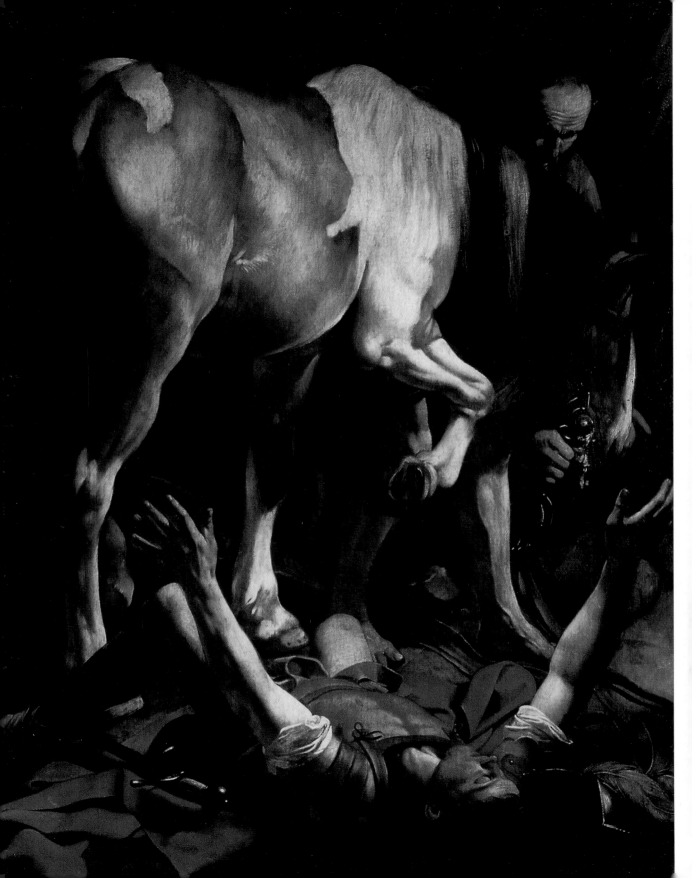

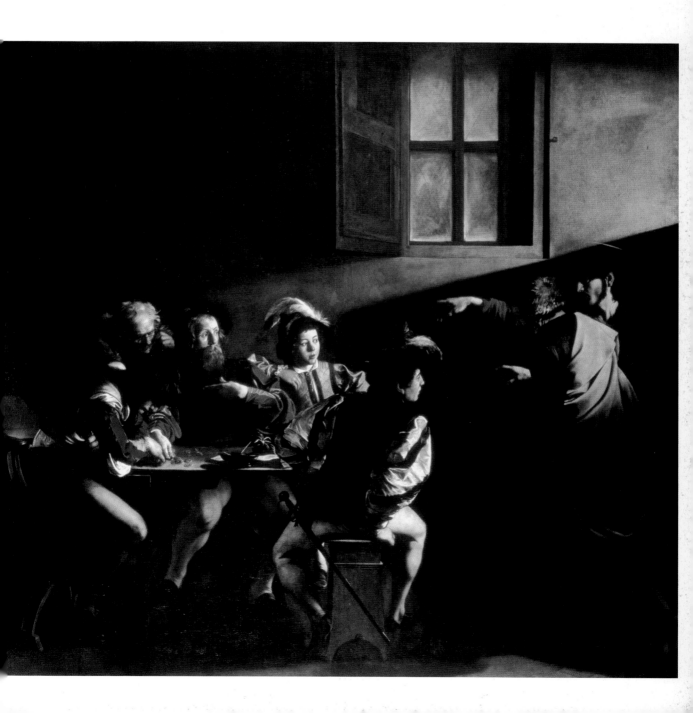

1562 Huguenot wars in France
1564 * William Shakespeare
1558 Elizabeth I becomes queen of England

1588 Destruction of the
Spanish Armada

1475–1600 HIGH RENAISSANCE BAROQUE 1600–1700

1520 1525 1530 1535 1540 1545 1550 1555 1560 1565 1570 1575 1580 1585 1590 1595 1600 1605

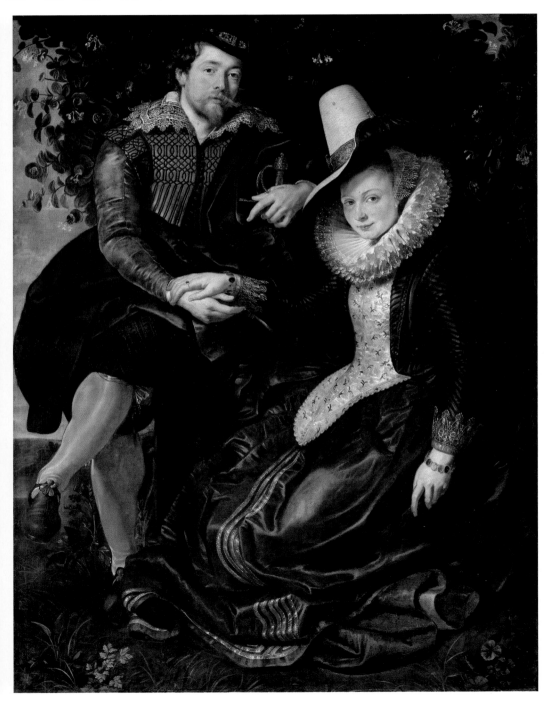

*Rubens and Isabella Brant in
the Honeysuckle Arbour,*
c. 1609. Oil on canvas,
179 x 136 cm. Alte Pinakothek,
Munich

1643 Louis XIV king of France (Sun King)
1643 * Isaac Newton

1618–1648 Thirty Years' War
1620 Mayflower lands in America
1630 Building begins on Taj Mahal, India **1648** Netherlands independent of Spain

| 1610 | 1615 | 1620 | 1625 | 1630 | 1635 | 1640 | 1645 | 1650 | 1655 | 1660 | 1665 | 1670 | 1675 | 1680 | 1685 | 1690 | 1695 |

PETER PAUL RUBENS

The Flemish Baroque painter turned unbending Renaissance models from antiquity into ample women and characters who enjoyed life. Rubens-esque is still used to describe voluptuous women, borrowing from his paintings. Rubens was a skilful linguist and also such a respected diplomat that he was knighted.

In 1603, a shower of rain almost put an end to the diplomatic mission on which the Duke of Mantua had sent his favourite painter, Peter Paul Rubens. Two of the valuable paintings that were among the gifts to the Spanish king were damaged in the downpour, but Rubens did not hesitate: he whipped out his paintbrushes and hurriedly created substitute pictures. Philip III was impressed, and the pictures went into the royal collection. Rubens's reputation was already very high in many of Europe's royal houses at the time. The Dutch king, Archduke Albrecht, had already inquired several times in Mantua whether the duke there would consider releasing the excellent young painter from his services. But the duke had refused, as he was very keen on Rubens's work himself. When the painter travelled to the Netherlands in 1609, Albrecht saw his chance. He quickly made the young artist his court painter, thus binding him with "golden chains", as Rubens himself put it.

Baroque forms
Like many Renaissance painters, Rubens admired the works of antiquity on his long Italian journeys. But his figures are very different from those of his colleagues. Rubens was determined that his people should not look as stiff and rigid as ancient marble statues. He breathed life into them with his paintbrush and transformed their hard lines into dynamic movements. Rubens did this particularly successfully with his female nudes, whose voluptuous bodies still remain his trademark. It is not just that these ample women fitted in with the ideal of beauty of his day: Rubens found such women attractive both as a man, and as an artistic challenge. In many of his religious and mythological pictures the canvas is teeming with colourful crowds of these figures and there is more movement and light than in any earlier picture. This is why Rubens is today regarded by many as the most important painter of the Baroque period.

Rubens's workshop
In fact, the Flemish artist's output was so high that in many of his pictures it is impossible to say what was painted by Rubens himself or what he actually assigned to one of his numerous assistants and workshop colleagues. This division of labour was also reflected in the price, as can be seen from a letter Rubens wrote about a particular work: "Original by my hand, with the exception of a beautiful landscape by a master well versed in this genre." It was not unusual for a phrase like "well-versed master" to conceal the identity of later world-famous painters like Anthony van Dyck or Jan Bruegel, who trained and worked in Rubens's workshop.

Baroque
The harsh colours, asymmetrical forms and emotional chilliness of Mannerism became too much for many painters in the late 16th century. They longed to return to clear and simple forms, but at the same time loved theatrical effects and dynamic movements. The Italian artists Annibale Carracci and Caravaggio were pioneers of this new approach to painting. The Flemish artist Peter Paul Rubens was a great admirer of these two trailblazers and, after his Italian journeys, he became the most famous Baroque painter north of the Alps until the Dutch painter Rembrandt challenged him for this position. English Baroque painting was greatly influenced by Rubens and by his pupil Anthony van Dyck, who made a name for himself as a portraitist on that side of the channel. The word baroque is thought to derive from the Portuguese 'barucca', which means something like 'irregularly shaped pearl'. This artistic style ran on into the mid-18th century, though the final phase with its especially playful and intricate forms is called Rococo.

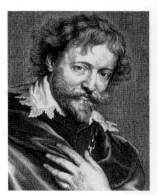

1577 Peter Paul Rubens born on 28 June in Siegen
1589 The Rubens family moves to Antwerp
1600 First journey to Italy
1603 Diplomatic mission to Philip III of Spain
1609 Rubens becomes court painter to Archduke Albrecht. Marries Isabella Brant
1622–25 Paints the Medici cycle
1626 His wife, Isabella, dies of the plague
1629 Charles I of England knights Rubens
1630 Marries Helene Fourment.
1640 Rubens dies on 30 May in Antwerp

MUSEUM AND INTERNET TIPS
The artist's former home, the Rubens House Antwerp, has been reconstructed and is now a museum: www.museum.antwerpen.be/rubenshuis Museums including the Alte Pinakothek in Munich and the Kunsthistorisches Museum in Vienna have large Rubens collections.

[above[
Paulus Pontius after Anthony van Dyck, *Portrait of Peter Paul Rubens* (detail). Copperplate engraving, 23.3 x 15.7 cm. Collection of the Prince of Liechtenstein, Vaduz

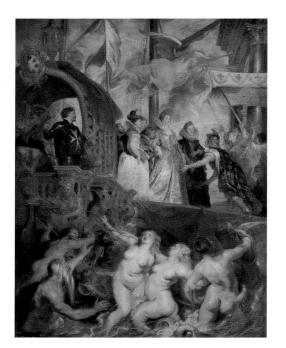

[left]
Maria de' Medici's Arrival in Marseilles,
from the Medici cycle, 1622–25. Oil on
canvas, 394 x 295 cm. Musée du Louvre,
Paris

[below]
Hunting for Rhinoceros and Crocodile,
c. 1615/16. Oil on canvas, 248 x 321 cm.
Alte Pinakothek, Munich

[right page above]
*Helene with her two children (Clara
Johanna and Frans),* c. 1636. Oil on wood,
113 x 82 cm. Musée du Louvre, Paris

[right page below]
The Festival of Venus, 1632. Oil on canvas,
217 x 350 cm. Kunsthistorisches Museum,
Vienna

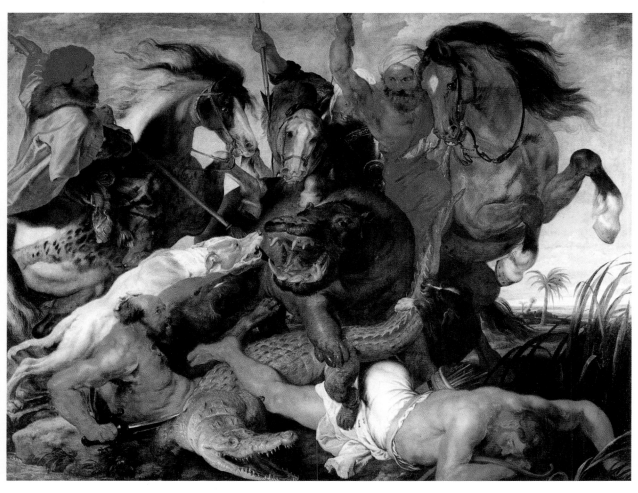

Diplomatic career

Rubens was deeply affected by the death of his wife, Isabella Brant, in 1626. But the artist did not retire. On the contrary: he had always been interested in diplomacy, and as he spoke fluent French, German, Spanish, Latin and also his native Flemish, he now moved successfully on the stage of top-level politics, while continuing to paint. Charles I of England was so impressed by the painting ambassador that he knighted him in 1629. Shortly after this, Rubens, still good-looking at fifty-three, married Helene Fourment, who was only sixteen at the time. "I have decided to marry again," he said, justifying the unusual marriage, "as I do not yet feel that a celibate life would suit me."

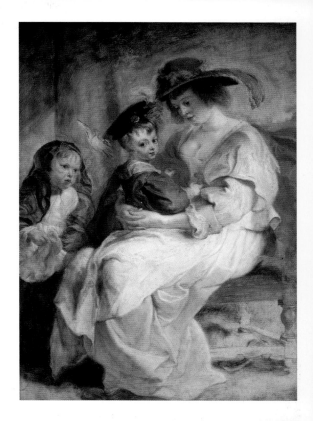

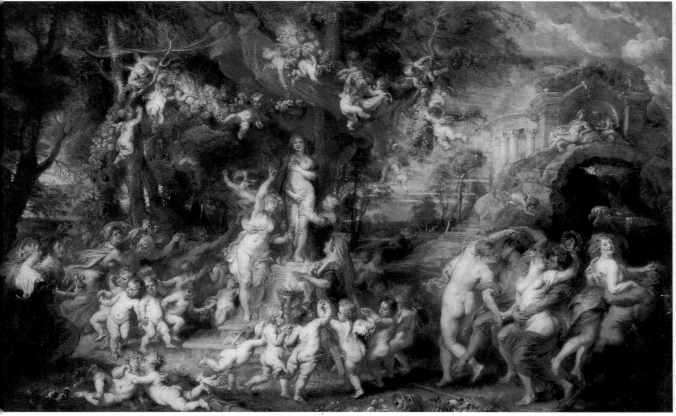

1588 Destruction of the Spanish Armada

1590 Dome of St. Peter's completed **1620** Mayflower lands in America

1585 English wars against the Spanish **1609** Moors driven out of Spain **1633** Galileo befo
the Inquisit

1475–1600 HIGH RENAISSANCE BAROQUE 1600–1700

| 1550 | 1555 | 1560 | 1565 | 1570 | 1575 | 1580 | 1585 | 1590 | 1595 | 1600 | 1605 | 1610 | 1615 | 1620 | 1625 | 1630 | 1635 |

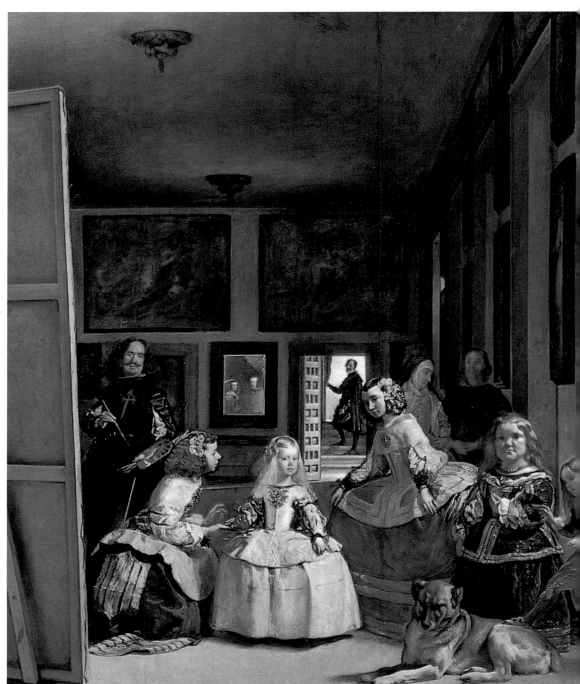

The Ladies-in-Waiting,
c. 1656. Oil on canvas,
318 x 278 cm. Museo
del Prado, Madrid

1642 *The Night Watch* (Rembrandt)

1643 Louis XIV king of France (Sun King)

1680 * Antonio Vivaldi

1668 Work begins on the Palace of Versailles near Paris

1600–1700 BAROQUE ROCOCO 1700–1750

1640 1645 1650 1655 1660 1665 1670 1675 1680 1685 1690 1695 1700 1705 1710 1715 1720 1725

DIEGO VELÁZQUEZ

In the early stages of his career the Spanish painter Diego Rodriguez de Velázquez painted still lifes, so-called kitchen pieces, as well as religious pictures and scenes from ordinary life. But he made his name with portraits of the Spanish king Philip IV, his family and his retinue.

Velázquez was extremely ambitious in his lifetime. His family were part of the gentry, and he strove to become one of the most famous painters in his home country. At the age of twenty-three he travelled to Madrid to become court painter to King Philip IV. His wish soon came true, and Velázquez was appointed 'painter to His Majesty', with a fixed income.

Painter to the king
The young king had so far appointed four court painters, but Velázquez soon became his favourite by far. He became an administrator, chief accountant, gentleman-in-waiting and 'attendant in the king's private chamber' (a particular honour), and head chamberlain. He also judged royal painting competitions, and was able to decide which portraits of the king should be destroyed as offensive and ignoble. When Velázquez set off for Italy to study Venetian art, the king decreed that his salary as court painter continue to be paid: an unusual privilege.

Philip IV had a chair placed in the painter's studio so that he could watch Velázquez at work at any time. In the painting called *The Ladies-in-Waiting*, an illustrious company from the court and the Infanta Margarita are watching the master painting in his studio. The mirror shows that the king and queen are present as well. But the main thing Velázquez is showing in this picture is himself painting, as self-confidently as if he were part of the royal family. Here, the painter is wearing a special costume: the king, shortly before he died, had made Velázquez a Knight of the Order of Santiago.

A court portrayed
Velázquez painted many portraits of the king in which one can see how unhappy the inadequate monarch was in his position. In addition to Philip IV, many other members of the court also sat for Velázquez, including Queens Isabella and Mariana, made up like dolls, lavishly coiffed and clad in stiff, expensively-embroidered garments, as well as the king's hounds and lapdogs, and his children, the Infantas Margarita and Maria Teresa and Prince Felipe Próspero. The children are already dressed like adults – court etiquette was more rigid in Spain than anywhere else. But Velázquez also painted the dwarfs and court jesters. He painted them with lines that were clearly much coarser, almost blurred, as can easily be seen in the picture called *The Ladies-in-Waiting*, thus setting them clearly apart from his refined depictions of the royal family.

At the beginning of his court career Velázquez was particularly successful in using Caravaggio's chiaroscuro style for vivid depictions of religious themes. He captivated people later with the richness of his palette and the delicacy of his painting, in which he took advantage of the different granularity of the colour pigments, and soft and coarser brushstrokes, to bring out differences of rank. Velázquez was not just especially ambitious, but also one of the best painters in the world.

1599 Velázquez baptised on 6 June in Seville

1618 Marries the daughter of his painting teacher, Francisco Pacheco del Rio

1623 Becomes court painter to the 18-year-old King Philip IV in Madrid

1629 Travels to Italy at the suggestion of Peter Paul Rubens

1631 Returns to Madrid

1649 Buys paintings by Veronese and Titian for the king

1660 Velázquez dies on 7 August in Madrid

[above]
Self-portrait, detail from *The Ladies-in-Waiting*, c. 1656. Museo del Prado, Madrid

[left]
Prince Felipe Próspero, 1659. Oil on canvas, 128.5 x 99.5 cm. Kunsthistorisches Museum, Vienna

PETER PAUL RUBENS

REMBRANDT

1618–1648 Thirty Years' War

1601 *Hamlet* (William Shakespeare)

1596 * René Descartes

1630 Building be
on Taj Mah.
India

1475–1600 HIGH RENAISSANCE BAROQUE 1600–1700

| 1550 | 1555 | 1560 | 1565 | 1570 | 1575 | 1580 | 1585 | 1590 | 1595 | 1600 | 1605 | 1610 | 1615 | 1620 | 1625 | 1630 | 1635 |

*The Company of Captain Frans Banning
Cocq (The Night Watch)*, 1642. Oil on
canvas, 359 x 438 cm. Rijksmuseum,
Amsterdam

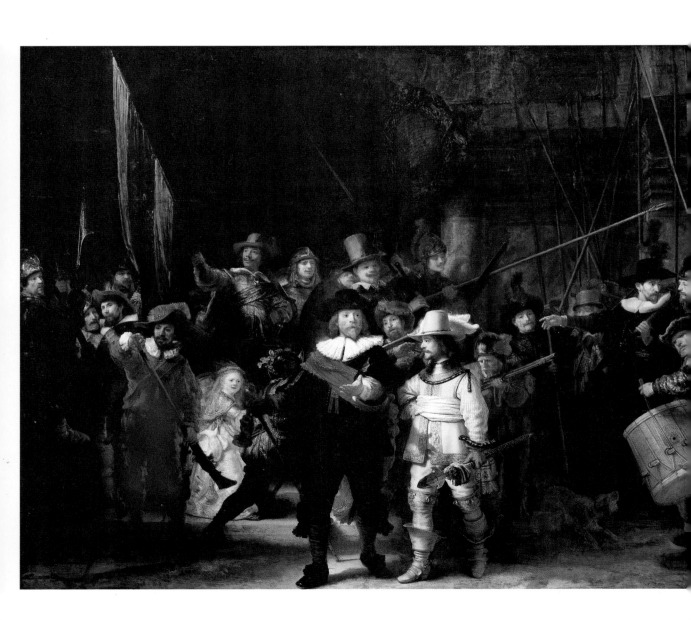

1643 Louis XIV king of France (Sun King)

1668 Work begins on the Palace of Versailles near Paris

1699 Austria great European power

1685 * Johann Sebastian Bach

1655 British trade with West Indies begins

1600–1700 BAROQUE ROCOCO 1700–1750

1640 1645 1650 1655 1660 1665 1670 1675 1680 1685 1690 1695 1700 1705 1710 1715 1720 1725

REMBRANDT

The Dutch painter Rembrandt made his name with pictures in which figures step dramatically out of darkness into a spotlight, like actors on a stage. And he was a real entrepreneur. We now know that many 'genuine Rembrandts' were painted by apprentices in his workshop.

Fortunately, the prosperous miller Harmen Gerritszoon of Leiden named one of his ten children Rembrandt. Rembrandt Harmenszoon van Rijn was thus able to confidently sign his paintings with his first name only, like a trademark, just as the revered Renaissance masters had done. This first name was, in fact, as unusual and individual as Rembrandt's art.

His parents probably had great plans for the boy, for they sent him to a strict Latin school and later to the famous Leiden University. Rembrandt learned stories from the Bible, often bloodthirsty, and later depicted them in many of his paintings, drawings and etchings.

Rembrandt's father did not see eye to eye with him at first about his son's desire to be a painter. But Rembrandt dug his heels in and was eventually allowed to be apprenticed to the Amsterdam historical painter Pieter Lastmann. Later, when he had his own workshop, he soon became so famous that he had to employ numerous assistants and apprentices. Rembrandt was one of the most sought-after artists of his day. About 600 paintings, 300 graphic works and 1,400 drawings are attributed to him. It is clear that producing and selling art in such quantities could not happen in a small painter's workshop, and that Rembrandt was obviously running a professional business.

Light and shade

Rembrandt oriented himself towards the Italian and Netherlandish master painters and achieved new mastery of Caravaggio's art of chiaroscuro, enabling him to make his pictures more dramatic. He painted many scenes that used to be depicted out in the open air in interiors. He also chose stories that had only rarely been used before. He was interested above all in showing his characters' emotions. This is also expressed in his many self-portraits.

In 1634, Rembrandt married his great love, Saskia van Uylenburgh. He portrayed his wife in various costumes and roles. But when Saskia died after the birth of their third child, Titus, Rembrandt lost his enthusiasm for painting. His chiaroscuro painting had slipped a little out of fashion, and his business was going downhill.

Financial ruin

Rembrandt was unable to manage money in his old age, and he finally had to declare himself bankrupt. His possessions were sold to pay off his debts: at the time he had more than 120 paintings hanging close together in his house, including works by Raphael and Rubens. But exotic shells, stuffed birds of paradise, Biblical illustrations and busts of famous philosophers also changed hands when he sold his belongings.

By the time Rembrandt died, he had long since acquired a new collection of paintings, plants and animals, for he simply did not wish to live without his beloved art and the wondrous works of nature.

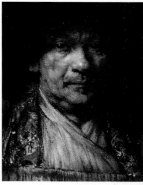

1606 Rembrandt born on 15 July in Leiden
1621 Begins an apprenticeship with the painter Jacob van Swanenburgh
1625 Becomes a freelance painter
1630 Rembrandt runs a studio with several apprentices
1634 Marries Saskia van Uylenburgh
1642 Saskia's death creates a crisis for the painter
1649 Geertghe Dircx takes him to court for a broken promise of marriage
1656 Rembrandt declares himself bankrupt
1669 The painter dies on 4 October in Amsterdam

MUSEUM AND INTERNET TIPS
The Rembrandt House in Amsterdam is a good centre for Rembrandt fans. A virtual visit is also recommended: www.rembrandthuis.nl

[above]
Self-portrait (detail), 1658.
133.7 x 103.8 cm. Frick Collection, New York

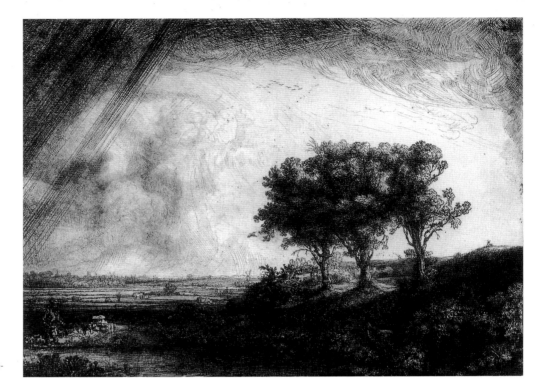

[above]
The Three Trees, 1643. Etching,
21.1 x 28 cm

[below]
*The Hundred Guilder Print or
Christ Healing the Sick*, c. 1642–49.
Etching, 27.8 x 38.8 cm

[right page]
Self-portrait with Saskia, c. 1635.
Oil on canvas, 161 x 131 cm. Gemälde-
galerie Alte Meister, Dresden

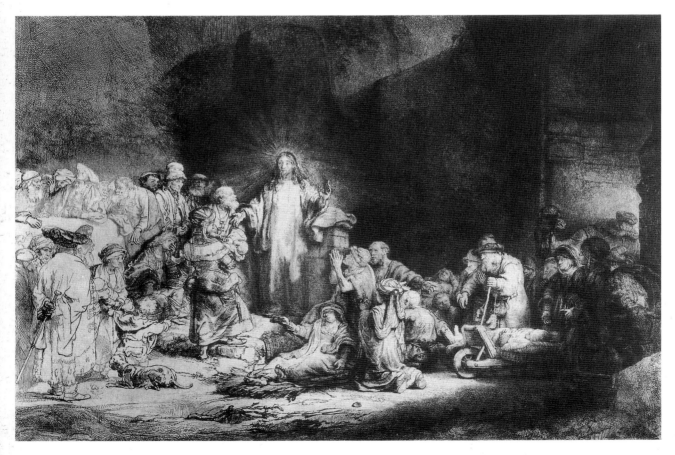

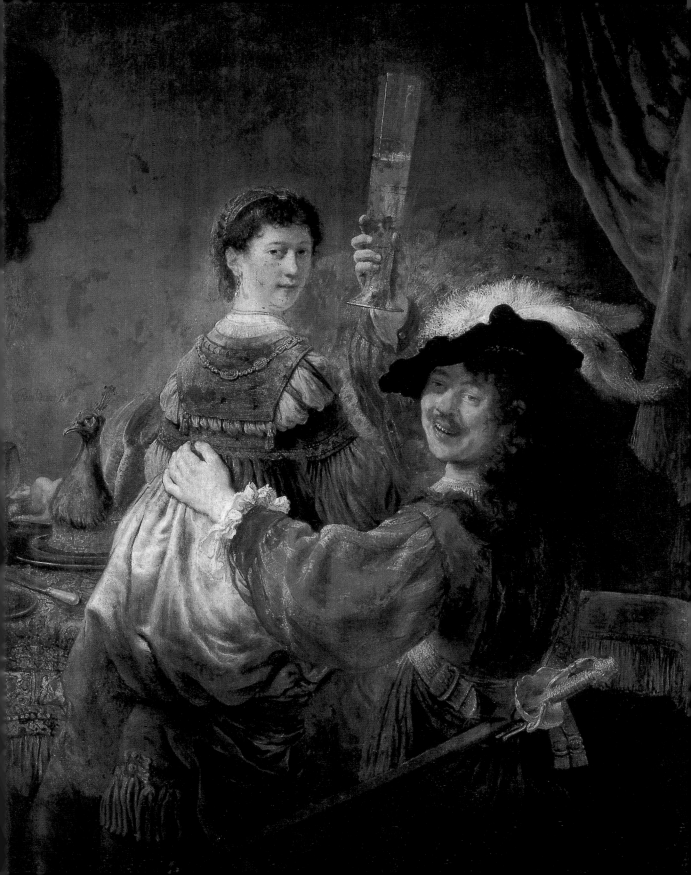

1643 Louis XIV king of France
(Sun King)

1618–1648 Thirty Years' War 1633 Galileo before the
Inquisition

1648 Netherlands inde
pendent of Spain

1475–1600 HIGH RENAISSANCE BAROQUE 1600–1700

1570 1575 1580 1585 1590 1595 1600 1605 1610 1615 1620 1625 1630 1635 1640 1645 1650 1655

JEAN-ANTOINE WATTEAU

1685 * Johann Sebastian Bach

1689 Peter the Great Tsar of Russia

55 British trade with West Indies begins

1672 Work begins on St. Paul's Cathedral in London

1668 Work begins on the Palace of Versailles near Paris

1600–1700 BAROQUE ROCOCO 1700–1750

| 1660 | 1665 | 1670 | 1675 | 1680 | 1685 | 1690 | 1695 | 1700 | 1705 | 1710 | 1715 | 1720 | 1725 | 1730 | 1735 | 1740 | 1745 |

JAN VERMEER

Glowing fabrics, gleaming reflections on porcelain jugs or pearl necklaces, and completely calm and balanced interiors are the trademarks of the Dutch painter Jan Vermeer. Almost all his pictures — there are only thirty-six of them, spread all over the world — show scenes from everyday life.

Vermeer's household was usually pretty noisy. He had fifteen children squealing and shrieking and getting under his feet. He often quarrelled with his stern mother-in-law, who also lived in the family's spacious home. And Vermeer's second profession did not give him much peace either. He was the landlord of an inn, and probably stood behind the bar far into the night providing the revellers with wine and music.

In those days, painting and drinking fitted in very well with the art of the Netherlands. Many contemporary paintings show drunken peasants and soldiers making a racket and fighting at inn tables, grabbing the serving-girls' skirts or snoring drunkenly in the corner of the bar. Vermeer showed himself with a glass in one of his pictures, cheerfully drinking the viewer's health.

Painted calm in a bourgeois room

But in contrast with his painter colleagues' noisy work, Vermeer's carefully constructed genre pictures are comfortingly quiet. Women sit absorbed in their needlework, make music in fine clothes or carefully pour milk into a bowl. Soft sunlight from the window makes the objects glow and lends the scene a gentle atmosphere. Even when alcohol features, everything is very civilised. In Vermeer's pictures, gallant gentlemen might tempt modest ladies to sip a little wine. Did the painter sometimes secretly wish that the hectic inn could be as calm as his pictures?

Home sweet home – the only happiness?

Despite all the hurly-burly, Vermeer liked being at home. He had his studio within his family circle, and all kinds of household objects – white-wine pitchers in Delft porcelain or leather-upholstered chairs from the home kitchen – appear in many of his paintings. For some of his pictures, the artist had his mother-in-law's heavy oak table moved upstairs into the studio. Sometimes he hung her works of art on the

wall there, so that they could be included as pictures within the painting itself. In his picture *The Allegory of Painting*, for example, a large map is hanging on the studio wall, showing the Netherlands before the country was partitioned after the Thirty Years War. The viewer is looking over the shoulder of the painter just as he is capturing his model's laurel wreath on canvas.

Sometimes the women in Vermeer's pictures seem to be dreaming of another life. Then they put on their strings of pearls and make themselves look beautiful for their beloved, who has just written them a letter. Often these women are standing at the open window – can they perhaps hear the clamour drifting over from the inns where they themselves would now rather be?

17th-century painting in the Netherlands

In Vermeer's day, painting in the Netherlands and nearby Flanders was intended above all for private rooms in bourgeois households, and therefore did not have to be as pompous as the art created elsewhere for the palaces or churches of princes, kings and popes during the Baroque period. Many painters from the Netherlands specialised in single, particularly popular subjects. In Amsterdam, Delft and Antwerp, Adrien Brouwer, Pieter de Hooch, Jan Steen, Adrian van Ostade and David Teniers the Younger created cheerful, sensual genre pictures showing scenes with peasants brawling and drinking. Willem Kalf's glowing still lifes with costly pitchers, glass vessels and fruit found a ready market, while other painters specialised in still lifes with flowers. Jacob van Ruisdael's pictures of the coast, cities and landscapes with windmills hung in many a rich burgher's house. Frans Hals was a master of joyous portraits. Alongside Vermeer and Rembrandt, Hals is considered to be one of the most important painters of his day in the Netherlands.

1632 Jan Vermeer baptised on 31 October in Delft

1635 Becomes a Roman Catholic

1653 Marries Catharina Bolnes, who bears him fifteen children

1662 The Delft painters' guild makes him its head

1670 Inherits the 'Mechelen' tavern after his mother's death

1671 Head of the painters' guild for the second time

1672 Travels to The Hague to check the authenticity of some Italian works of art

1675 Applies for a loan for his extended family in Amsterdam

1675 Jan Vermeer is buried on 16 December in his birthplace, Delft

INTERNET TIP
The website www.essentialvermeer.com includes a detailed catalogue, interesting material on Vermeer's technique, a view of his home town Delft and a great deal more

[above]
Self-portrait, detail from the painting *The Matchmaker*, 1656. Oil on canvas, 143 x 130 cm. Gemäldegalerie Alte Meister, Dresden

[left]
The Art of Painting, c. 1665/66. Oil on canvas, 120 x 100 cm. Kunsthistorisches Museum, Vienna

[left]
The Kitchen Maid, c. 1658/60. Oil on canvas, 45,5 x 41 cm. Rijksmuseum, Amsterdam

[right]
Girl with a Pearl Earring, c. 1665. Oil on canvas, 44,5 x 39 cm. Königliches Gemäldekabinett Mauritshuis, The Hague

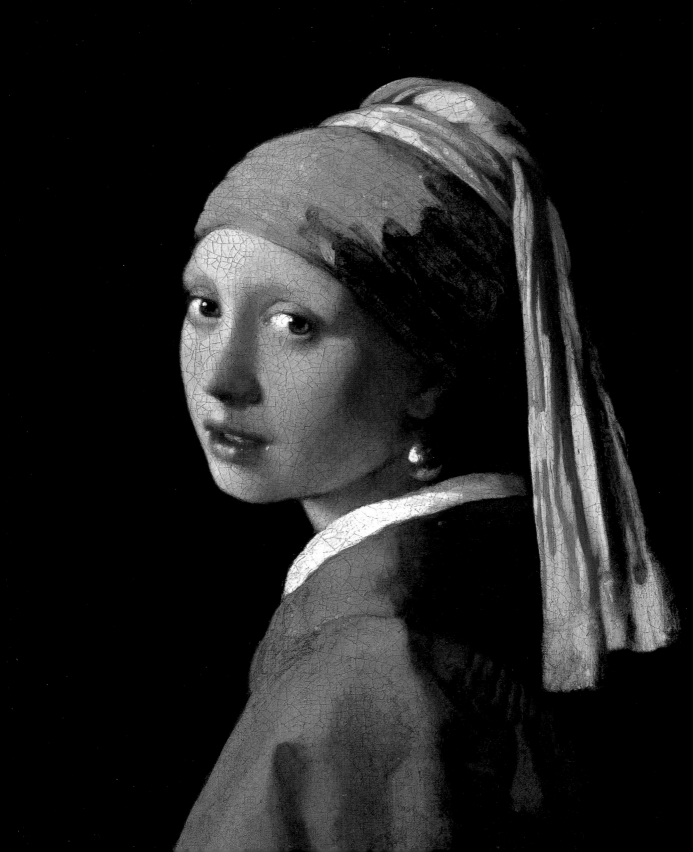

1668 Work begins on the Palace of Versailles near Paris

1667 Louis XIV launches
Paris Salon

1685 * Johann Sebastian Bach

1600–1700 BARO

| 1610 | 1615 | 1620 | 1625 | 1630 | 1635 | 1640 | 1645 | 1650 | 1655 | 1660 | 1665 | 1670 | 1675 | 1680 | 1685 | 1690 | 1695 |

Gilles, c. 1719. Oil on canvas, 184 x 149 cm.
Musée du Louvre, Paris

Rococo

The French word 'rocaille' conjures up grottoes and shell work and it is from 'rocaille' that the term 'rococo' is derived. And paintings by famous Rococo painters like Antoine Watteau, François Boucher, Jean-Honoré Fragonard and Gabriel Germain Boffrant do indeed have such qualities of intricacy, full of decorative, refined detail. They wanted to use this new way of painting to draw a line between themselves and the monumental emotionalism the Baroque artists so loved. The Rococo style began in France and then spread into other European countries. It became particularly popular in Germany and Austria, where it helped the Baroque style to fade away playfully. The downfall of absolutism in the French Revolution of 1789 also sealed the fate of Rococo, with Classicism taking over from this intricate artistic style.

1707 England, Scotland and Ireland
unite to become Great Britain
1699 Austria great European power **1712** * Jean-Jacques Rousseau **1749** * Johann Wolfgang von Goethe
1703 Building of Buckingham Palace in London begins

ROKOKO 1700–1750 1700–1750 ROCOCO CLASSICISM 1750–1790

| 1700 | 1705 | 1710 | 1715 | 1720 | 1725 | 1730 | 1735 | 1740 | 1745 | 1750 | 1755 | 1760 | 1765 | 1770 | 1775 | 1780 | 1785 |

JEAN-ANTOINE WATTEAU

The French Rococo painter Antoine Watteau was a great admirer of Italian clowns. His costumed figures usually act out their little dramas in park-like landscapes. It is only at second glance that isolated, lonely figures can be made out in the cheerful pictures.

Watteau began his career as a kind of conveyor-belt painter. The eighteen-year-old, working with a whole crowd of pieceworkers, produced copies of works by famous masters in a 'picture factory' in Paris. But he must have disliked the work pretty strongly, as he put all his efforts into escaping from it – and succeeded. The painter and etcher Claude Gillot made Watteau his assistant and showered the young man with stories from the world of commedia dell'arte. Gillot loved the masked figures in this Italian theatre of improvisation, and liked drawing its famous jokers, like Harlequin or Pulcinella.

Melancholy Harlequins
Watteau also acquired a taste for these Italian comedians, and they romp around his pictures from this time onwards, acting out little dramas among themselves. A pushy suitor gets the brush-off, a lover sings a serenade to his inamorata and watches, pining mournfully, the love of his life from a distance. Many of the pictures have melancholy themes. Watteau repeatedly painted lonely people among others enjoying a celebration, laughing and joking. This mournful mood probably came from the fact that the painter had suffered from consumption

since his youth. Enduring love, happiness and health often seemed very distant prospects for Watteau, who perhaps sensed how short his life would be. He usually seemed irritable and restless, and was distant with strangers. Watteau was never content with his work, always wanting to paint things over to improve them. His pictures had to be perfect. Just like those of his great hero, the Baroque painter Peter Paul Rubens, whose magnificent colours and brilliant depiction methods Watteau drew upon to a considerable extent.

Target for revolutionaries
Watteau's shaky health affected him increasingly. He took five years to complete *L'Embarquement pour Cythère*, the work he submitted to qualify for membership of the Académie Royale. Venus, the goddess of love and beauty, is said to have risen from the waves on the Greek island of Cythera. The painting gained Watteau full membership of the Académie in 1717. Very shortly afterwards his colleagues there named him a 'peintre des fêtes galantes', painter of elegant celebrations.

Watteau died on 18 July 1721 at the age of only thirty-six. It would certainly have broken his heart to see art students during the French Revolution in 1789 using *L'Embarquement pour Cythère* as a target and throwing bread pellets at it. The students were reacting against Watteau's Baroque paintings because these were reminiscent of the affected and immoral aristocracy the students were fighting against. It was only years later that his critics came to appreciate the real modernity of this French painter, who has become famous for his sensual, sensitive images.

1684 Jean-Antoine Watteau born on
10 October in the French border
town of Valenciennes
1702 Moves to Paris
1703–08 Works as an assistant to the
painter and etcher Claude Gillot
1708/09 Assistant to the decorative
painter Claude III Audran
1717 Watteau submits *L'Embarquement
pour Cythère* and becomes a full
member of the Académie Royale
1721 Watteau dies on 18 July at the age
of thirty-six in Nogent-sur-Marne

[above]
François Boucher after a drawn self-portrait by Watteau (detail). Etching, 33 x 23 cm

[left]
L'Embarquement pour Cythère, 1717. Oil on canvas, 129 x 194 cm. Musée du Louvre, Paris

1685 * George Frederick Handel **1703** Building of Buckingham Palace in London begins

1600–1700 BAROQUE ROCOCO 1700–1750

1640 1645 1650 1655 1660 1665 1670 1675 1680 1685 1690 1695 1700 1705 1710 1715 1720 1725

[left]
The Shrimp Girl, c. 1745. Oil on canvas,
63,5 x 52,5 cm. National Gallery, London

[below left]
The Triumph, 1753. Copperplate
engraving from the cycle *The Polling*,
35.3 x 30 cm

[below right]
Gin Lane, 1751. Copperplate engraving,
45 x 56 cm

1749 * Johann Wolfgang von Goethe 1769 Invention of the steam engine (James Watt)
1756 * Wolfgang Amadeus Mozart 1776 American Declaration of
1760 England conquers Canada Independence
1789 Start of the French Revolution
1789 George Washington first president of the USA
1700–1750 ROCOCO CLASSICISM 1750–1790 1750–1790 CLASSICISM ROMANTICISM 1790–1840

| 1730 | 1735 | 1740 | 1745 | 1750 | 1755 | 1760 | 1765 | 1770 | 1775 | 1780 | 1785 | 1790 | 1795 | 1800 | 1805 | 1810 | 1815 |

WILLIAM HOGARTH

The painter William Hogarth was a moralist through and through. He wanted to improve 18th-century English society by depicting the wretched lives of whores and drinkers. This painter and copperplate engraver is seen as the father of English caricature, thanks to his biting and humorous social satire.

Tom Rakewell was a debaucher who squandered his lavish inheritance on drinking and gambling at the inn. Ultimately, he came to himself, completely down and out, in a debtors' prison, where an ugly woman whom he had married only for her money made life hell for him. Tom Rakewell is an invented character, but the English artist William Hogarth insisted that all the characters he captured in paint or in copperplate engravings were to be found in real life. Hogarth was an inveterate moralist and intended his works to pillory social injustice. Rather like a play, *The Rake's Progress* proceeds act by act – until Tom Rakewell comes to a sticky end. It was clear even to uneducated people what his pictures were saying. The copperplate engravings Hogarth made of his pictures found a wide audience.

Painting for a better society

Hogarth's work did not address only the drunkenness and frantic gambling of the masses; he also captured in his pictures the political corruption of his day, the luxury of the rich and their depraved morals. And Hogarth's commitment did not end at his workshop door: as patron of a foundling hospital for orphans he persuaded many of his artist colleagues to donate pictures to the building. These pictures, in turn, drew visitors to the hospital and they often left donations. Just like his father-in-law Sir James Thornhill, who taught impoverished yet talented pupils free in his art school, Hogarth also wanted to help young people, and founded the St. Martin's Lane Academy in 1735. Convinced that the traditional art schools simply smothered new ideas and any sort of criticism, Hogarth allowed his pupils a certain say, though not at the expense of a rigid academic training. The artists of the day also benefited from Hogarth's rage about unscrupulous art dealers who reduced his own profits by pirating prints of his engravings. Hogarth and his colleagues protested against this outside Parliament. In fact, in 1735, the upper house passed legislation to

protect copyright. The parliamentary act, generally known as Hogarth's Act, is still valid in England.

Biting scorn

The older Hogarth became, the more caustic were his humorous and satirical engravings and paintings. He was visibly disappointed with his fellow human beings and their immoral, corrupt ways and his pictures were now often directed against all levels of society at the same time. So there is not a dry eye in the house when, in his last great cycle of paintings, *The Polling*, Hogarth targets the folly and idiocy of all the people portrayed. Thanks to such pictures painted with mordant wit, Hogarth is today seen not just as a superb copperplate engraver and painter, but also as the father of English caricature.

1697 William Hogarth born on 10 November in London
1712 Is apprenticed to the silversmith and engraver Ellis Gamble
1720 Hogarth embarks on an independent career as a copperplate engraver
1729 Marries Jane Thornhill, the daughter of the court painter and art teacher Sir James Thornhill
1735 Hogarth completes *The Rake's Progress* cycle. St. Martin's Lane Academy founded
1764 Dies in London on 25 October

READING TIP
Jenny Uglow, *Hogarth: A Life and a World*, New York 2002.

Moral pictures

Holding up a mirror to human beings to show them how their immoral lives have gone to rack and ruin is a task the painters of so-called moral pictures set themselves. In doing so, artists like William Hogarth of course always cherished the hope that people looking at their work might gain an insight and change their way of life. Even though scenes of everyday life have featured in art since ancient times, it was above all painters from the Netherlands like Pieter Bruegel the Elder, David Teniers and Jan Steen who brought fame to genre painting. Their pictures of cheerful goings-on in taverns and parlours were usually also taken as light-hearted warnings against immoral behaviour and paved the way for moral pictures by the likes of William Hogarth.

[above]
Self-portrait (detail), 1748/49

1703 Building of Buckingham Palace
in London begins

1707 England, Scotland and Ireland unite to
become Great Britain

1600–1700 BAROQUE ROCOCO 1700–1750 1700–1750 ROCOCO

1665 1670 1675 1680 1685 1690 1695 1700 1705 1710 1715 1720 1725 1730 1735 1740 1745 1750

[above]
Peasant Smoking a Pipe, 1788. Oil on
canvas, 196 x 158 cm. University of
Southern California, Los Angeles

[below]
Portrait of Mr. and Mrs. Andrews,
1748/49. Oil on canvas, 70 x 119 cm.
National Gallery, London

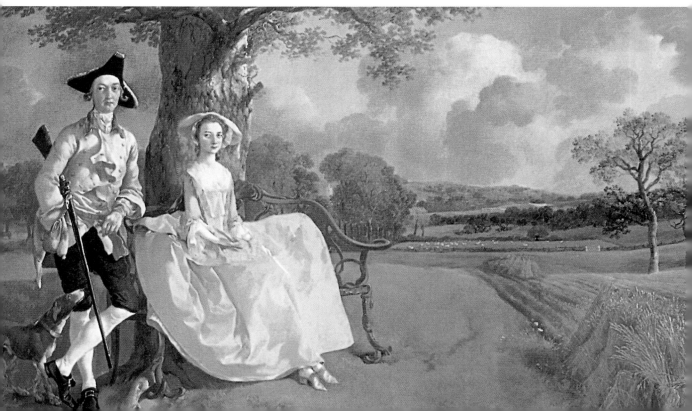

JOHN CONSTABLE

1756 * Wolfgang Amadeus Mozart
1760 England conquers Canada
1769 Invention of the steam engine (James Watt)
1770 * Ludwig van Beethoven

1776 American Declaration
of Independence

1789 Start of the French Revolution
1789 George Washington first president of the USA

SSICISM 1750–1790 1750–1790 CLASSICISM ROMANTICISM 1790–1840 1790–1840 ROMANTICISM

1755 1760 1765 1770 1775 1780 1785 1790 1795 1800 1805 1810 1815 1820 1825 1830 1835 1840

THOMAS GAINSBOROUGH

Inspired by Dutch landscape painting, Thomas Gainsborough made a name for himself as a highly individual artist. The master of English Rococo earned his living by painting portraits, but his passion was for depicting nature: he would even let a head of broccoli sit for him.

Philip Thicknesse, a nobleman and art lover, was delighted. Someone had painted a tiny picture of a man dozing in a large slouch hat and fastened it to a garden wall. The natural quality of the figure took Thicknesse's breath away. He had never seen anything like it.

Gainsborough, who was only twenty-five at the time, had the good fortune to meet a great patron of his art in this way. Although the portrait-painting business was going pretty well, Gainsborough did not like the genre and practised it only to earn a living. His real interest lay in landscape painting and in genre depictions of peasant life. Gainsborough, who was constantly making music on his viola da gamba, once said of himself: "I paint portraits to live, landscapes because I love them, and music because I cannot leave it alone."

Inventor of the landscape portrait

Gainsborough was a clever man. In order to be able to devote himself to his beloved landscape painting, he regularly painted portraits of his well-to-do clients in the open air. In this way the painter created a new genre almost in passing: the landscape portrait. He became a master of playful little shadows and a delicate, refined atmosphere, which clearly identifies him as a Rococo painter. He did not, however, paint his elaborate pictures out in the open, but often blacked out his studio out even during the day in order to paint by candlelight. This made it easier for him to mix his warm tones. Gainsborough brought the landscape he needed into his studio: he collected foliage, moss and leaves, made small rocks from pieces of coal, created brooks out of broken glass, and is said to have once even used a head of broccoli to represent a wood in the background of the painting.

A painter makes himself available

While his colleagues often went off on long trips to Italy to study the works of famous painters, Gainsborough never thought it necessary to leave the island, although he was pleased to accept invitations from his rich clients and friends to view their art collections. His own pictures became increasingly popular, and his clients and patrons even put up with the artist's strange moods and unreliability. One thing was clear to Gainsborough: "Painting and punctuality go together like oil and water." Nevertheless, he succeeded in becoming the king's favourite portrait painter and one of the co-founders of the Royal Academy of Art.

Unlike many of his colleagues, Gainsborough reached his best form in the later years of his life, creating masterly paintings which already contain hints of an emerging Romanticism and which, in their lightness, rank as early forerunners of Impressionism.

English portrait painting

English artists were much less called upon than their counterparts in other European states to depict the glory of god-like rulers and military leaders. And it was also easier for ordinary people to have their portraits painted. Pictures of this kind were commissioned for special occasions like weddings or important birthdays from artists, many of whom made their living by painting portraits. Inspired by the soft colours in which the Dutch artist Anthony van Dyck had portrayed 17th-century aristocrats, the painters Thomas Gainsborough, Joshua Reynolds and Thomas Lawrence raised portrait painting to a pinnacle of fame. William Hogarth was also celebrated for his dignified and realistic individual portraits and lively group pictures. But unlike his austere colleagues, Hogarth loved working elements of caricature into his pictures.

1727 Thomas Gainsborough born in Sudbury, Suffolk
1744 Opens his own studio in London
1746 Marries the well-to-do Margaret Burr, an illegitimate daughter of the Duke of Beaufort
1752–59 Gainsbrough moves to Ipswich, Suffolk, where he meets the patron Philip Thicknesse
1761 First exhibition in London
1768 Is one of the founder members of the Royal Academy
1784 Organises private exhibitions only after quarrelling with the Royal Academy
1788 Dies in London on 2 August

MUSEUM AND INTERNET TIPS
Thomas Gainsborough's birthplace in Sudbury is a museum. You will find all kinds of information about the artist there and many illustrations of his works: www.gainsborough.org

[above]
Self-portrait, 1750–55. British Museum, London

FRANCISCO DE GOYA

THOMAS GAINSBOROUGH

CASPAR DAVID FRIEDRICH

1776 American Declaration
of Independence

1756 * Wolfgang Amadeus Mozart

ROCOCO 1700–1750 1700–1750 ROCOCO CLASSICISM 1750–1790 1750–1790 CLASSICI

1700 1705 1710 1715 1720 1725 1730 1735 1740 1745 1750 1755 1760 1765 1770 1775 1780 1785

The Third of May, 1808: The Execution
of the Defenders of Madrid, 1814. Oil on
canvas, 266 x 345 cm. Museo del Prado,
Madrid

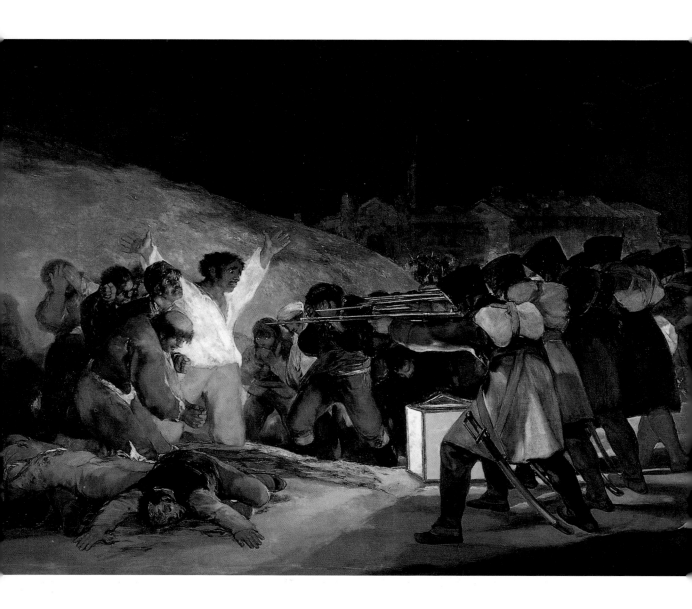

1787 Don Carlos (Friedrich Schiller) 1815 Napoleon defeated at Wate·loo

1789 Start of the French Revolution 1826 First photograph 1877 Queen Victoria
 empress of India

 1804 Napoleon Bonaparte French emperor 1830 Railway Liverpool–Manchester

 ROMANTICISM 1790–1840 1790–1840 ROMANTICISM IMPRESSIONISM 1860–1915

1790 1795 1800 1805 1810 1815 1820 1825 1830 1835 1840 1845 1850 1855 1860 1865 1870 1875

FRANCISCO DE GOYA

The Spanish painter and draughtsman Francisco de Goya y Lucientes was one of the first artists who wanted to create works for the ordinary people, rather than for church and state. His etchings on the folly of man and the cruelty of war became world-famous.

Francisco de Goya was obstinate and pig-headed, and did not want to keep to the traditional rules of painting. Even as a child he already took part in competitions run by the official academy of art, but usually did not win any prizes because he refused to follow the prescribed guidelines. "Irrelevant!" the jury would then snort in self-justification.

But Goya did not let this bother him. He thought it was impossible to teach art at the academies. The ambitious Goya went his own way, and was soon allowed to paint frescos for Zaragoza Cathedral. For the royal manufactory in Madrid he drew light-hearted pictures of ball players, woodcutters, people walking on stilts or out for a stroll, and bull-fighters on cardboard boxes – images that were used as patterns for costly carpets. He eventually became painter to the king and was later appointed court painter, creating portraits of noblemen and rulers as well as pictures for churches.

Art for citizens and the people

Actually, Goya, as a 'free' artist, also wanted to work for the people, whose often arduous lives he depicted again and again in his pictures. He studied the technique of etching, as prints had the advantage of being cheaper than oil paintings. Given that a number of prints could be made from an etching, and that many well-to-do citizens of Madrid wanted to buy Goya's art, this was, not least of all, also good for business.

Critical looks

In 1792, Goya was taken seriously ill. He recovered, but became increasingly deaf, which was a heavy blow for him. His paintings became even darker and more sorrowful and his bitterness is evident in a series of etchings he called Caprichos. He advertised his 'ideas' in Madrid newspapers, and sold the sheets in a perfume and liqueur shop directly beneath his apartment, for there were no galleries at the time. Goya's images of love-crazed men, depraved women, evil procurers, proud asses, stupid monks, charlatans and mysterious bird people were not least a criticism of the human weaknesses that emerge when common sense ceases to operate.

1746 Francisco de Goya born on
 30 March in Fuendetodos
1773 Marries Josefa Bayeu
1786 Is appointed painter to the king,
 and made court painter three years
 later
1792 Loses his hearing as the result of
 an illness
1795 Becomes director of painting at
 the Royal Academy of San
 Fernando
c. 1798 Paints his Naked Maja
1799 The Caprichos are published
1810 Begins work on the etching
 sequence The Disasters of War
1814 Goya has to answer to an
 Inquisition court
1824 Hides at a friend's house for
 several months for political
 reasons
1828 Francisco de Goya dies on 16 April
 in Bordeaux

LITERATURE TIPS
Lion Feuchtwanger's novel This is the
hour, A Novel about Goya is an exciting
read, London 1969. Also recommended:
Dagmar Feghelm, I, Goya, Munich 2004.

[left]
The Sleep of Reason Produces Monsters,
Capricho no. 43, 1797/98. Etching and
aquatint, 21.6 x 15.2 cm

[above]
Self-Portrait in Studio (detail), 1790–95.
Oil on canvas, 42 x 28 cm. Real Academia
de bellas Artes de San Fernando, Madrid

Goya's etchings depicting the cruelty of the war raging between Spain and the French Emperor Napoleon also became famous. The etchings are a grim rendering of the senseless devastation, the suffering of mothers and children, and helpless attempts by ordinary people to defend themselves against the overwhelming aggressor. His picture *The Third of May, 1808: The Execution of the Defenders of Madrid* (see page 74) was also painted when Spain was occupied by French troops.

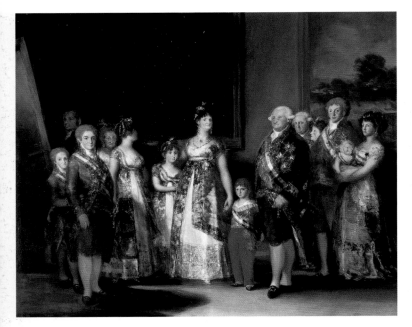

[above]
The Family of Charles IV, 1800/01. Oil on canvas, 280 x 336 cm. Museo del Prado, Madrid

[right page]
The Naked Maja, c. 1798–1805. Oil on canvas, 97 x 190 cm. Museo del Prado, Madrid

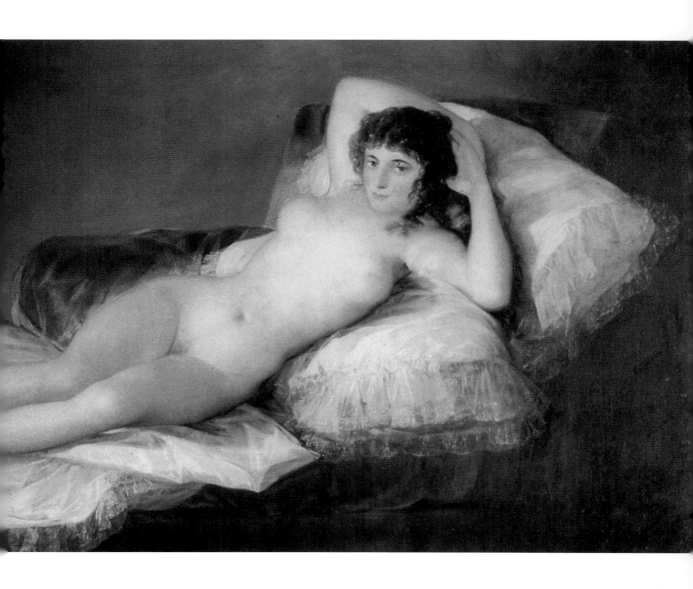

JACQUES-LOUIS DAVID ════════════════════════════

FRANCISCO DE GOYA ════════════════

 JOSEPH MALLORD WILLIAM TURNER ═════════

 1776 American Declaratio
 of Independence

 1770 * Ludwig van Beethoven

ROCOCO 1700–1750 1700–1750 ROCOCO CLASSICISM 1750–1790 1750–1790 CLASSIC

1700 1705 1710 1715 1720 1725 1730 1735 1740 1745 1750 1755 1760 1765 1770 1775 1780 1785

The Death of Marat, 1793. Oil on canvas, 165 x 128.3 cm. Musées Royaux des Beaux-Arts, Brussels

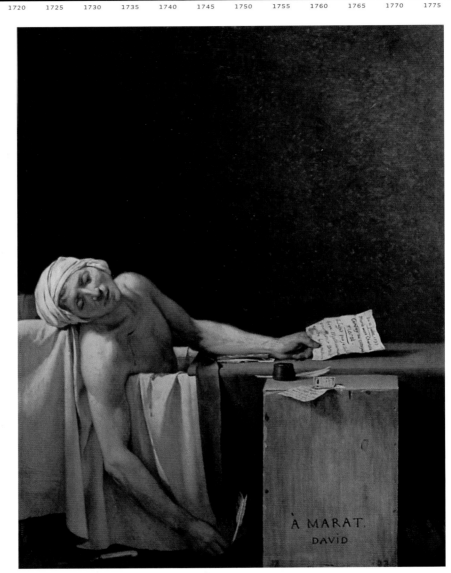

Classicism

The champions of the French Revolution saw themselves as the new Greeks and Romans and, naturally, this attitude also found expression in the art of the late 18th century. The painters of the day, above all the French artist Jacques-Louis David and his pupil Jean-Auguste-Dominique Ingres, did their utmost to get away from the playfulness of the Rococo period and the overblown pictures of late Baroque as the art forms of the hated nobility. They admired the simple forms of Greek and Roman antiquity as well as its austere and lucid handling of line and colour. Many philosophers and men of letters also looked back at the distant past as if to a golden age in which order, justice and morality prevailed

1789 Start of the French
Revolution

1804 Napoleon Bonaparte
French emperor

1826 First photograph

1808 Faust I (Johann Wolfgang von Goethe)

1815 Napoleon defeated at Waterloo

1848 The Communist Manifesto
(Karl Marx, Friedrich Engels)

ROMANTICISM 1790–1840

1790–1840 ROMANTICISM

IMPRESSIONISM 1860–1915

1790 1795 1800 1805 1810 1815 1820 1825 1830 1835 1840 1845 1850 1855 1860 1865 1870 1875

JACQUES-LOUIS DAVID

*The French painter David was keen on ancient art. His paintings in the Classical style glorify first the
revolutionaries and, later, Napoleon I. He is seen as the father of French Classicism.*

When Jacques-Louis David won the Prix de Rome
art award for his picture *Dr. Erasistratus* in 1774,
the first thing he did, no doubt, was to buy himself
something to eat. Previous failures had so de-
pressed the artist that he intended to starve himself
to death. He regained his strength, but the next
source of despair was not long in appearing.

On a journey to Italy the following year, David
saw works of art from the ancient world for the first
time. His own pictures in the Rococo style seemed
incompetent and trivial alongside these master-
pieces. David became profoundly depressed again.
Before setting off for Italy he had boasted loudly
that antiquity could never 'seduce' him, but there
he was, running about Rome busily sketching
ancient sculptures and buildings. He was no less
enthusiastic about the great Renaissance masters:
Michelangelo and Raphael had wrapped David
round their little fingers with their art.

Liberté, Égalité, Fraternité

The figures in David's pictures subsequently
became more sculptural, and the flowing garments
of previous years suddenly looked as though they
had been carved in stone. David was not the only
person to be fired with enthusiasm for antiquity.
This was the time of the French Revolution, whose
champions also looked back longingly at the moral
values of Ancient Greece and Ancient Rome.
Patriotism, citizenship and heroic self-sacrifice in
the struggle for freedom were seen as the most
excellent qualities. Scarcely anyone could express
these ideas better than David in paintings like *The
Oath of the Horatii* or *The Murder of Marat*. The
Bastille was being stormed and David was cele-
brated as the artistic leader of the revolutionary
government. The artist's euphoria was such that
he placed his art entirely at the disposal of political
propaganda and created idealised images of heroes
of the Revolution, such as Marat and Robespierre.

From revolutionary to court painter

Dangerous times lay ahead for David. Robespierre
fell in 1794 and was beheaded with due haste.
David, as his faithful supporter, landed behind bars
for six months. He skilfully played down his role in
the Revolution and asserted that he had been
seduced by various "individuals". He was released,
and before long David proved to be an ardent sup-
porter of the new ruler, Napoleon I, who appointed
him as his 'premier peintre', his house and court
painter. Napoleon felt that David's Classical style
was very well suited to glorify his person and his
campaigns. But times remained restless. Napoleon
was banished after losing the Battle of Waterloo in
1815. David immediately found himself in the role of
enemy of the state again. He fled to Switzerland,
and later went into exile in Brussels. There he
suffered a serious accident, and died of its conse-
quences on 29 December 1825. Permission to take
his body back to France was not granted.

1748 Jacques-Louis David born on
30 August in Paris
1774 Wins the Prix de Rome with his
painting *Dr. Erasistratus*
1775 Travels to Italy. Enthusiastic
about the art of antiquity
1782 Marries the royalist Charlotte
Pécoul. Divorces and subsequently
remarries during the Revolution
1789 Outbreak of the French Revolution;
David becomes its most important
painter and champion
1794 Is arrested and imprisoned
1804 Is appointed 'premier peintre' to
Napoleon I
1816 Flees to Brussels
1825 Dies in exile on 29 December

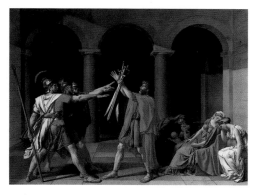

[above]
Self-portrait (detail), 1790/91. Oil on
canvas, 64 x 53 cm. Uffizi, Florence

[left]
The Oath of the Horatii, 1784. Oil on
canvas, 330 x 425 cm. Musée du Louvre,
Paris

FRANCISCO DE GOYA

CASPAR DAVID FRIEDRICH

JOSEPH MALLORD WILLIAM TURNER

1789 Start of the French
Revolution

1776 American Declaration
of Independence

1791 Brandenburg Gate
built in Berlin

1793 *The Death of Marat*
(Jacques-Louis David)

1804 Napoleon Bonaparte
French emperor

1700–1750 ROCOCO CLASSICISM 1750–1790

1750–1790 CLASSICISM ROMANTICISM 1790–1840

| 1720 | 1725 | 1730 | 1735 | 1740 | 1745 | 1750 | 1755 | 1760 | 1765 | 1770 | 1775 | 1780 | 1785 | 1790 | 1795 | 1800 | 1805 |

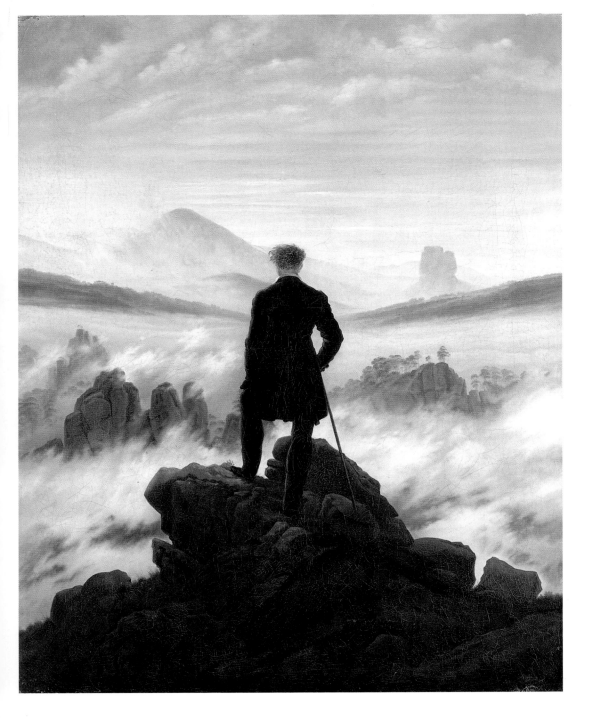

5 Battle of Trafalgar

1815 Napoleon defeated at Waterloo

1848 *The Communist Manifesto*
(Karl Marx, Friedrich Engels)

1877 Queen Victoria empress of India

1790–1840 ROMANTICISM

IMPRESSIONISM 1860–1915

1810 1815 1820 1825 1830 1835 1840 1845 1850 1855 1860 1865 1870 1875 1880 1885 1890 1895

CASPAR DAVID FRIEDRICH

The German painter Caspar David Friedrich created some of the most important works of Romanticism with his paintings of well-nigh endless landscapes in which people stand in awe before the might of the creation like tiny, lost creatures. This is how he was able to make landscape painting an acceptable element on church altars.

Caspar David Friedrich did not want to travel to Italy like his artist friends to study the work of Raphael and Michelangelo or to capture the sun-flooded landscapes of Florence or Rome in drawings and paintings. He preferred the port of Greifswald, and Dresden. This somewhat introspective painter felt at home in his native area with its dark clouds, mills and ruins, cold winters, gnarled, old oak trees, wide expanses of heathland and the beaches of the Baltic.

A wanderer in God's nature
This was the landscape that Friedrich wanted to paint, and explore over and over again on foot. As a student at the Dresden Academy of Art he would often grab his walking stick and sketchbook and go out into the open countryside. Later, he travelled to the coast, to Bohemia or to the Riesengebirge range of mountains. Even years later, the gigantic paintings he created in his sparsely furnished studio were modelled on these sketches.

Friedrich usually went hiking alone, to sort himself out in the silence and to be entirely at one with the landscape. "I have to give myself up to what is around me," he once wrote, "make myself part of my clouds and rocks, in order to be what I am. I need solitude in order to converse with nature." God's nature, to be precise. Friedrich's landscape paintings reflect his belief in God's omnipresence and creative power.

Wedding pictures
Friedrich was particularly taken by the Baltic island of Rügen with its rugged, ancient, chalk cliffs, and returned there time and again. His honeymoon in 1818 also took him and his bride, Christiane, to Rügen. He painted the *Chalk Cliffs in Rügen*, one of his most famous paintings, the same year as a kind of holiday souvenir. It shows three visitors to the island with their backs to the viewer, entirely immersed in the view of the landscape and the sea.

A ship is passing in the background: perhaps the beginning of a new voyage in life? Friedrich later painted himself with his wife on board a ship, sailing towards their future together. In 1824, the famous painter became a professor at the Dresden Academy of Art. Together with his wife and their first daughter, Emma, Friedrich moved into a house on the outskirts of Dresden. From there, it was but a short distance to go hiking in the surrounding area whenever he was seized with a longing for the countryside.

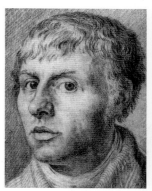

1774 Caspar David Friedrich born on
5 September in Greifswald
1794 Studies painting in Copenhagen
and later in Dresden
1801 Meets the painter Philipp Otto
Runge
1802 Friedrich goes hiking on Rügen
Island
1807 Switches from paintbrush drawing
to oil painting
1808 Paints *The Mountain Cross* and
The Monk by the Sea
1818 Marries Christiane Caroline
Bommer
1819 Emma born as first of two
daughters
1824 The artist becomes professor at
the Kunstakademie Dresden
1840 Caspar David Friedrich dies on
7 May in Dresden

Romanticism
The Romantic painters, poets and musicians were passionate people. They were overwhelmed by the infinite expanse of nature, the imposing mountains and the sea. It filled them with enthusiasm, and through their work they wanted to convey precisely this sense of profound emotion to other people. Back then, paintings of sweeping mountain landscapes, misty forests, moonlit tombs and 'romantic' church ruins were in fashion all over Europe. But these artists' imaginations were also stimulated by the emotional fairy-tale world of knights and castles and the rich legends of the mysterious Orient. Romanticism lasted from about 1790 to 1830. Famous exponents were the French artists Théodore Géricault and Eugène Delacroix, the English artists William Turner and Henry Fuseli, and in Germany, Friedrich's acquaintance Philipp Otto Runge.

[above]
Self-portrait, c. 1800. Chalk drawing,
42 x 27.6 cm. Copenhagen, Statens
Museum for Kunst

[left page]
The Wanderer above the Sea of Fog,
c. 1818. Oil on canvas, 94.8 x 74.8 cm.
Kunsthalle, Hamburg

[right]
The Mountain Cross (Tetschen Altar),
1808. Oil on canvas, 115 x 110.5 cm.
Gemäldegalerie Neue Meister, Dresden

[below]
The Sea of Ice, c. 1823/24. Oil on canvas,
96.7 x 126.9 cm. Kunsthalle, Hamburg

[right page]
Cliffs on Rügen, c. 1818. Oil on canvas,
90.5 x 71 cm. Sammlung Oskar Reinhart,
Winterthur

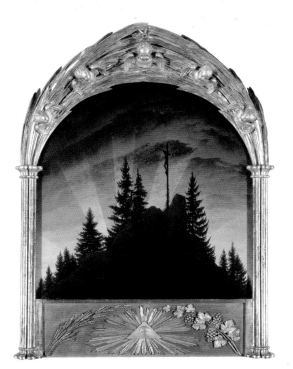

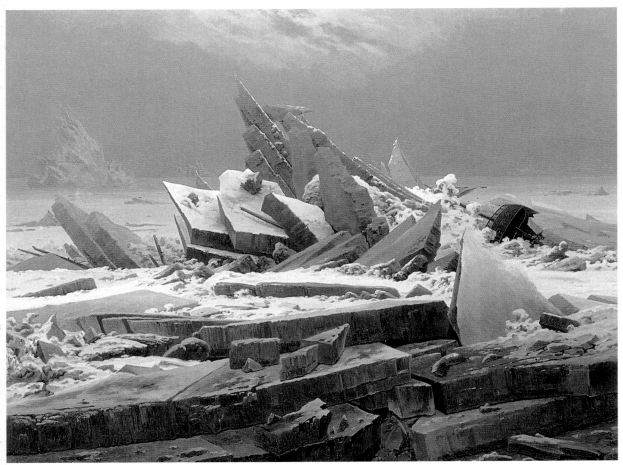

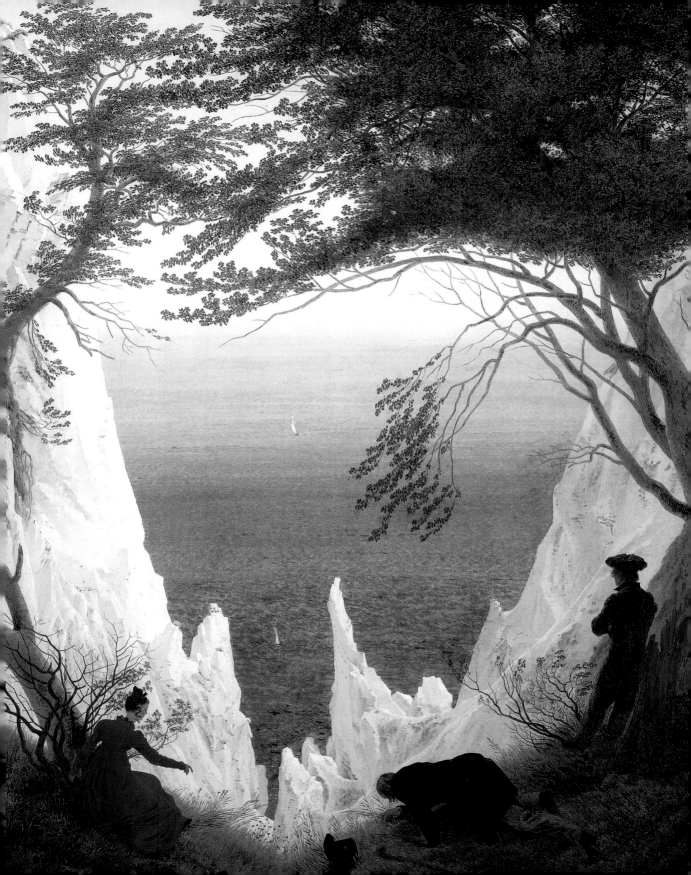

GUSTAVE COURBET

1776 American Declaration
of Independence

1789 Start of the French
Revolution

1804 Napoleon Bonaparte
French emperor

1805 Battle of Trafalgar

1700–1750 ROCOCO CLASSICISM 1750–1790 1750–1790 CLASSICISM ROMANTICISM 1790–1840

1730 1735 1740 1745 1750 1755 1760 1765 1770 1775 1780 1785 1790 1795 1800 1805 1810 1815

[above]
*The Dogana, San Giorgio and the Citella
from the steps of the Hotel Europa,* 1842.
Oil on canvas, 61.6 x 92.7 cm.
Tate Gallery, London

[below]
*Snowstorm – steam boat off a harbour's
mouth making signals in shallow water,
and going by the lead. The author was
in this storm on the night the Ariel left
Harwich,* 1844. Oil on canvas,
91.5 x 122 cm. Tate Gallery, London

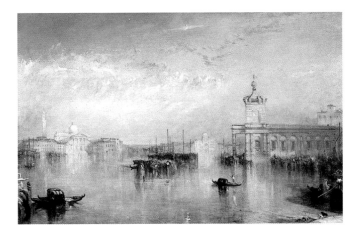

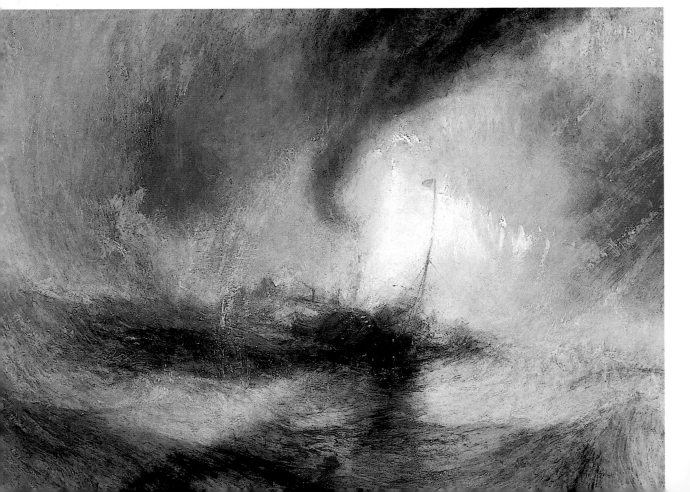

1824 Building begins
on Windsor Castle

1837 Victoria becomes queen of England
1842 China cedes Hong Kong to Britain

1865 Slavery abolished in the USA

1830 Railway Liverpool–Manchester

1871 *The Origin of Species* (Charles Darwin)

1790–1840 ROMANTICISM

IMPRESSIONISM 1860–1915

1820 1825 1830 1835 1840 1845 1850 1855 1860 1865 1870 1875 1880 1885 1890 1895 1900 1905

WILLIAM TURNER

Not even great danger could deter William Turner from studying the play of colours during violent natural phenomena, and it was this that enabled him to become a true master of light.

This highly distinctive English painter never missed an opportunity to get as close as possible to tornadoes, floods, avalanches and volcanic eruptions. When his ferry was caught in a massive snowstorm, for example, he had himself tied to the mast so that he would miss nothing of the raging, roaring wind and the play of colour in the sky. He wrote two words in tiny letters on the edge of his sketches of this storm: "Almost capsized". Later, in his studio, this adventurous voyage became one of Turner's most turbulent compositions, *Snowstorm*. The viewer's eye seems to be drawn into the energetic midst of this picture as if by a vortex. The painter leaves no doubt about how powerless human beings are in the face of nature.

Early practice

Even as a young boy Turner was fascinated by natural forces. He particularly loved the restless waters of the Thames, which flowed through London only a few steps from his parental home. He captured the harbour facilities on the river and the ships' rigging, which usually half disappeared into the mist, in little drawings, which he was allowed to exhibit regularly in his father's hairdressing salon. Even though he never had any artistic training, Turner's assiduous drawing and great talent gained him a scholarship to the Royal Academy at the age of fourteen. Turner was soon both famous and infamous there. He resentfully regarded all other artists, even the old masters, as rivals. When, in the spring of 1799, he had the opportunity to study a painting by the generally admired Claude Lorrain, Turner set himself the task of painting very similar landscapes. Instead of being intimidated by the great painters, he wanted to prove to all that he was the greatest. In this way, Turner quickly made a name for himself as a master of Romantic landscape painting.

Italian impressions

The eruption of Vesuvius that Turner experienced on a visit to Italy in 1819 was a spectacle entirely to his taste. Turner changed his approach to painting radically after seeing the glowing lava pour down the volcano, gleaming in the incomparable southern light. Unlike almost any other artist he made the most of every conceivable lighting effect. The colours almost exploded out of his pictures now, and they became increasingly abstract in subsequent years. Apart from painting tremendous natural phenomena and ships he also captured on canvas light-flooded views of cities such as Rome and Venice.

Turner saw his pictures as creatures in their own right, and before he died on 19 December 1851 he insisted that they should stay together like a family. But the Victoria and Albert Museum in London was unable to keep them together for long and the colourful family, consisting of 20,000 works, was soon split up.

1775 Joseph Mallord William Turner
born on 23 April in London
1790 His first watercolour is shown at
the Royal Academy
1802 Full membership of the Academy
1807 Begins teaching perspective
1819 Travels to Italy, producing
2,000 sketches in four months
1829 Death of his father
1851 Turner dies on 19 December in
Chelsea

[above]
Self-portrait (detail), c. 1799.
Oil on canvas, 58 x 72.5 cm.
Tate Gallery, London

Rain, Steam and Speed, 1844. Oil on canvas, 91 x 121.8 cm. National Gallery, London

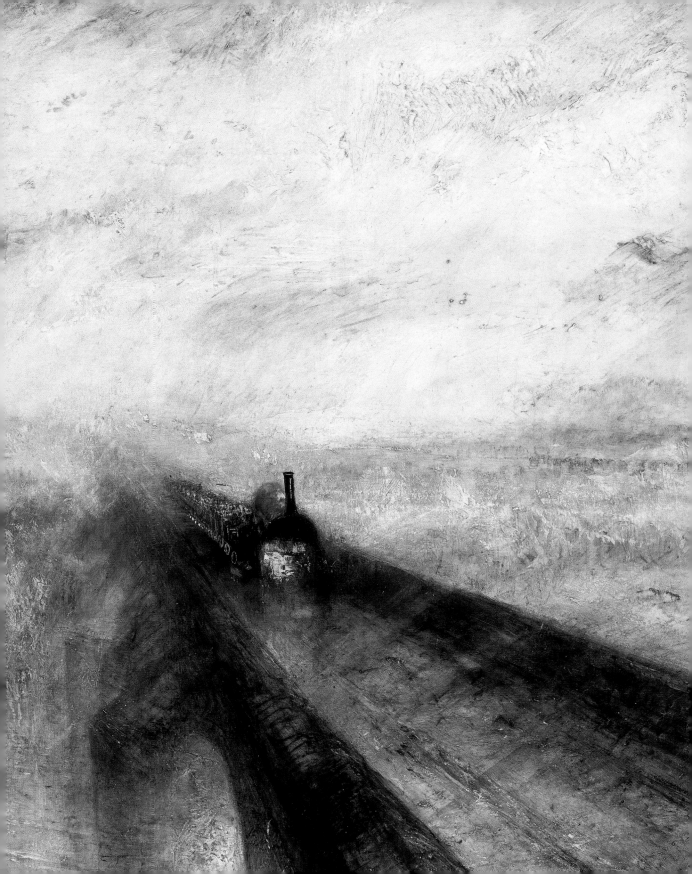

JOSEPH MALLORD
WILLIAM TURNER

ÉDOUARD MANET

1804 Napoleon Bonaparte French emperor

1842 China cedes Hong
Kong to Britain

1815 Napoleon defeated at Waterloo

1844 *The Three Musketeers*
(Alexandre Dumas)

1750–1790 CLASSICISM ROMANTICISM 1790–1840

1790–1840 ROMANTICISM

1760 1765 1770 1775 1780 1785 1790 1795 1800 1805 1810 1815 1820 1825 1830 1835 1840 1845

[above]
The Cliff at Etretat after the Storm,
1869–70. Oil on canvas, 133 x 162 cm.
Musée d'Orsay, Paris

[below]
The Painter's Studio, 1855. Oil on canvas,
359 x 598 cm. Musée d'Orsay, Paris

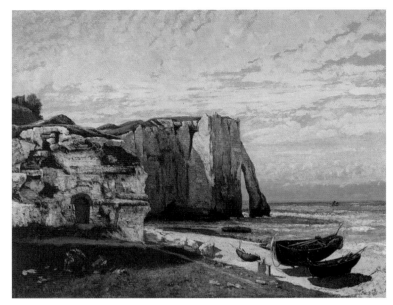

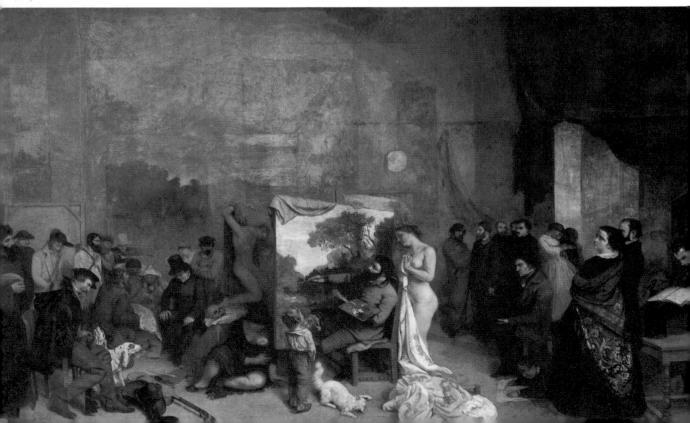

1857 *Madame Bovary*
(Gustave Flaubert)

1871 German armies take Paris

1861–1865 American Civil War

1887–1889 Eiffel Tower built in Paris

1888 *Sunflowers* (Vincent van Gogh)

IMPRESSIONISM 1860–1915

1860–1915 IMPRESSIONISM CUBISM 1915–1920

1850 1855 1860 1865 1870 1875 1880 1885 1890 1895 1900 1905 1910 1915 1920 1925 1930 1935

GUSTAVE COURBET

The Parisian public was shocked by the monumental paintings of the French artist Gustave Courbet, for not even ugliness could intimidate him.

Visitors to Gustave Courbet's studio must have had the fright of their lives. They would certainly not have expected to encounter a wild-looking bull thrashing around with its tail as they went in. It was just that the French painter occasionally preferred somewhat different models from the usual ladies and gentlemen. So it is not surprising that the critics regularly rejected his unusual pictures because the figures represented seemed too ugly, scruffy or drunken. Courbet saw things differently: a true painter should not be put off by ugliness.

In the temple of realism

The Brasserie Andler in Paris, the "Temple of Realism", as the writer Jules Champfleury once called the popular beer-drinkers' haunt, was Courbet's local. There, he would meet friends such as writer Charles Baudelaire, philosopher Pierre Proudhon or poet Max Buchon. They were all proponents of realism and also sympathised with the revolutionaries who brought down the moderate monarchy of King Louis-Philippe on 24 February 1848. Because of his lively manner, as well as his often quick temper, Courbet soon became the central figure at the table reserved for regulars.

Success at the 1848 Salon

Courbet, who had attended the art academy in Besançon but had left in 1839 without graduating, enjoyed little success at the large annual art exhibitions, the Salons. Only three of his works were accepted by the Salon jury between 1841 and 1847. How fortunate for the artist that his family, who owned a vineyard, supported him financially. When, after the 1848 Revolution, a Salon was held without a jury, Courbet grabbed the opportunity to exhibit ten of his works and – indeed – the critics were enthusiastic. From then on all his pictures caused a stir, despite some setbacks. When three of his submissions were rejected for the 1855 World's Fair, Courbet put on an exhibition of his own in a shed

alongside the Fair. His exhibition called *Le Réalisme*, is regarded as the birth of Realism.

Flight to Switzerland

Courbet's republican friends elected him president of the republican art commission in 1870 after the fall of Napoleon III. Shortly after that he became a city councillor, and thus a member of the Paris Commune. But after the Commune was overthrown, Courbet was accused of having been involved in destroying a monument in honour of Napoleon's victories. Courbet was ordered to pay 300,000 francs so that the monument could be rebuilt, but this was too much for the artist and he fled to French-speaking Switzerland. He never stopped hoping that he would be able to return to France but no pardon ever came. Courbet died of dropsy in his Swiss exile on 31 December 1877.

Realism

The realist painters aimed to depict reality in a way that was as true to nature as possible. There had certainly been tendencies of this kind in painting since ancient times, but Realism as a name for an art movement caught on only as a result of the famous exhibition that Gustave Courbet put on in a shed in Paris in 1855, and which he called *Le Réalisme*. The most famous realists alongside Courbet are the painter and caricaturist Honoré Daumier, Adolf Menzel, Wilhelm Leibl, who was so important for German art, and Jean-François Millet, whose picture *The Gleaners* became world-famous. Millet was one of the painters of the so-called Barbizon school, who came together in the French village of Barbizon at the time of the 1848 revolution. These painters focused increasingly on nature and devoted themselves to open-air painting on a lavish scale in the woods near Paris. They also include Jean-Baptiste Camille Corot, who is known for his poetic landscapes.

1819 Courbet born on 10 June in Ornans, in eastern France

1837 Takes drawing lessons at the Besançon academy of art

1839 Moves to Paris

1847 His beloved Virginie Binet bears their son

1848 Critics celebrate Courbet's contribution to the Salon for the Year of Revolutions, which had no jury

1850/51 *A Burial at Ornans* shown in the Salon

1855 Courbet stages his own exhibition, *Le Réalisme*, where he first presented *The Painter's Studio*, at the same time as the World's Fair

1873 Courbet flies to Switzerland to avoid paying 300,000 francs for the memorial to Napoleon damaged by the Commune

1877 Courbet dies on 31 December in Swiss exile

READING AND MUSEUM TIPS
Marie Luise Kaschnitz, *Die Wahrheit, nicht der Traum. Das Leben des Malers Courbet*, Frankfurt am Main 1989.
Courbet's birthplace in Ornans is now a museum: www.musee-courbet.com

[above]
Gustave Courbet. Photograph

1815 Napoleon defeated at Waterloo **1837** Victoria becomes queen of England

1824 Building begins on Windsor Castle **1842** China cedes Hong Kong
to Britain

1750–1790 CLASSICISM ROMANTICISM 1790–1840 1790–1840 ROMANTICISM

| 1770 | 1775 | 1780 | 1785 | 1790 | 1795 | 1800 | 1805 | 1810 | 1815 | 1820 | 1825 | 1830 | 1835 | 1840 | 1845 | 1850 | 1855 |

[right]
Beate Beatrix, 1864–70. Oil on canvas,
86.4 x 66 cm, Tate Gallery, London

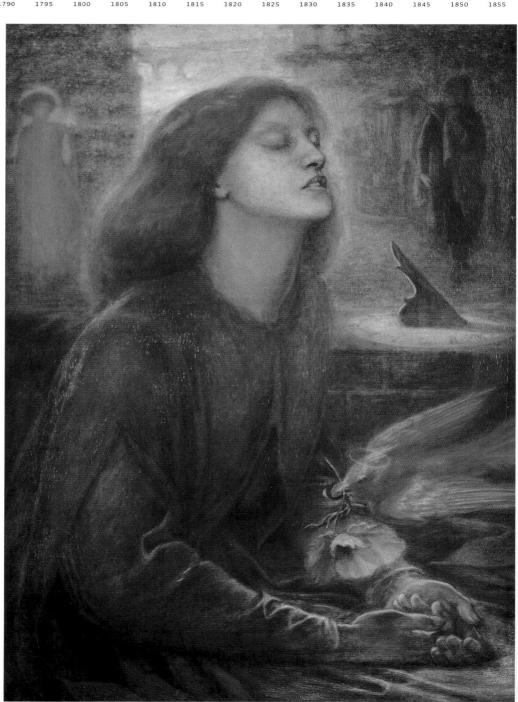

1861–1865 American Civil War

1888 *Sunflowers* (Vincent van Gogh)

1900 *The Interpretation of Dreams* (Sigmund Freud)

1883 First skyscraper in Chicago
1883 *Treasure Island* (Robert Louis Stevenson)

IMPRESSIONISM 1860–1915

1860–1915 IMPRESSIONISM CUBISM 1915–1920 EXPRESSIONISM 1920–1940

1860 1865 1870 1875 1880 1885 1890 1895 190C 1905 1910 1915 1920 1925 1930 1935 1940 1945

DANTE GABRIEL ROSSETTI

The most important of the Pre-Raphaelites pointed the way to English Art Nouveau with his linear style and highly individual depictions of people.

Dante Gabriel Rossetti loved his wife, Elizabeth Siddal, whom he nicknamed 'Guggum', more than anything else, and painted her over and over again. The young Elizabeth, with her "extravagant mass of auburn hair", can be found in many of his pictures. She died of a laudanum overdose on 11 February 1862, a year after they were married. A doctor had prescribed the drug because of her lingering illnesses. Rossetti was devastated, and in his grief he buried the only manuscript of his poems with her in her coffin. After Guggum's death it would seem that he ran out of ideas for good poems; at any rate, seven years later he had the coffin dug up and published the poems.

The Pre-Raphaelites

Rossetti's career got off to a very promising start: his very first large oil painting, *The Girlhood of Mary Virgin*, was much praised by critics – until they noticed three small letters PRB, in the bottom left-hand corner of the picture. When the press found out that this was an abbreviation for the secret Pre-Raphaelite Brotherhood, who wanted to thoroughly shake up British art, Rossetti suddenly became the target of abuse from all sides.

Rossetti and seven of his painter friends felt that British art was nearing its decline, as all artists ever tried to do was to paint like Raphael. The Pre-Raphaelites had, therefore, sworn to act as though Raphael had never existed, and modelled themselves on the artists of the Gothic period instead. Medieval romances became their preferred subjects.

Three femmes fatales

For a long time, Rossetti's favourite model was the complete opposite of his delicate and gentle Elizabeth: Fanny Cornforth was buxom, red-cheeked and had a coarse sense of humour. He also liked Jane Morris, the wife of his friend William Morris, the pioneer of the Arts and Crafts movement. These three women appear as true femmes fatales in almost all of Rossetti's pictures – irresistibly beautiful and sensual women who wrap men round their little fingers and who are usually the cause of their downfall. Rossetti painted these women with an incredible grace that he achieved by employing a highly unusual technique. He used a watercolour brush for his oil paintings, and applied the paint so thinly that everything seemed very delicate, fragile and dream-like.

Lonely end

In 1872, Rossetti had a nervous breakdown and subsequently tried to commit suicide. The painter then withdrew from society and his behaviour became increasingly strange. He rarely left his house, which was almost overflowing with antiquities, or his garden, which had all kinds of racoons, armadillos and peacocks running around in it. Rossetti's alcohol consumption and the various drugs he took usually made his hands tremble too much to be able to paint pictures. He died on Easter Sunday, 1882.

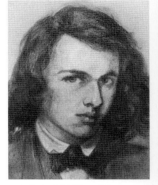

1828 Dante Gabriel Rossetti born on 12 May in London
1848 He and six friends found the Pre-Raphaelite Brotherhood
1849 The picture *The Girlhood of Mary Virgin* greeted with enthusiasm
1860 Rossetti marries Elisabeth 'Lizzie' Siddal
1862 Lizzie dies. Rossetti suffers from depression
1872 Rossetti has a nervous breakdown. Begins to take drugs
1881 His left leg and left arm are paralysed by a stroke
1882 Rossetti dies in Birchington-on-Sea, Kent, on 9 April

[above]
Self-portrait, 1853. Private collection

[left]
Paolo and Francesca da Rimini, 1855. Watercolour on paper, 25.4 x 44.9 cm. Tate Gallery, London

ÉDOUARD MANET

GUSTAVE COURBET

PAUL CÉZANNE

1815 Napoleon defeated at Waterloo

1826 First photograph

1750–1790 CLASSICISM ROMANTICISM 1790–1840 1790–1840 ROMANTICISM

1770 1775 1780 1785 1790 1795 1800 1805 1810 1815 1820 1825 1830 1835 1840 1845 1850 1855

Le Déjeuner sur l'Herbe, 1863. Oil on
canvas, 214 x 270 cm. Musée d'Orsay,
Paris

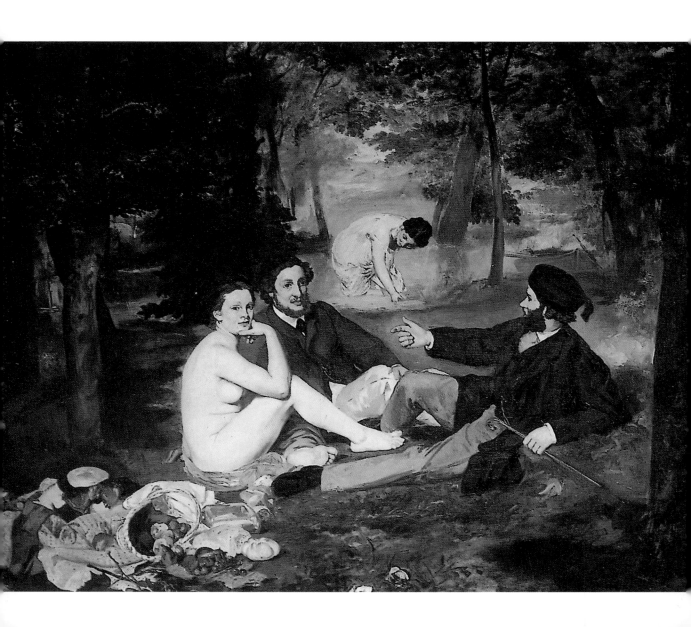

1857 Madame Bovary (Gustave Flaubert) **1886** Statue of Liberty in New York harbour
 1869 * Mahatma Ghandi **1887–1889** Eiffel Tower built in Paris
 1871 German armies take Paris **1888** Sunflowers (Vincent van Gogh) **1900** The Interpretation of Dreams (Sigmund Freud)

IMPRESSIONISM 1860–1915 1860–1915 IMPRESSIONISM CUBISM 1915–1920 EXPRESSIONISM 1920–1940

1860 1865 1870 1875 1880 1885 1890 1895 1900 1905 1910 1915 1920 1925 1930 1935 1940 1945

ÉDOUARD MANET

The French painter and graphic artist Édouard Manet captured the full spectrum of Parisian life in his shimmering paintings. Even though he never took part in an Impressionist exhibition his rapid, seemly fleeting brushstrokes influenced the Impressionist artists to an extraordinary extent.

"One must live in one's times and create what one sees" was Manet's firm conviction. This is why he would stroll down the magnificent boulevards of his home city of Paris in top hat, gloves and smart boots – seeking inspiration in bars, cafés and cabarets, at race meetings and masked balls in the midst of the seething mass of people with their elegantly gleaming silk dresses and glittering jewellery, black tailcoats and top hats. As the son of a high-ranking civil servant Manet had enough money to visit the city's places of entertainment with his artist friends. "I love this life," Manet once said, "I love the salons, the noise, the lights, the parties, the colour." But Manet did not just show the joys and beauty of Paris, he also identified the loneliness that can assail people who live in big cities.

The many faces of Paris
In Manet's day, artists in painting schools and academies were still being taught to paint historical pictures showing scenes from the Bible or Greek mythology. Manet, on the other hand, showed everyday life in cafés, stations, operetta theatres and parks with their beggars, street singers, construction workers and the fashionably adorned coffee-house clientele in all their variety and shimmering colours. The Academy prescribed that artists should paint precisely and carefully, but Manet painted in a 'modern' way, with many colour nuances and rapid brushstrokes that blurred the details; his 'blobs' of colour set next to each other produce an image only when viewed from a distance. Manet also made use of photography, which had become fashionable. In his paintings, a passer-by occasionally enters the scene, half cut off, as if captured in a random snapshot. In *A Bar at the Folies-Bergère*, for example, the legs of a trapeze artist are projecting into the top left-hand corner of the picture – inconceivable in the carefully planned pictures of Academy artists.

Nudes that caused a stir
Manet's nudes in particular created a great to-do at exhibitions and were constantly rejected by the jury for the famous Parisian art competitions, the annual Salons. Viewers of his picture *Le Déjeuner sur l'Herbe* found the woman's nakedness as scandalous as the liberties in painting style. The perspectives and relative sizes are not correctly portrayed in the picture: in comparison with the bathing woman, the boat by the river bank is far too small. Manet defiantly placed one of these pictures, showing a self-confident woman at her morning toilet, in the window of a junk shop on a Parisian boulevard. After all, his pictures were created not in museums, but in the city's streets and public buildings.

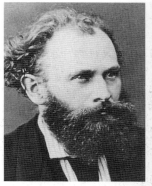

1832 Édouard Manet born on 23 January in Paris
1849 Decides to become an artist
1859 His first picture submitted to a Salon is rejected
1862 Turns to painting Parisian life
1863 The Emperor pronounces *Le Déjeuner sur l'Herbe* "indecent"
1867 Organises his own show in a specially constructed wooden hut
1872 Receives his first commissions
1874 Marries Berthe Morisot
1883 Manet dies on 30 April in his native Paris

[above]
Édouard Manet. Photograph

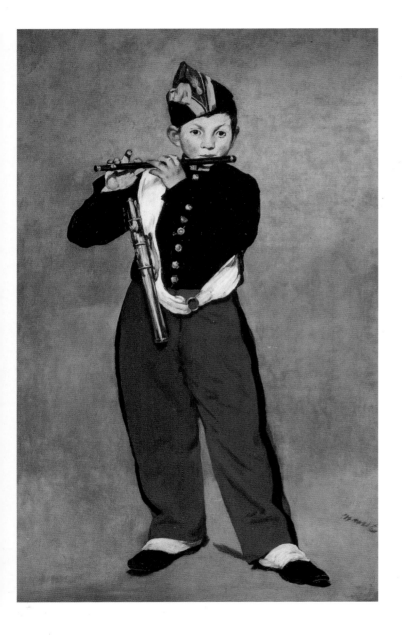

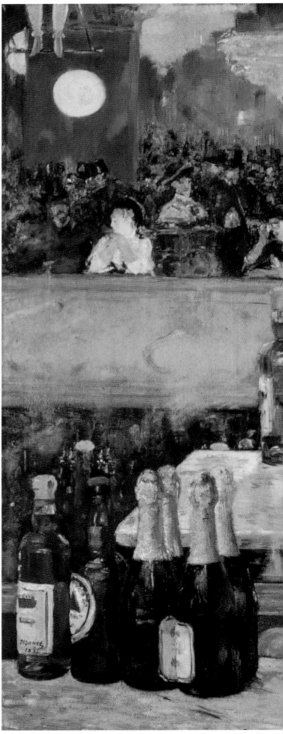

[left]
The Young Piper, 1866. Oil on canvas,
161 x 97 cm. Musée d'Orsay

[right]
A Bar at the Folies-Bergère, 1881/82.
Oil on canvas, 96 x 130 cm. Courtauld
Institute Galleries, London

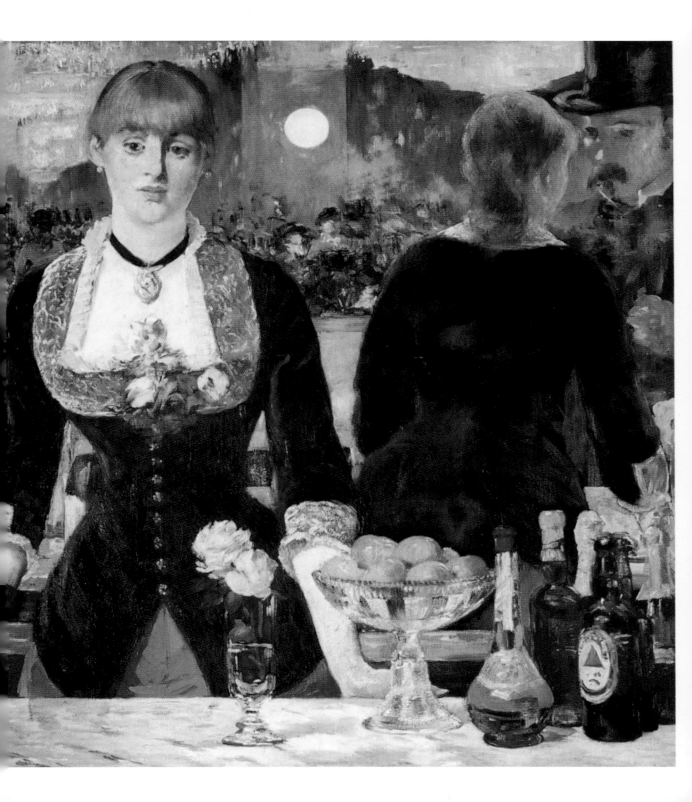

PAUL CÉZANNE ═══════════════════════════════════

ÉDOUARD MANET ═══════════════════════════════════

CLAUDE MONET ═══════════════════════════════════

1826 First photograph

1857 *Madame Bovary* (Gustave Flau

ROMANTICISM 1790–1840 1790–1840 ROMANTICISM IMPRESSIONISM 1860–1915

| 1785 | 1790 | 1795 | 1800 | 1805 | 1810 | 1815 | 1820 | 1825 | 1830 | 1835 | 1840 | 1845 | 1850 | 1855 | 1860 | 1865 | 1870 |

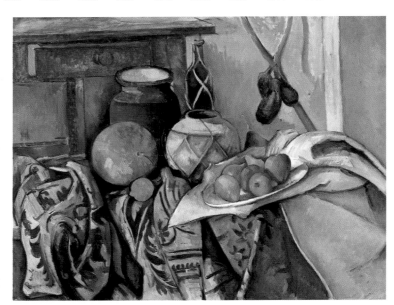

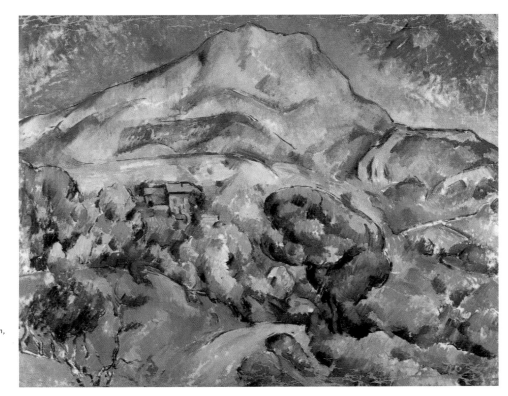

[above]
Still Life with Ginger Jar, Pumpkin and Aubergines, 1893–94. Oil on canvas, 72.4 x 91.4 cm. State Hermitage Museum, St. Petersburg

[below]
View of L'Estaque and the Chateau d'If, 1883–85. Fitzwilliam Museum, Cambridge

1 German armies take Paris 1887–1889 Eiffel Tower built in Paris 1901 * Walt Disney
1888 Sunflowers (Vincent van Gogh) 1905/07 Die Brücke and Der Blaue Reiter
1897–1899 Water Lily Pond artists' associations founded
(Claude Monet) 1914–1918 World War I

1860–1915 IMPRESSIONISM CUBISM 1915–1920 EXPRESSIONISM 1920–1940 ABSTRACT EXPRESSIONISM 1940–1960

1875 1880 1885 1890 1895 1900 1905 1910 1915 1920 1925 1930 1935 1940 1945 1950 1955 1960

PAUL CÉZANNE

The French painter Paul Cézanne assembled his landscape paintings as if from a construction kit, in order to show the "simple beauty" of the South of France. In doing so, he influenced the Cubist painters, but also Claude Monet, Edgar Degas and Pablo Picasso, to a greater extent than any other artist, and has since been seen as the most important pioneer of Modernism.

Cézanne loved the countryside around his birthplace, Aix-en-Provence, in the South of France. He often spent days walking in Provence with his classmate Émile Zola, enjoying its rolling hills, fertile fields and craggy cliffs. He was particularly taken with Mont Sainte-Victoire, and painted one of his pictures there in the shadow of the pines, while Zola worked on his poems.

When Zola decided to go to Paris, Cézanne begged his father for permission to follow his friend to the centre of the art world. He was finally allowed to move there to study painting. But the young artist was so homesick that he went back to Provence a few months later.

Landscape from a construction kit

Cézanne later tried seven times to settle in Paris and escape from his father's strict regime. He had a studio there, where he lived in great poverty, and also took part in two exhibitions by Impressionist artists. But he soon noticed that he was not convinced by the Impressionist approach to painting.

Cézanne returned again and again to his father's country seat in his beloved home region. During the Franco-German War, he hid in the nearby fishing village of L'Estaque to avoid being called up. Some of his most beautiful pictures were produced here. Cézanne was not concerned about whether the subject of a picture was new. For example, he turned his attention to Mont Sainte-Victoire or still lifes with apples countless times. He minded less what he painted than how he painted it.

When Zola was already a famous writer he recalled Provence, which for him consisted of nothing but shapes and colours: "The gleaming white of the rocky mountains is muted by shades of yellow and brown, and the pines stand out against the red earth like green dots. The blue sky stretches like an endless ribbon high above the black edging of pines." Cézanne saw Provence in a similar way and that is just how he painted it, in broad strokes, with

brush and palette knife, composed of simple shapes and powerful colours, with no black and white.

The end of a boyhood friendship

Zola's novel *L'Oeuvre*, about a failed artist, appeared in 1886. Cézanne, who had yet to make a breakthrough, believed that his friend had based the novel's main character on him. Hurt by this, Cézanne broke off his friendship with Zola. Nor was he particularly interested in his own later fame in Paris, where he had previously been shunned. He fell ill, and became grumpy and lonely. He died after a last walk in Aix-en-Provence, as he had predicted: "I was born here, and I shall die here, too."

1839 Paul Cézanne born on 19 January in Aix-en-Provence
1852 Makes friends with the future novelist Émile Zola
1861 Cézanne moves to Paris for the first time
1869 Meets his lover Hortense Fiquet
1870 Lives in the fishing village of L'Estaque during the Franco-Prussian War
1872 Cézanne's son Paul born
1886 Breaks off contact with Émile Zola. Marries Hortense in April
1895 Cézanne's first major exhibition held in Paris
1900 His pictures are also shown in Germany
1906 Paul Cézanne dies on 22 October in his birthplace, Aix-en-Provence

MUSEUM AND INTERNET TIPS
Cézanne's studio can still be visited in Aix-en-Provence in the South of France. Many of the objects he painted in his still lifes are there:
www.atelier-cezanne.com

[above]
Cézanne on the hill at Les Lauves, 1905. Photograph by Émile Bernard

[left]
Boy with a Red Waistcoat, 1888–90. Oil on canvas, 79.5 x 64 cm. Privately owned, Switzerland

CLAUDE MONET

ÉDOUARD MANET

VINCENT VAN GOGH

1826 First photograph

1837 Victoria becomes queen of England

1871 German armies take Paris

ROMANTICISM 1790–1840 1790–1840 ROMANTICISM IMPRESSIONISM 1860–1915

| 1790 | 1795 | 1800 | 1805 | 1810 | 1815 | 1820 | 1825 | 1830 | 1835 | 1840 | 1845 | 1850 | 1855 | 1860 | 1865 | 1870 | 1875 |

Water Lilies, 1903. Oil on canvas,
73 x 92 cm. Musée Marmottan, Paris

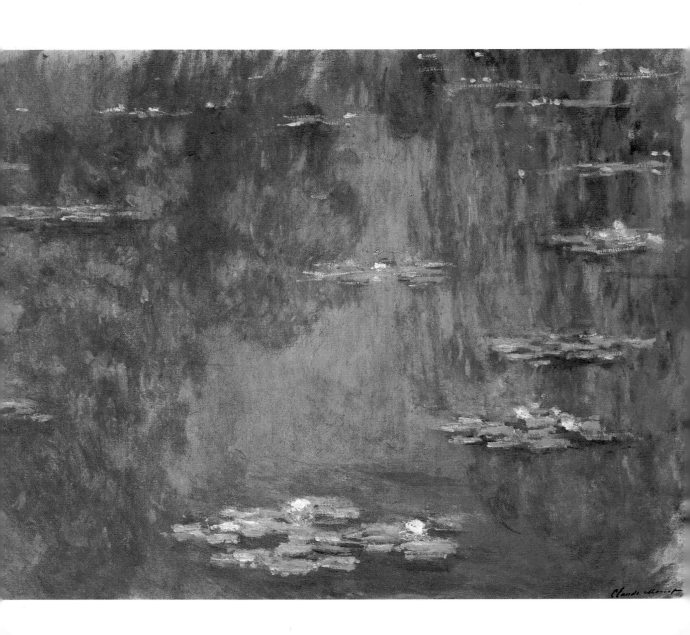

1887–1889 Eiffel Tower built in Paris
1888 *Sunflowers* (Vincent van Gogh)

1905/07 Die Brücke and Der Blaue Reiter
artists' associations founded

1914–1918 World War I

1921 Nobel Prize for Albert Einstein

1927 Charles Lindbergh flies across the Atlantic

1860–1915 IMPRESSIONISM CUBISM 1915–1920 EXPRESSIONISM 1920–1940 ABSTRACT EXPRESSIONISM 1940–1960

1880 1885 1890 1895 1900 1905 1910 1915 1920 1925 1930 1935 1940 1945 1950 1955 1960 1965

CLAUDE MONET

The French painter Claude Monet was more interested in sunlight than anything else. Capturing changing moods at various times of the day and year was more important to him than a photographically precise likeness of the world. It was a view that paved the way for Impressionism.

Monet was not exactly a model schoolboy. At least that is what he always liked to say later. If the sun seemed inviting, he preferred to go walking on the coast around the cliffs near the port of Le Havre, or swimming in the sea. Monet said that his life at the time was not sensible, but it was very healthy.

From his childhood days on, Monet was enchanted by the way light sparkled on water, by the gleam of summer on the reddish-green poppy meadows and golden-yellow fields of wheat, and by the play of shadows on façades or in the folds of a shimmering dress. When he moved to Paris to become a painter he tried to capture in his pictures the thousand facets of this glow and glitter.

Artistic beginnings as a caricaturist
Monet had drawn a lot even when he was at school, above all during lessons. If a teacher bored him he scribbled him in his writing or arithmetic book "in the most disrespectful fashion". He depicted him "as distortedly as possible", with a gigantic head on a tiny body.

Monet soon made a name for himself in Le Havre with these caricatures, and a lot of people bought his tiny portraits, which he displayed in a picture-framer's window. Later, he had to earn his living by selling caricatures, for his parents were not prepared to support his wish to become a professional painter. In 1861, Monet was called to military service and served in Algeria. He returned to France the following year after contracting typhoid. He said later that the impressions of light and colour he gained in Africa were what first trained his eye for his profession as a painter.

Painting in the open air
Back in France, Monet tried to capture the colours shimmering in the sunlight. He painted his pictures on the rugged Atlantic coast of Le Havre, in the forest of Fontainebleau, in the charming Argenteuil countryside or in the London docks, in sunshine or

wind, rain or snow. His pictures were not going to be created at home or in a studio, but in direct confrontation with nature, out in the open, in the fresh air.

Monet had a little houseboat built in Paris. He rowed out on to the Seine and painted its banks and portraits of people, their faces flecked with the sunlight reflected from the water. Monet was able to capture the delights of summer bathing, boating parties, coastal areas and regattas from an unusual angle by using his painting boat. This was not the custom of the time, and many artists turned up their noses disparagingly at Monet and his open-air painting colleagues.

Impressionism
The French Impressionists loved light. In good weather they would move out into the countryside or the city streets to capture – in the open air (French: plein air), in public squares, at racecourses or in parks – the glowing shimmer of sunlight falling through the leaves, the mist over the Seine, or the steam from a locomotive. They wanted to catch in pure colour the fleeting impression of the light at a certain time of day. They applied the paint to the canvas directly in rapid brushstrokes, without framing outlines. When viewed from close up, these paintings seem to dissolve into lines and dots again. It is only from a distance that an impressive picture emerge. Impressionism lasted from about 1860 to 1880. Important exponents included Auguste Renoir, Edgar Degas, Alfred Sisley and Édouard Manet; in Germany, Max Liebermann, Max Slevogt and Lovis Corinth. The movement is named after Monet's picture *Impression, Sunrise*, in which the painter captured the morning mist in the harbour at Le Havre.

1840 Claude Monet born on 14 November in Paris
1845 The Monet family moves to Le Havre
1856 Earns money with caricatures
1872 Paints river landscapes from his houseboat
1874 Monet's picture *Impression: Sunrise* features at the first Impressionist exhibition
1883 Rents a house in Giverny, where he lays out his famous garden
1897 Produces his first water-lily paintings in Giverny
1900 His eyesight declines increasingly through illness
1926 Claude Monet dies on 6 December in Giverny

MUSEUM AND INTERNET TIPS
The most extensive selection of Monet's work is to be found in the Musée Marmottan, Paris. The artist's house and garden can be visited at the Fondation Claude Monet in Giverny: www.intermonet.com

[above]
Claude Monet, December 1899.
Photograph by Nadar

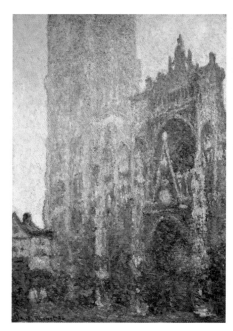

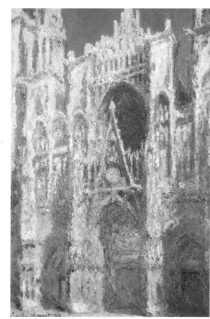

[left]
Rouen Cathedral: The Portal (Morning),
1894. Oil on canvas, 107 x 74 cm.
Fondation Beyeler, Riehen/Basel

[right]
The Portal (Sun), 1892. Oil on canvas,
100 x 65 cm. Private collection, USA

[below]
Impression: Sunrise, 1872. Oil on canvas,
48 x 63 cm. Musée Marmottan, Paris

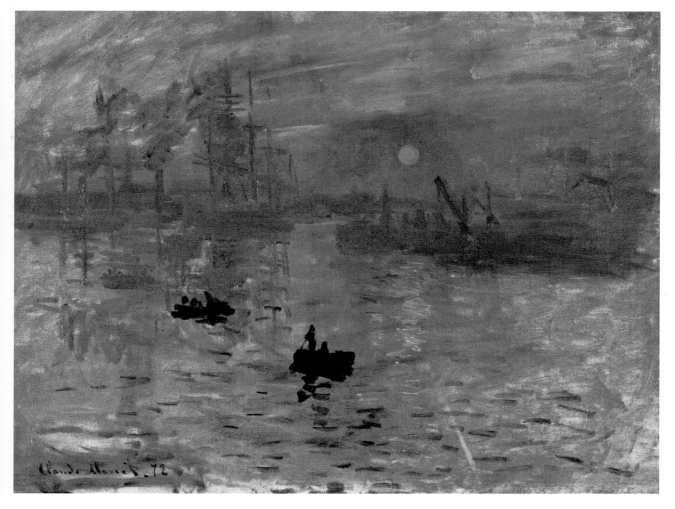

Impressionism comes into being

Monet's painting methods also drew scorn and mockery from his critics: he applied paint to the canvas directly from the tube, instead of mixing it on his palette first. He placed shades of colour together in bright blobs. Monet used this impressionistic style to paint locomotives in clouds of hot steam, river landscapes made up of snowflake points, delicately dabbed tulip fields in the spring breeze and colourful sunflower meadows. Not even the shadows in these pictures were black, but were made up of little dots and lines of pure colour. And even the winter snow in these pictures shows colour.

A stock of motifs from a garden

When Monet finally won recognition as a painter and was earning more money, he rented a house in the French village of Giverny. Here, he planted an enormous garden – a colourful sea of flowers and fruit trees, and a lily pond surrounded by weeping willows, and with a Japanese bridge over it. Monet captured this impression in more than 200 paintings, so fascinated was he by it: a brightly coloured carpet of water-lily dabs on a calm stretch of water, in which the sky and the trees are often hazily reflected, in white, light blue and olive green.

The Japanese Bridge, 1897–99. Oil on canvas, 90 x 90 cm. Princeton University Art Museum, Princeton

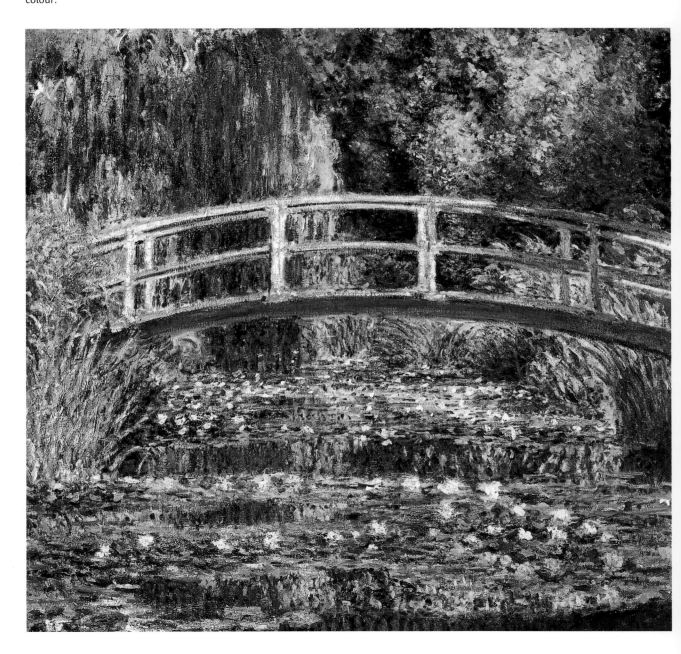

VINCENT VAN GOGH

CLAUDE MONET

GEORGES SEURAT

1826 First photograph

1857 *Madame Bovary* (Gustave Flaubert)

1871 German armies
take Paris

ROMANTICISM 1790–1840 1790–1840 ROMANTICISM IMPRESSIONISM 1860–1915

1790 1795 1800 1805 1810 1815 1820 1825 1830 1835 1840 1845 1850 1855 1860 1865 1870 1875

The Bridge at Langlois, 1888.
Oil on canvas, 54 x 65 cm.
Rijksmuseum Kroiller-Müller, Otterlo

1905/07 Die Brücke and Der Blaue Reiter artists'
associations founded

1887–1889 Eiffel Tower built in Paris **1914–1918** World War I

1895 First films shown **1921** Nobel Prize for Albert Einstein

1897–1899 *Water Lilies* (Claude Monet)

1860–1915 IMPRESSIONISM CUBISM 1915–1920 EXPRESSIONISM 1920–1940 ABSTRACT EXPRESSIONISM 1940–1960

| 1880 | 1885 | 1890 | 1895 | 1900 | 1905 | 1910 | 1915 | 1920 | 1925 | 1930 | 1935 | 1940 | 1945 | 1950 | 1955 | 1960 | 1965 |

VINCENT VAN GOGH

This late-Impressionist Dutch painter painted his most important pictures in the South of France. Vincent van Gogh's exuberantly colourful oeuvre came into being in fewer than ten years. He sold scarcely any pictures in his lifetime, but is today seen as one of the most important painters in the history of art.

For almost his entire life, van Gogh was afraid that he was incapable of painting properly. In one of his many letters to his beloved brother, Theo, he referred to his early drawings as "scribbles". Later, when Vincent was studying painting at the Academy he was actually put down a year, ostensibly because he was unable to draw. In fact, his rather clumsy early pictures do not show anything of his later ability. "You learn by working," he wrote to Theo, showing clear insight, "you become a painter by painting".

A long road to becoming a painter

Vincent had little luck throughout his life: he lost his job as an art dealer in a gallery after quarrelling with customers, and he was just as little suited to being a supply teacher or itinerant preacher. He had to rely on Theo's support until he died. Theo sent painting materials to his studio, as well as money. Even so, Vincent often had to choose between buying a hot meal or paint – usually opting for tubes of paint.

At first, Vincent depicted the poverty of peasants and farmworkers in dark, 'dusty' shades of colour. *The Potato Eaters* is a famous picture from this early period. Later, in Paris, he met many Impressionist painters and developed their discovery of light and colour further in his own style.

The colours of Provence

Vincent moved to Arles in 1888. Under the brilliantly blue sky of the South of France, he would walk, enthralled, through cornfields shimmering with light to capture the sunlit landscape. Vincent painted up to four pictures a week: portraits of friends and neighbours; landscapes with boats or apricot trees in bloom; stormy, starry nights with cypresses flickering to the sky; or still lifes with sunflowers in smouldering orange. He painted the southern landscape with thick, powerful, swirling brush strokes, in gleaming, warm shades of red and green, blue and orange, sulphurous yellow and purple: "You have to make sure that the big lines are in place at lightning speed," he wrote to Theo.

Van Gogh had always been a difficult person, but in Arles he was taken seriously ill. One day, after a violent quarrel with his painter friend Paul Gauguin, he even cut off a piece of his own ear. After this act of desperation he spent months in a psychiatric hospital in the small, southern French town of Saint-Rémy.

By the time he died, van Gogh had sold only one painting: people found his approach too strange. Before long, however, his art began to influence many young painters. Today, his paintings fetch high prices. The man who believed he could not paint is now not just one of the most important painters in the world, but also one of the most expensive.

1853 Vincent van Gogh born on
30 March in Zundert, Holland
1879 Goes to Cuesmes as an auxiliary
preacher and begins drawing
1882 Takes painting lessons in the
The Hague
1886 Moves to Paris and meets the
Impressionists
1888 Travels to Arles in the South of
France and finds his unmistakable
style there
1888 Paul Gauguin visits van Gogh in his
yellow house
1889 Van Gogh is admitted to the
psychiatric hospital in Saint-Rémy
1890 Sells an oil painting at an
exhibition for the first time
1890 Vincent van Gogh dies on 29 July
in Auvers-sur-Oise.

MUSEUM AND INTERNET TIPS
You can learn a great deal about the artist in the Van Gogh Museum in Amsterdam. It has the largest collection of his works in the world. You can also visit it at www.vangoghmuseum.nl

[above]
Self-portrait with Bandaged Ear (detail),
1889. Oil on canvas, 60 x 49 cm. Courtauld Art Institute Galleries, London

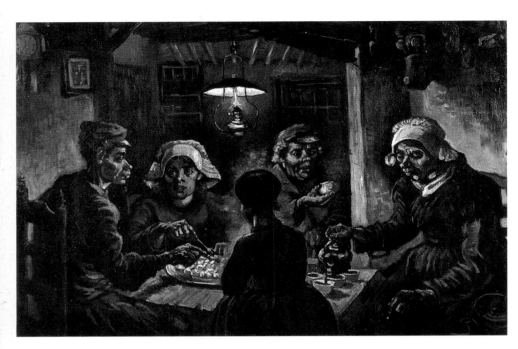

[left above]
The Potato Eaters, 1885.
Oil on canvas, 82 x 114 cm.
Van Gogh Museum, Amsterdam

[left below]
Cornfield with Crows, 1890.
Oil on canvas, 50.5 x 103 cm.
Van Gogh Museum, Amsterdam

[right]
Vase with Sunflowers, 1888. Oil on canvas,
91 x 72 cm. Neue Pinakothek, Munich

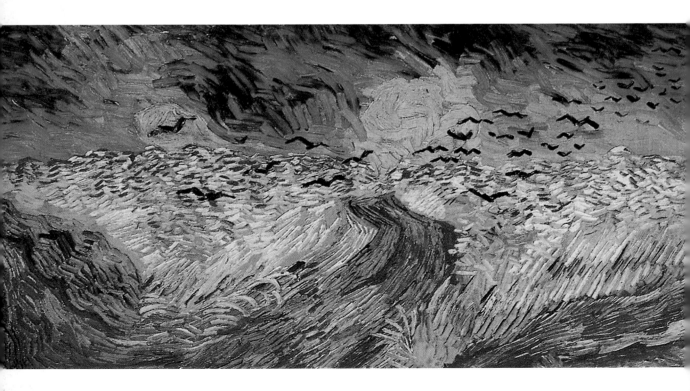

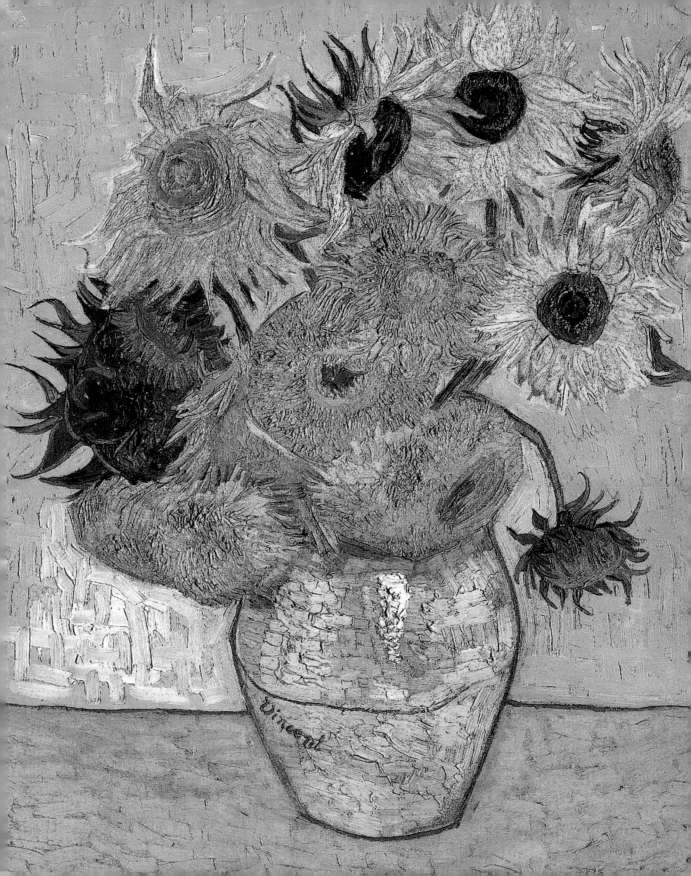

1826 First photograph

1857 *Madame Bovary* (Gustave Flaubert)

1871 German armies take Paris

ROMANTICISM 1790–1840 1790–1840 ROMANTICISM IMPRESSIONISM 1860–1915

1790 1795 1800 1805 1810 1815 1820 1825 1830 1835 1840 1845 1850 1855 1860 1865 1870 1875

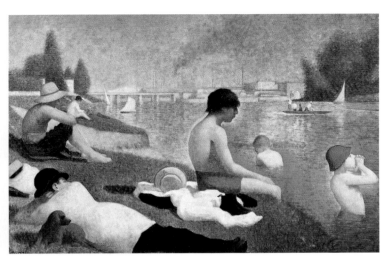

[above]
Bathers at Asnières, 1883/84. Oil on canvas, 201 x 300 cm. National Gallery, London

[below]
La Grande Jatte, 1884–86. Oil on canvas, 206 x 306 cm. The Art Institute of Chicago

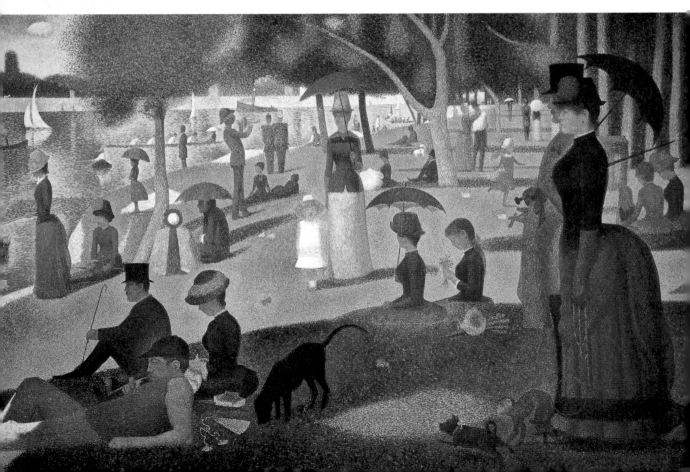

1905/07 Die Brücke and Der Blaue Reiter
artists' associations founded

1887–1889 Eiffel Tower built in Paris

1888 *Sunflowers* (Vincent van Gogh) **1914–1918** World War I

1897–1899 *Water Lilies* (Claude Monet) **1921** Nobel Prize for Albert Einstein

1860–1915 IMPRESSIONISM CUBISM 1915–1920 EXPRESSIONISM 1920–1940 ABSTRACT EXPRESSIONISM 1940–1960

| 1880 | 1885 | 1890 | 1895 | 1900 | 1905 | 1910 | 1915 | 1920 | 1925 | 1930 | 1935 | 1940 | 1945 | 1950 | 1955 | 1960 | 1965 |

GEORGES SEURAT

The inventor of Pointillism achieved a hitherto unknown luminosity and harmony in his paintings dab by dab. With his new painting technique, the French painter Seurat laid the foundations for Neo-Impressionism.

"He is one of those good-natured, stubborn people who seem anxious but in reality are not afraid of any challenge," a contemporary once wrote about this taciturn painter. After his painting *Bathing at Asnières* had been rejected by the Salon, Seurat simply turned his back on this springboard that was so important for artists at the time and joined a group of young and independent painters. They called themselves Artistes Indépendants, and held their first exhibition in a shabby hovel in Paris on 15 May 1884. It was a financial disaster, but suddenly Seurat's new painting technique was the talk of the town.

Hard work and success

Seurat found the admiration he enjoyed in Parisian artistic circles an appropriate acknowledgement of his intelligence, but also of his hard, dogged approach to work. His colleagues and the critics both saw the introverted painter as a true innovator, who had taken Impressionism a step further by developing Pointillism.

While criticism and sycophantic praise of his paintings left him relatively cold, Seurat did all he could to leave no doubt about Pointillism as intellectual property. The painter guarded the details of his theory jealously. The fact was that Seurat left nothing to chance on a canvas. He planned his enormous works far in advance, made thousands of sketches and devised the pictures down to the last detail. For his picture *La Grande Jatte* he went to the Seine island of the same name every morning over a period of months and sketched the visitors. Then, in the afternoons, he worked his new impressions and ideas through on his canvas. Finally, he set one dab of paint next to another, aware that the tiny dots would merge to form a whole in the viewer's mind, without losing any of their luminosity and intensity. Thanks to this method, Seurat's typically Impressionist motifs – summer landscapes, harbour and coastal scenes –

convey a harmony that scarcely any other artist has achieved. But when one looks more closely at the people in Seurat's pictures, it is clear, despite all the harmony, that these people often seem isolated, still and mute. An echo of this isolation is to be found even in the otherwise light-hearted circus pictures that the artist painted shortly before he died.

The secret family

Seurat's appearance is said to been as immaculate and correct as a supervisor in a department store, and his sharp-tongued painter colleague Degas called him the "notary". Seurat was so reserved that he did not introduce his small family even to his mother until only a few days before his early death, at the age of 31. He had moved in secretly with the model Madeleine Knoblock two years earlier. Their son, Pierre-Georges, was born in 1890.

1859 Georges-Pierre Seurat born on 2 December in Paris
1878 Student at the École des Beaux-Arts
1879 Military service in Brest
1884 *Bathers at Asnières* is rejected by the Salon. Seurat becomes a co-founder of the Société des Artistes Indépendants
1886 Shows *La Grande Jatte* for the first time
1890 His partner, Madeleine Knoblock, gives birth to a son
1891 Seurat dies on 29 March in Paris, presumably of meningitis

Pointillism

The painting technique called Pointillism, developed by Georges Seurat, is similar to the image composed of many thousands of pixels on a television screen. The paintings are also made up of countless dots of colour, dabbed laboriously on to the canvas. The brain then scans these 'points', the tiny dots, and understands them as areas of colour and motifs by optical mixing. Seurat's friend Paul Signac also devoted himself to this technique to a considerable extent, and some other artists adopted it later. But Pointillism is a relatively rigid process, and this put a stop to further development of this painting technique.

[above]
Georges Seurat. Photograph

1871 German armies take Paris

1826 First photograph

1886 First cars with
petrol engines

1790–1840 ROMANTICISM IMPRESSIONISM 1860–1915

| 1800 | 1805 | 1810 | 1815 | 1820 | 1825 | 1830 | 1835 | 1840 | 1845 | 1850 | 1855 | 1860 | 1865 | 1870 | 1875 | 1880 | 1885 |

1905/07 Die Brücke and Der Blaue Reiter
artists' associations founded **1933** Hitler becomes Chancellor, later Führer

1888 Sunflowers (Vincent van Gogh)
1895 First films shown **1914–1918** World War I
1921 Nobel Prize for Albert Einstein

1860–1915 IMPRESSIONISM CUBISM 1915–1920 EXPRESSIONISM 1920–1940 ABSTRACT EXPRESSIONISM 1940–1960 POP ART 1960–1975

1890 1895 1900 1905 1910 1915 1920 1925 1930 1935 1940 1945 1950 1955 1960 1965 1970 1975

GUSTAV KLIMT

The Austrian painter Gustav Klimt created the face of Viennese Jugendstil with his portraits. His most famous picture, the golden-glowing painting The Kiss, *is also the most important of this period. Although he is best known for his portraits of women, Klimt's landscapes are also enchanting.*

Klimt did good business with art even as a child. At the age of fifteen he was already creating portraits from photographs, working with his brother Ernst, with whom he later produced a number of paintings as state commissions. Even though Klimt's style became increasingly more 'unrealistic' when painting clothes and backgrounds, he usually painted the faces of his subjects with photographic accuracy to the end.

Klimt always worked on several pictures at the same time, and each one had to turn out perfect. When he died, he left behind an unfinished painting called *The Bride*, which shows how he went about his work: first he painted people naked, then dressed them – in gold and pure colour.

Klimt's fame was due to his beautiful portraits of distinguished women in elegant clothes. His pictures of grimly-staring snake-women or water-nymphs had much less appeal in Vienna. Whenever Klimt had had enough of criticism and mockery or the hurly-burly of the big city he would move into the countryside to recuperate. He walked around the Attersee like the loner he was, wearing his wide, painter's smock and grumpily looking for subjects, then filling square canvases with blossoming expanses of sunflowers, pear trees and poppy fields.

Co-founder of the Vienna Secession

The professors of painting at the Vienna art college also found Klimt's magnificently coloured pictures with their ornate circles and undulating lines rather too novel and too sensual. As Klimt himself was refused a professorship, he and like-minded colleagues founded their own association for new art, the Secession, which suggests a splitting away. Klimt became the first president of the Secession. The architect Joseph Maria Olbrich built the group their own building in Vienna, with a golden dome reminiscent of a temple. Klimt decorated one of the rooms with a gigantic frieze dedicated to the

composer Ludwig van Beethoven and his Ninth Symphony. Here, Klimt portrayed man's eternal longing for happiness and the threat to his dreams from sickness, madness and the forces of death. A couple embracing passionately features in the cheerful section of the *Beethoven Frieze*. This alludes to Beethoven's symphony, where an enormous choir thunders the portentous words "Freude, schöner Götterfunken. Diesen Kuss der ganzen Welt" (Joy, beautiful spark of the gods. This kiss to the whole world). A kiss is also the motif for what is probably Klimt's best-known picture: in the large-format painting *The Kiss*, the painter shows the 'insurmountable' differences between man and woman – an important subject for Jugendstil. The 'angular' man is wearing a robe with rectangular ornaments in black and white, whereas the 'soft' woman's dress is flower-like, with colourful circles.

Jugendstil
Architects, painters and sculptors, but also cabinetmakers, glass artists and jewellers, were all fired by decorative Jugendstil around 1900. Everything was intended to become fresher and more imaginative, younger and more lively than the dull and dusty art produced by the academies. Decorative ornaments, reminiscent of flowers and squiggles, were popular in works of art and on furniture. The movement was called Secession in Vienna, and in Paris, where it originated, it was known as Art Nouveau. Important exponents of the Europe-wide movement were Aubrey Beardsley in England, Antoni Gaudí in Spain, Henry van de Velde in Belgium and Franz von Stuck in Germany.

1862 Klimt born on 14 July in the village of Baumgarten near Vienna
1876 Attends the Vienna Kunstgewerbeschule
1886 Produces pictures for the Burgtheater in Vienna with his brother Ernst
1893 The minister of culture refuses him a professorial chair
1897 Klimt and friends found the Secession
1898 Landscape at the Attersee becomes a theme
1902 Klimt paints the *Beethoven Frieze* in the Secession building. Auguste Rodin is impressed
1910 Participates successfully in the Venice Biennale
1918 Klimt dies in Vienna on 6 February after a stroke

MUSEUM AND INTERNET TIPS
Many of Klimt's works are now to be found in the Österreichische Galerie Belvedere in Vienna. You can also visit the artist's last studio at 11 and 15a Feldmühlgasse in Vienna, information at www.klimt.at

[above]
Klimt outside his studio in his garden in Josefstädterstraße, c. 1912/14. Photograph

[left]
The Kiss, 1907/08. Oil, silver and gold applied to canvas, 180 x 180 cm. Österreichische Galerie Belvedere, Vienna

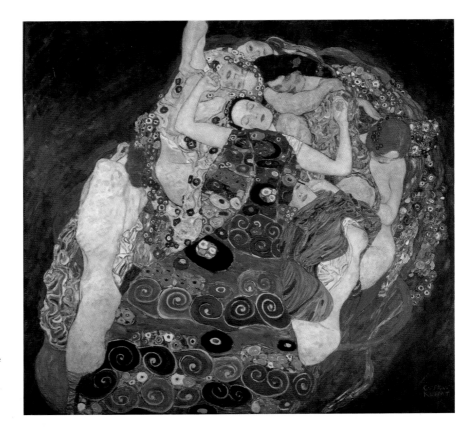

[right]
The Virgin, 1913. Oil on canvas,
190 x 200 cm. National Gallery, Prague

[below]
Detail from the *Beethoven Frieze*, 1902.
Casein paint on stucco ground,
220 x 636 cm. Österreichische Galerie
Belvedere, Vienna

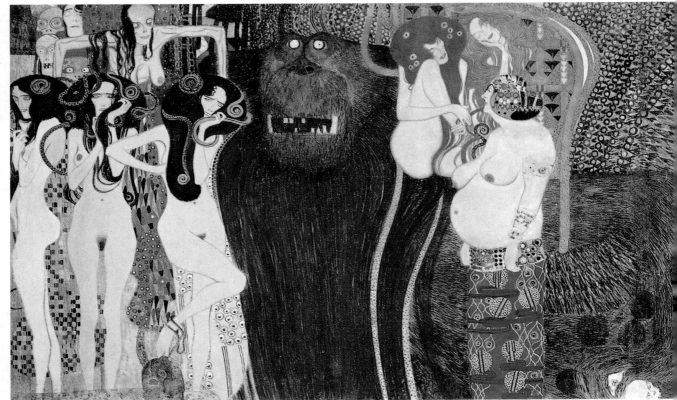

Mountain Slope at Unterach on the Attersee, 1916. Oil on canvas, 110 x 110 cm. Private collection

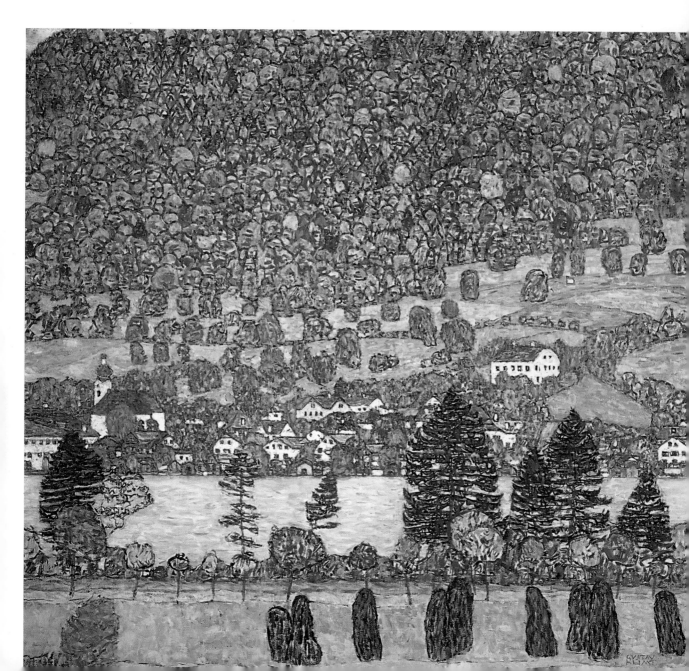

1840 * Peter Tchaikovsy **1871** German armies take Paris

1895 First films shown

1790–1840 ROMANTICISM **IMPRESSIONISM 1860–1915**

1815 1820 1825 1830 1835 1840 1845 1850 1855 1860 1865 1870 1875 1880 1885 1890 1895 1900

Improvisation 26 (Rudern), 1912. Oil on
canvas, 97.2 x 107.5 cm. Städtische
Galerie im Lenbachhaus, Munich

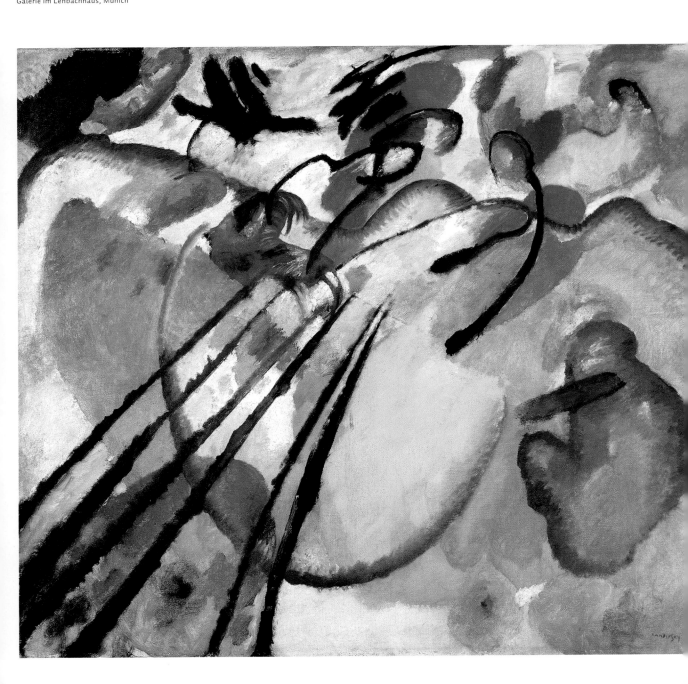

1905/07 Die Brücke and Der Blaue Reiter artists' associations founded

1914–1918 World War I

1927 Charles Lindbergh flies across the Atlantic

1933 Hitler becomes Chancellor, later Führer

1937 Degenerate Art exhibition in Munich

1939–1945 World War II

1860–1915 IMPRESSIONISM CUBISM 1915–1920 EXPRESSIONISM 1920–1940 ABSTRACT EXPRESSIONISM 1940–1960 POP ART 1960–1975

1905 1910 1915 1920 1925 1930 1935 1940 1945 1950 1955 1960 1965 1970 1975 1980 1985 1990

WASSILY KANDINSKY

The Russian painter Wassily Kandinsky was a co-founder of the Munich group of artists called 'Der Blaue Reiter'. He made colour and form into subjects for pictures in their own right, thus changing our view of art for ever.

When Kandinsky thought back to his Russian birthplace, Moscow, from Munich it was the colours there that came to him first. The painter once said that, as he remembered it, "The sun melts the whole of Moscow into a single patch of colour: pistachio-green, flame-red houses, churches – each colour a song in its own right." 'Patches' like this crop up frequently in Kandinsky's work.

The disappearance of things

Kandinsky moved into a house in Murnau, near Munich, with the painter Gabriele Münter, with whom he also travelled a great deal. This village with its red roofs, gleaming white church and green fields under a brilliantly blue sky seems to have reminded Kandinsky of the colours of his childhood. They suddenly reappear in his work and begin to take on a life of their own, to the point where the objects in the picture ultimately have no part to play at all. People, towers, fir trees, hills and churches sink into a sea of yellow and blue and red in his pictures, into a pure 'realm of colour'. What is left are shades and shapes that are no longer reminiscent of reality.

Kandinsky's picture titles often suggest the things that might be found in them: *Landscape with Tower*, for example, or *Gendarme*. In the picture *Improvisation 26 (Rowing)* it is still possible to make out two shadowy figures in the boat and the dark lines of the long oars, seeming to sink into a sea of colour. Kandinsky often called his paintings and watercolours simply *Composition*, *Yellow-Red-Blue* or *Little Worlds* – and, in fact, they are ultimately meant to be little worlds in their own right.

Painter, author and teacher

Kandinsky created compositions, as many of his pictures are called, from shapes and colours: they are intended to sound harmonious or dramatic, like a piece of music that makes us feel a particular emotion, but by using lines, geometrical figures or patches of colour instead of notes. This was the birth of abstract painting. What Kandinsky intended to achieve by this is explained in his book *Über das Geistige in der Kunst*.

Kandinsky founded the artists' group 'Der Blaue Reiter' with Franz Marc in Munich; it included Gabriele Münter, Alexei Jawlensky and Paul Klee. These artists painted pictures as pictures, not as portrayals of something that really existed outside the pictures. Later, too, as a teacher at the Bauhaus, Kandinsky passed this idea on to his students. After the Bauhaus was closed by the National Socialists, who later exhibited Kandinsky's paintings as 'degenerate art', the artist fled to France and settled in Neuilly-sur-Seine, near Paris.

1866 Wassily Kandinsky born on 4 December in Moscow
1896 Decides to become an artist and moves to Munich
1909 Lives with Gabriele Münter in Murnau
1910 Paints his first abstract watercolour
1911 Founds the 'Der Blaue Reiter' group of artists with Franz Marc
1912 His essay *Über das Geistige in der Kunst* (About the Spiritual in Art) appears
1922 Kandinsky becomes professor at the Bauhaus in Weimar and Dessau
1928 Becomes a German citizen
1937 The National Socialists confiscate his pictures as "degenerate art"
1939 Kandinsky acquires French citizenship
1944 Dies on 13 December in Neuilly-sur-Seine

MUSEUM AND INTERNET TIPS
Thanks to a donation from Gabriele Münter, the Städtische Galerie im Lenbachhaus in Munich has an important collection of Kandinsky's work: www.lenbachhaus.de

[above]
Kandinsky in Ainmillerstrasse, Munich, June 1913. Photograph

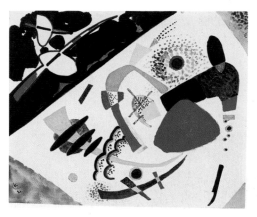

[left]
Design for Red Patch II, 1921. Watercolour on paper, 19.1 x 22.9 cm. museum kunst palast, Düsseldorf

1887–1889 Eiffel Tower
built in Paris

1905/07 Die Brücke and
Der Blaue Reiter artists
associations founded

1790–1840 ROMANTICISM IMPRESSIONISM 1860–1915 1860–1915 IMPRESSIONIS

| 1825 | 1830 | 1835 | 1840 | 1845 | 1850 | 1855 | 1860 | 1865 | 1870 | 1875 | 1880 | 1885 | 1890 | 1895 | 1900 | 1905 | 1910 |

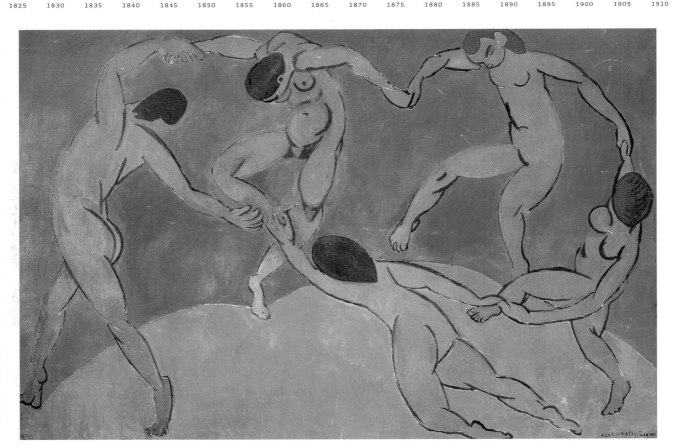

[above]
The Dance, 1909/10. Oil on canvas,
260 x 391 cm. State Hermitage Museum,
St. Petersburg

[right]
Harmony in Red, 1908. Oil on canvas,
180 x 220 cm. State Hermitage Museum,
St. Petersburg

1914–1918 World War I 1939–1945 World War II 1955 Beginnings of Pop art
 1927 Charles Lindbergh flies across the Atlantic 1969 US moon landing
 1937 *Guernica* (Picasso) 1945 Atomic bombs dropped
 on Hiroshima and Nagasaki
 CUBISM 1915–1920 EXPRESSIONISM 1920–1940 ABSTRACT EXPRESSIONISM 1940–1950 POP ART 1960–1975

1915 1920 1925 1930 1935 1940 1945 1950 1955 1960 1965 1970 1975 1980 1985 1990 1995 2000

HENRI MATISSE

The French artist Henri Matisse transformed the visible world into simple, two-dimensional forms full of lightness and poetry in his intensely coloured pictures, drawings and sculptures. He was one of the most important exponents of modern art.

One day, when Henri was still a child and sick in bed, his mother gave him a paintbox to help pass the time. The love he developed for the pure colours red, yellow, green and blue remained with him for ever. The Impressionist painters wanted to capture sunlight on their canvases – for Matisse, the colours had to glow in their own right. The importance of colour can also be seen in his picture *The Served Table (Harmony in Red)*. The colour and pattern of the wallpaper and the tablecloth are the same, and they create an impression of ornaments proliferating like trees on a red surface. The woman is composed of simplified shapes with blurred hands, and seems like a foreign body placed in this space. On the left of the picture is a chair with a woven seat of the kind painted by the Dutch artist Vincent van Gogh, whose paintings impressed Matisse with their showers of colour.

Take-home Tahiti

A visit to Tahiti provided Matisse with the inspiration for many of his pictures. Like a diver waiting on a coral bed for colourful fish, Matisse was 'after colour' on this South Sea island with its shimmering underwater world and the colourful fabrics and garments of its inhabitants. He was so overwhelmed by this splendour that there were times when he was unable to paint, and could but look and be amazed. He once said: "These pictures in lively, dazzling colours crystallised from memories of the circus, traditional fairy tales and journeys."

Later, when he was confined to his bed after an operation, Matisse created his own private Tahiti. The underwater island world, its jellyfish and coral shapes, came into being in the middle of his home in a former hotel on the French coast. Matisse was extremely inventive: he painted the walls while lying down, with an elongated paintbrush he had made himself, or stuck colourful paper silhouettes on to it.

Drawing with scissors

When Matisse's arm had grown stiff from painting on the high walls, he laid aside his brush and carried on instead with scissors and coloured paper, cutting out pictures for himself. Suddenly, flowers and leaves, women skipping and men swimming, starfish and seaweed appeared from a sea of colour. Just as a musician composes a tune note by note, Matisse composed his shapes into pictures. He pushed the round and angular, curved and jagged shapes to and fro until they produced a picture he liked. Matisse also published his cut-out silhouettes in book form. He named the work after the exuberant music that was popular in France at the time: *Jazz*.

Fauvism

Henri Matisse, André Derain and Maurice de Vlaminck exhibited their innovative paintings in Paris in 1905. Some visitors to the exhibition found their bright pictures with their shrill colours and simplified forms much too gaudy. One visitor said scornfully that the artists painted like wild animals (French: fauves). And so, without meaning to, he gave the new style its name: Fauvism. Other famous Fauvists from France were Georges Rouault and Georges Braque, who later invented Cubism with Pablo Picasso.

1869 Henri Matisse born on 31 December in Le Cateau-Cambrésis
1890 Begins painting when confined to bed after an appendicitis operation
1898 Marries Amélie Parayre, and has a daughter with her. Two sons are born later
1905 The Fauves hold their first exhibition in Paris
1912 Matisse travels to Morocco
1930 Travels to Tahiti
1936 Discovers the silhouette as an art form
1938 Moves into an apartment in the former Hotel Régina near Nice
1940 Amélie and Matisse separate
1954 Henri Matisse dies on 3 November in Nice

MUSEUM AND INTERNET TIPS
The Musée Matisse in his birthplace, Le Cateau-Cambrésis, is dedicated to the artist. There is another Matisse museum in Nice, not far from his last home in the Hotel Régina:
www.musee-matisse-nice.org

[above]
Henri Matisse in Nice, 1953.
Photograph by Hélène Adant

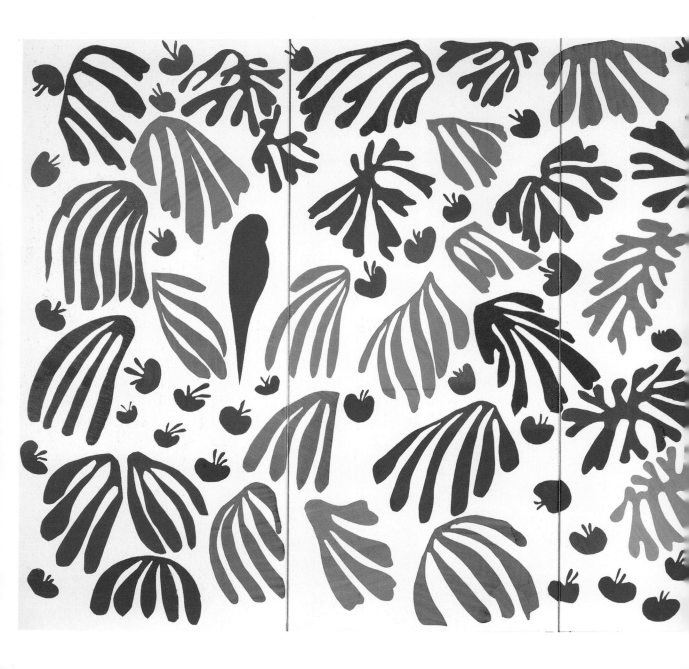

The Parrot and the Mermaid, 1952/53.
Cut papers painted with gouache,
337 x 773 cm. Stedelijk Museum,
Amsterdam

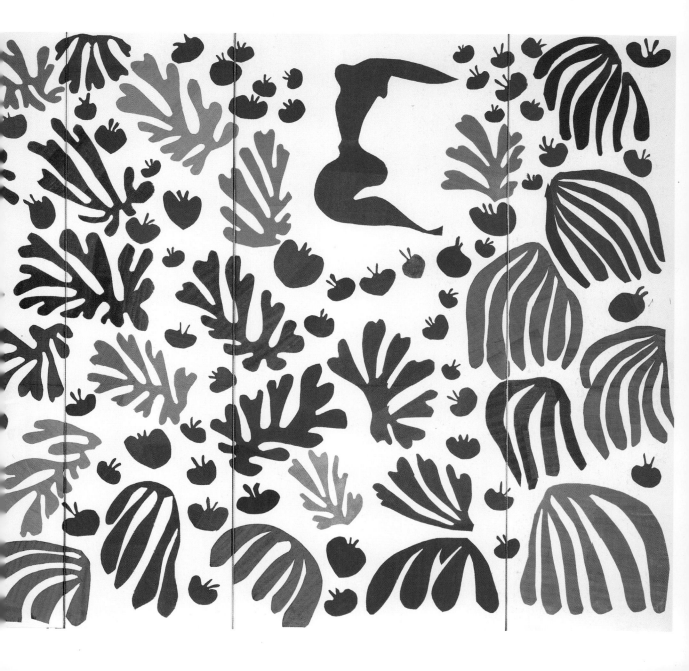

1886 First cars with
petrol engines

1905/07 Die Brücke and Der Blaue Reiter
artists' associations founded

1894 Reichstag completed
in Berlin

1900 *The Interpretation of
Dreams* (Sigmund Freud)

1790–1840 ROMANTICISM **IMPRESSIONISM 1860–1915** **1860–1915 IMPRESSIONISM**

1825 1830 1835 1840 1845 1850 1855 1860 1865 1870 1875 1880 1885 1890 1895 1900 1905 1910

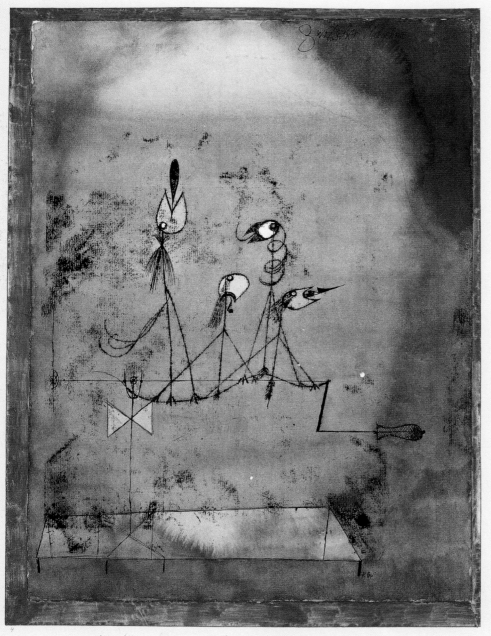

The Twittering Machine,
1922, 151. Transfer drawing
and watercolour on paper
mounted on board,
41.3 x 30.5 cm. The Museum
of Modern Art, New York,
Mrs John D. Rockefeller
Jr. Purchase Fund

1914–1918 World War I
1939–1945 World War II
1933 Hitler becomes Chancellor, later Führer
1960 John F. Kennedy becomes president of the USA
1937 Degenerate Art exhibition in Munich

CUBISM 1915–1920 EXPRESSIONISM 1920–1940 ABSTRACT EXPRESSIONISM 1940–1960 POP ART 1960–1975

1915 1920 1925 1930 1935 1940 1945 1950 1955 1960 1965 1970 1975 1980 1985 1990 1995 2000

PAUL KLEE

After discovering the colours of Africa for himself, the Swiss painter and draughtsman Paul Klee composed a cheerful world of his own on the 'colour piano' of his palette and watercolours. Klee is an important Bauhaus figure and representative of abstract art.

Even as a child, Paul Klee, the son of a music teacher and a singer, could play the violin. But there were also many painters in his family, and Klee inherited his drawing talents from them. Whenever he was bored at school, he would scribble illustrations to fairy tales in his exercise books. And that was not all – he was a talented poet, too. He later opted for painting and moved to Munich, where he became a member of the artists' group 'Der Blaue Reiter'. But Klee never completely stopped writing poetry, and he also kept up his music, even joining the Berne city orchestra later. He met his wife, a pianist, at a music-making session.

Trip to Africa

It can be said that, in a way, Paul Klee always remained a musician, even when he was a draughtsman. He wanted his pen and brush to move over his pictures like a tune. In 1922, when Klee was already in demand as an artist, and teaching at the Bauhaus school of arts and crafts in Weimar, he once said that a painted line in a picture should go for a "walk" on the paper, leaping around aimlessly.

Shortly before the outbreak of World War I, Klee travelled to Tunisia with his painter friends August Macke and Louis Moilliet. The North African landscape with its Bedouin people, camels and palm trees seemed to Klee like a new and mysterious world, like a fairy tale from *A Thousand and One Nights*: colourful bazaars with delicious smells, houses with domed roofs, people in magnificent clothes.

Discovering colour

Klee, who had previously created pictures with lines and strokes in black and white, discovered colour in Africa. "The bushes make a fine patchwork rhythm," he noted in his diary, and he wanted to reproduce that rhythm in his watercolours. Just as he had previously composed with lines, he now

composed with the help of his watercolours. After this journey, colour never let go of Klee, not even during his period as a soldier in World War I. "Colour has got me," he therefore wrote, "I do not need to go out and catch it. It has got me for ever, I know. That is the meaning of this happy hour, I and colour are one. I am a painter."

In his pictures, Klee created a whole series of new worlds, usually cheerful ones, with transparently shimmering fish, strange jungles, dancing matchstick figures, mysterious plants and airy spirits, ships, houses and animals. They are all part of Klee's colour orchestra, which does not consist of violins, percussion and trumpets, but of squares, triangles, arrows and circles. In the oil painting called *The Twittering Machine*, four little matchstick-bird-fishmen are on their perches, trilling away at the tops of their voices. The creatures are sitting on a crank handle – as though it has to be turned to make them sing.

In his later years, Klee painted large-format pictures, often using very few lines, with broad brushstrokes: like a new kind of musical notation.

1879 Paul Klee born on 18 December in Münchenbuchsee near Berne
1898 Moves to Munich, where he studies art
1903 Produces his first etchings
1911 Shows his pictures in the 'Blauer Reiter' galleries
1914 Travels to Tunisia with his painter friends August Macke and Louis Moilliet
1917 Klee is called up into the armed forces
1920 Becomes a teacher at the Bauhaus
1924 An exhibition of his pictures is shown in New York
1937 Seventeen works by Klee feature in the Nazi *Degenerate Art* exhibition in Munich
1940 Paul Klee dies on 29 June in Locarno-Muralto

MUSEUM AND INTERNET TIPS
The Paul-Klee-Zentrum in the artist's birthplace is dedicated to presenting and promoting his work:
www.paulkleezentrum.ch

[above]
Paul Klee with his cat Bimbo, Berne, 1935. Photograph. Paul Klee Zentrum, Bern, gift

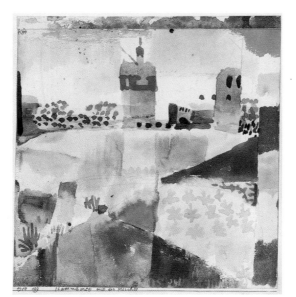

[right]
Hammamet with its Mosque, 1914.
Watercolour and pencil on paper
mounted on board, 20.6 x 19.4 cm.
The Metropolitan Museum of Art, New
York, The Berggruen Klee Collection

[below]
Landscape with Yellow Birds, 1923, 32.
Watercolour on paper mounted on
board, 35.5 x 44 cm. Private collection,
Switzerland

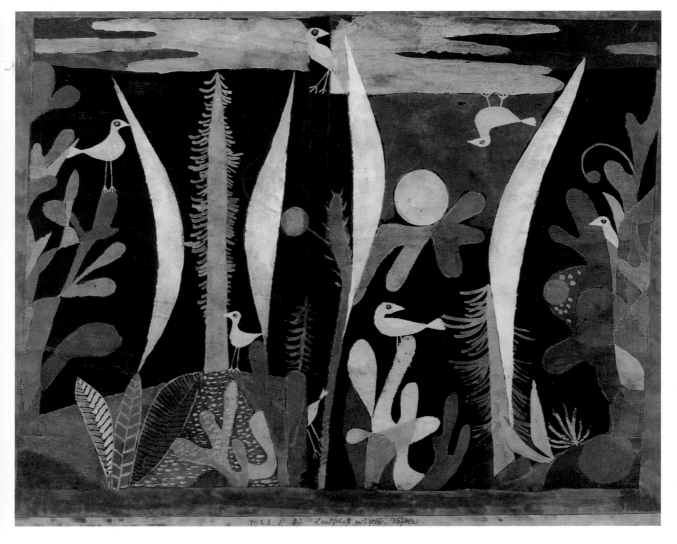

1886 First cars with petrol engines

1914–1918
World War I

IMPRESSIONISM 1860–1915

1860–1915 IMPRESSIONISM CUBISM 1915–1920

| | | | | | | | | | | | | | | | | | |
1835 1840 1845 1850 1855 1860 1865 1870 1875 1880 1885 1890 1895 1900 1905 1910 1915 1920

Les Demoiselles d'Avignon, 1907.
Oil on canvas, 243.9 x 233.7 cm.
Museum of Modern Art, New York

PABLO PICASSO

Even in his younger days, the Spanish artist Pablo Picasso could paint like an old master. He said that by the age of ten he was unable to scribble like a child. His father, a drawing teacher and animal painter, was highly enthusiastic about Pablo's realistic and perfect pictures. Picasso himself thought they were pretty terrible in retrospect. He still had to learn to paint like an uninhibited child: "You need a lot of time to become young."

Picasso wanted to draw even a simple cock differently from the artists of his day, who were committed to realism: "There have always been cocks. It is just a matter of discovering them, like the rest of life." So Picasso's life in general can be seen as an attempt to rediscover life, animals, people and simple things all the time – and with a child's curiosity.

For Picasso, depicting ordinary life in an unusual way first meant capturing the world of poor people, beggars and circus artistes in sad-blue and pink shades, hence allusions to his 'Blue Period' and his 'Pink Period'. At this time, Picasso had so little money himself that he sometimes had to use his own pictures and drawings as fuel for the stove to heat his Paris studio.

The invention of Cubism

Later, discovering the world, to Picasso, meant rearranging it in his paintings. In *Les Demoiselles d'Avignon*, the five women featured are reduced to simple forms and colours. The face of the woman sitting on the right is captured front-face and in profile at the same time. Increasingly, Picasso dissected objects into different geometrical shapes on the canvas, using triangles, circles and cubes. That is why this way of representing things, which Picasso and his friend Georges Braque invented in Paris, is called Cubism. But Picasso was soon looking for a different way of painting.

Ladykiller and father

Temperamental and imperious as he was, Picasso broke a lot of hearts. He produced countless portraits of his wives and mistresses, changing his style all the time: Picasso was not just extraordinarily hard-working, but also extremely imaginative. He often portrayed women, particularly his partner Marie-Thérèse Walter, the photographer Dora Maar and his last wife, Jacqueline Rocque. Picasso usually tried to capture moods. He painted the women as

he saw them: sometimes sad and weeping, sometimes ranting and raving, sometimes calm and absorbed in a good book; and he put them together like that in shape and colour.

Picasso had four children: Paolo, Maya, Claude and Paloma, which means 'dove' in Spanish. Doves play a major part in Picasso's picture, along with other creatures. In 1949, the year Paloma was born, he created his world-famous poster with a dove as a symbol of peace. Picasso loathed war. One of his most important pictures, *Guernica*, is a moving indictment of the destruction and annihilation wrought by war. The work was inspired by the air raid on the small Spanish town of Guernica by German aircraft in the Spanish Civil War.

Art for children

Picasso also sawed and painted toy dolls for his children. From two cars the art dealer Henry Kahnweiler had given to his son Claude, he con-

Cubism

From the Renaissance onwards, artists had tried to create the illusion of depth in canvases with the aid of central perspective. Pablo Picasso and Georges Braque did away with this in Paris around 1907. They deliberately emphasised the two-dimensional quality of their pictures, and simply broke down the faces, musical instruments, jugs and architecture depicted in their portraits and still lifes into flat circles, triangles and squares. The movement was then named after these squares (cubes). Paul Cézanne had started to do something similar, but these young artists were more radical than he had been. Early Cubism is called analytical (dissecting). Later, there emerged synthetic (assembling) Cubism, which composed geometrical forms into new figure-collages. Other famous Cubists were Robert Delaunay, Juan Gris, Fernand Léger and Marcel Duchamp.

1881 Pablo Picasso born on 25 October in Málaga
1901 Start of the 'Blue Period'
1904 Moves to Montmartre artists' quarter. Start of the 'Pink Period'
1907 Develops Cubism with Georges Braque
1918 Picasso marries the dancer Olga Koklowa
1921 Their son Paolo is born
1927 Meets Marie-Thérèse Walter and leaves Olga
1935 His daughter Maya is born
1936 Dora Maar becomes Picasso's mistress
1946 Françoise Gilot becomes Picasso's partner; he has two children with her: Claude and Paloma
1953 Picasso meets Jacqueline Rocque, whom he marries in 1961
1973 Picasso dies on 8 April in Mougins near Cannes

READING AND MUSEUM TIPS
Olivier Widmaier Picasso, *Picasso. The Real Family Story*, Munich 2004. The Museum Ludwig in Cologne has an important Picasso collection. There are five museums dedicated exclusively to Picasso's work. The Museu Picasso in Barcelona has an extensive collection of his early work; the Picasso Museum in Lucerne shows mainly his late work. Other large collections are to be found in the Paris Musée Picasso and in the artist's birthplace. There is a house specialising in his graphic art in Münster.

[above]
Pablo Picasso. Photograph

structed something new: because the cars reminded him of a baboon's head, he used tin lids, jugs, a door hinge, a table-tennis ball and other objects he found to assemble the whole into a sculpture of a she-monkey with her baby. Another time, two bent forks became a crane's talons, and then a bicycle saddle and handlebars turned into a bull. In 1950, Picasso used 'objets trouvés' of this kind to create a fat goat. He may have been inspired to do this by his goat, Esmeralda, who lived in the huge garden of his house in the South of France with several dogs, cats, doves and donkeys.

As well as making such assemblages and composite sculptures for his children, Picasso also liked to draw Claude and Paloma while they themselves were drawing. These pictures show how much he admired childlike imagination even though he was one of the world's most original and individual artists, always coming up with new styles and thus influencing countless artist-colleagues. Picasso's paintings, sculptures, drawings, etchings, ceramics, collages and lithographs pointed art in a completely new direction.

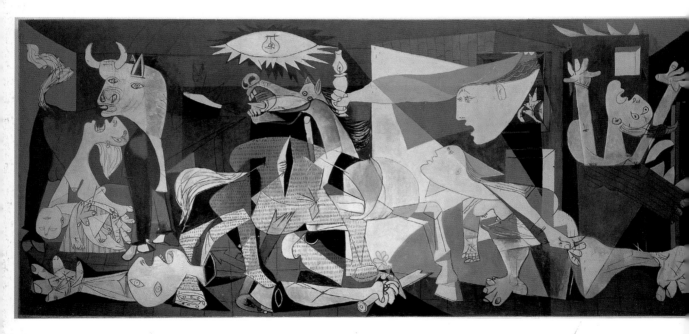

[above]
Guernica, 1937. Oil on canvas,
351 x 782 cm. Centro de Arte Reina Sofia,
Madrid

[right]
Jacqueline with Crossed Hands, 1954. Oil
on canvas, 116 x 88.5 cm. Musée Picasso,
Paris

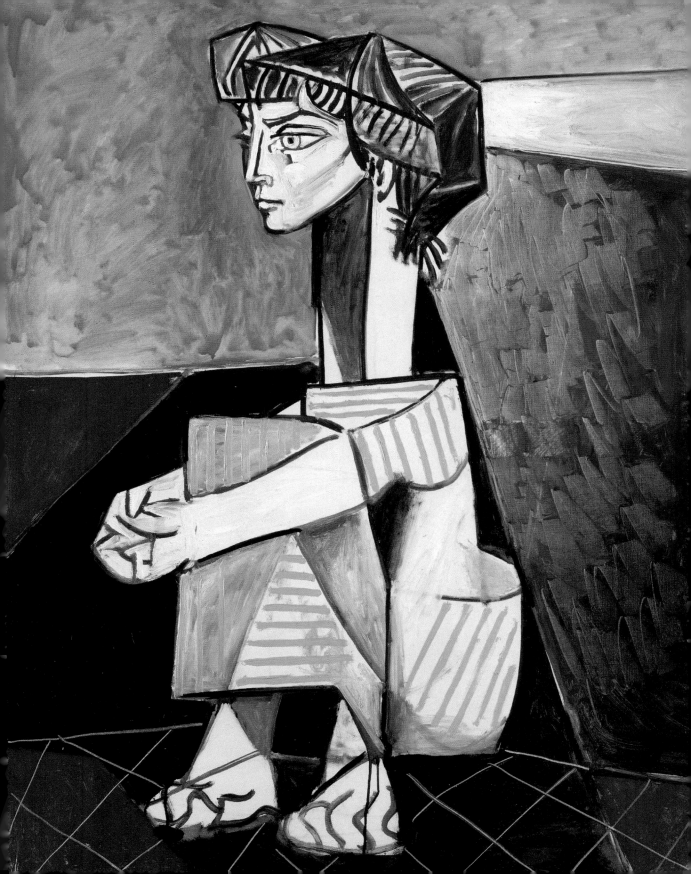

1861–1865 American Civil War **1891** End of the Indian Wars in the USA

1883 First skyscraper in Chicago

1914–1918
World War I

IMPRESSIONISM 1860–1915 1860–1915 IMPRESSIONISM CUBISM 1915–192

| 1835 | 1840 | 1845 | 1850 | 1855 | 1860 | 1865 | 1870 | 1875 | 1880 | 1885 | 1890 | 1895 | 1900 | 1905 | 1910 | 1915 | 1920 |

[below]
Lighthouse Hill, 1927. Oil on canvas,
73.8 x 102.2 cm. Dallas Museum of Art,
Texas

[right page below]
Office at Night, 1940. Oil on canvas,
56.4 x 64 cm. Walker Art Center,
Minneapolis, Gift of the T.B.Walker
Foundation, Gilbert M.Walker Fund, 1948

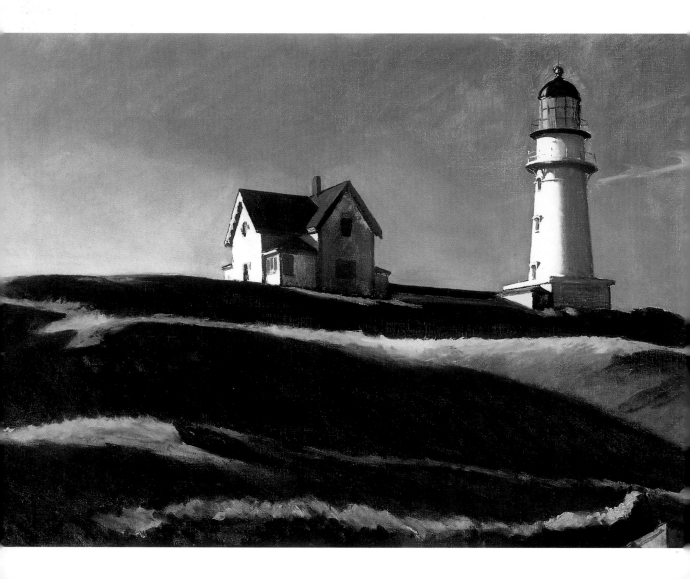

1939–1945 World War II **1963** John F. Kennedy assassinated
1945 Atomic bombs dropped on Hiroshima and Nagasaki
1950 End of racial segregation in the USA **1981** First flight by Columbia space shuttle
1952 Elvis Presley becomes popular

XPRESSIONISM 1920–1940 **ABSTRACT EXPRESSIONISM 1940–1960** **POP ART 1960–1975**

1925 1930 1935 1940 1945 1950 1955 1960 1965 1970 1975 1980 1985 1990 1995 2000 2005 2010

EDWARD HOPPER

The American painter Edward Hopper was a sort of painter of loneliness. His paintings of people in hotel rooms, offices and all-night bars look like snapshots of the everyday American world. Hopper was one of the most important 20th-century American painters. He influenced the exponents of photographic realism in particular.

Hopper lived in the same studio in New York for almost all his life. He sat at his easel and painted his pictures for over fifty years, until he died. When he met his wife, Jo, who was also a painter, he bought an extra studio for her in the same building. They spent their holidays in Cape Cod each year, where Hopper had a holiday home built – with a studio. He seems not to have been too keen on change.

Everyday New York

Hopper's favourite activity was moving around New York, on foot or on the elevated railway. He could look into homes, shops and hotel windows from there, and draw his inspiration from them. One evening, the painter was looking down from the 'El' and glimpsed into a brightly-lit room, for a fraction of a second. Shortly after that he painted *Office at Night*, which looks like a mysterious scene from a film thriller. In this picture, Hopper was particularly keen to get the electric light right – here, it is coming from the ceiling lighting, the desk lamp and from outside. Like the Impressionist painters, whose work he had got to know in Paris, Hopper also wanted to capture and reproduce light in

its many facets, although he used a different technique: he did not break it down into shimmering patches of colour painted in the open air, but re-created it very realistically.

Hopper wanted to paint the city lights, everyday American life, which so fascinated him, with all its hotels, all-night cafés, waiting rooms and fast-food restaurants, its wooden buildings, giant highway flyovers, lighthouses and railroads. Perhaps Hopper was even the first artist to paint something as ordinary as a filling station. This was not usual in America at the time either; only many years later did Pop artists like Andy Warhol begin to depict everyday objects in their pictures. There is only one thing that does not appear in Hopper's pictures, strangely enough: the skyscrapers that are so typical of New York.

Silent film on the city stage

Many of Hopper's pictures look like very brightly-lit scenes from plays being acted out in the street, in an all-night bar or in a hotel room. And, in fact, Hopper's wife, Jo, does appear like an actress in various roles in the paintings: sometimes she plays a secretary, an anonymous character in a hotel lobby, or even a cinema usherette, leaning tiredly against a wall under a lamp.

But unlike theatre performers, the people in Hopper's pictures are silent. Even when they are sitting in a restaurant like *Night Owls* in the painting of the same name, they seem to be completely absorbed in themselves. Perhaps Hopper found it even more important to portray the loneliness that can overcome people in big cities than to portray light.

1882 Edward Hopper born on 22 July in Nyack, New York
1900–06 studies graphic and illustrative art at the New York School of Art
1906 Travels to Paris for the first time, to study painting
1913 Moves into the New York studio where he was to live until he died
1920 His first exhibition in the Whitney Studio Club establishes his reputation
1924 Marries the painter Josephine Verstille Nivison, called Jo
1925 Travels in Colorado and New Mexico
1933 A major exhibition in the famous Museum of Modern Art in New York shows a retrospective of his work
1934 The home and studio he designed for himself on Cape Cod is completed
1952 Is represented at the Venice Biennale
1967 Edward Hopper dies on 15 May in New York

MUSEUM AND INTERNET TIPS
There are numerous works by Edward Hopper in the Whitney Museum of American Art in New York; his widow left them to this museum: www.whitney.org

[above]
Edward Hopper in Cape Elizabeth, Maine, 1927. Photograph, private collection

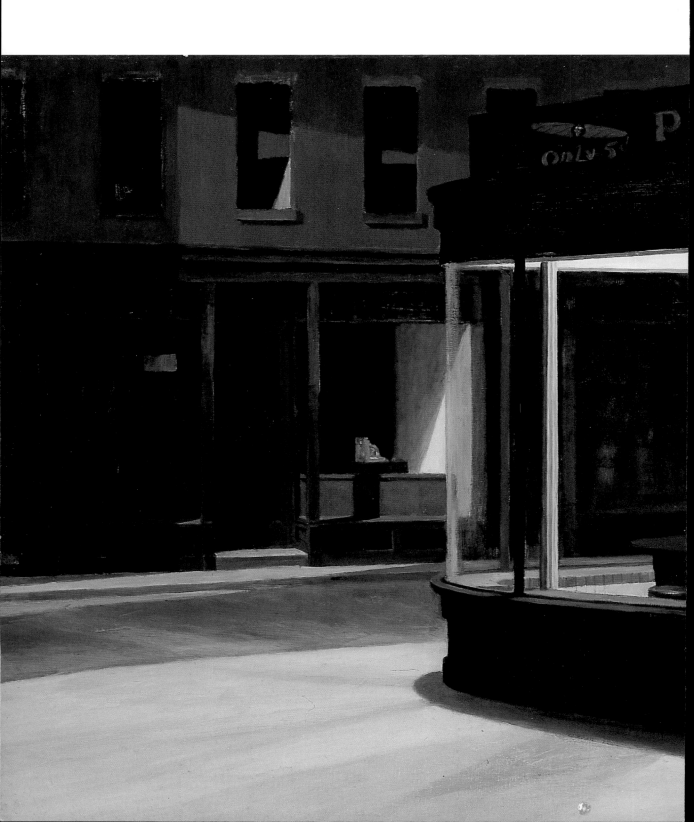

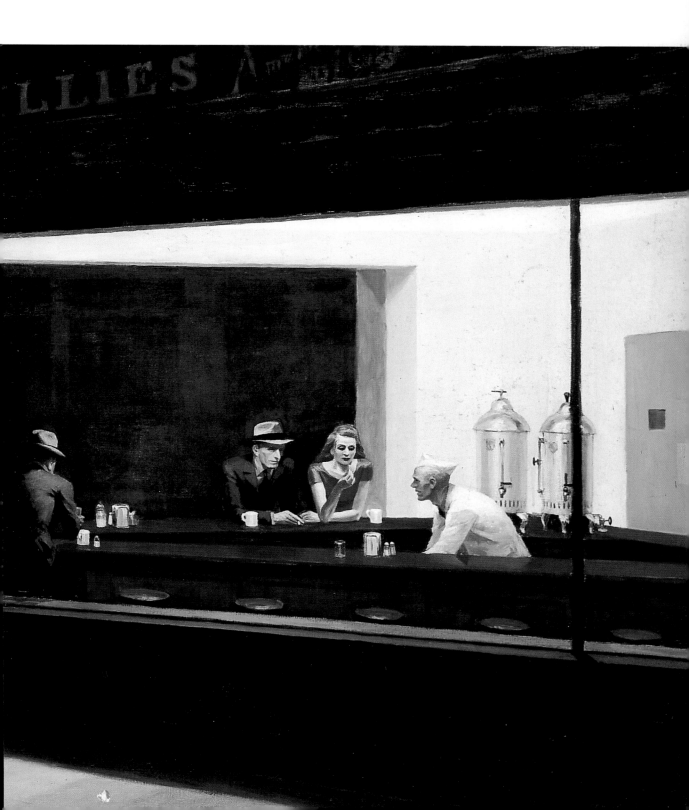

Nighthawks, 1942. Oil on canvas,
84.1 x 152.4 cm. Art Institute of Chicago

1886 First cars with
petrol engines

1905/07 Die Brücke and Der Blaue Reiter
artists' associations founded

1894 Reichstag completed in Berlin

1914–1918
World War I

IMPRESSIONISM 1860–1915

1860–1915 IMPRESSIONISM CUBISM 1915–1920

| 1835 | 1840 | 1845 | 1850 | 1855 | 1860 | 1865 | 1870 | 1875 | 1880 | 1885 | 1890 | 1895 | 1900 | 1905 | 1910 | 1915 | 1920 |

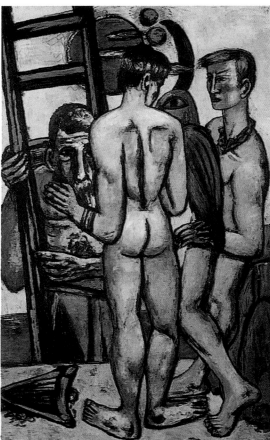

The Argonauts, 1949/50. Oil on canvas,
each panel 189 x 84 cm, centre panel
203 x 122 cm. National Gallery of Art,
Washington D.C.

1933 Hitler becomes Chancellor, later Führer
1937 *Guernica* (Picasso)
1937 *Degenerate Art* exhibition in Munich
1939–1945 World War II

1960 John F. Kennedy becomes president of the USA

1981 First flight by Columbia space shuttle

EXPRESSIONISM 1920–1940 ABSTRACT EXPRESSIONISM 1940–1960 POP ART 1960–1975

1925 1930 1935 1940 1945 1950 1955 1960 1965 1970 1975 1980 1985 1990 1995 2000 2005 2010

MAX BECKMANN

While his colleagues were searching for new forms and techniques with which to do justice to the modern world, the German artist Max Beckmann was experimenting with the classical resources of painting familiar since the Middle Ages. And yet he developed a very private language of his own with his art, which made him one of the most important painters and graphic artists of his day.

Beckmann always appears in his self-portraits looking grim and sinister, even when he is dressed as a clown. He said that his self-portraits allowed people to look into the depths of his soul. The horrors of World War I, which he experienced as a medical orderly and captured in drawings, shaped his view of the world.

Success all along the line

Beckmann's talent was evident from an early stage. In Dresden and Berlin he painted Biblical scenes showing tormented humanity, as well as urban landscapes with bridges and houses. In these pre-war paintings, Beckmann always portrayed himself in an exquisite tail coat or dinner jacket, holding a cigarette and looking self-confident and contented; he was a welcome guest at receptions and parties.

In 1925, Max Beckmann was appointed professor of painting at the famous Städelschule in Frankfurt am Main. He was a strict teacher who set great store by the study of old masters like Rembrandt, Rubens, Vermeer and Frans Hals. His colleagues are said to have envied his skill, and his young students were afraid of him. One of his classes consisted of only one student, as all the others were too afraid of Beckmann's criticism.

In exile in America

Beckmann's critical images were a thorn in the flesh of the National Socialists. He had to leave the Städelschule and his pictures were removed from the museum walls. He and his wife left Germany and went first to Amsterdam and then to the USA, where he became professor again. He never returned to Germany. A major retrospective of his paintings and graphic art was held in America shortly before he died.

In America, Beckmann painted some of his enormous three-part pictures. In these triptychs he combined famous legends with personal experience to make pictures about man's destructive fury, his blindness and his suffering. *The Argonauts* tells of the seafaring heroes of Greek mythology and his search for the Golden Fleece. Beckmann loved the sea, and often painted the ocean or seafarers. In this triptych he juxtaposes the legend of the Argonauts with the fate of artists who had to flee across the sea to America to escape from Hitler's Germany.

1884 Max Beckmann born on 12 February in Leipzig
1903 Becomes a member of the Secession in Berlin after studying art in Weimar
1913 His pictures are shown in the United States for the first time
1914 Volunteers as a medical orderly in World War I
1925 Is appointed professor at the Städelschule in Frankfurt am Main
1925 Marries Mathilde Kaulbach, whom he calls Quappi
1933 Is denounced as a 'degenerate artist'; is dismissed from the Städelschule by the National Socialists
1937 Goes to Amsterdam
1947 Emigrates to the United States
1950 Max Beckmann dies on 27 December in New York

MUSEUM AND INTERNET TIPS
The Saint Louis Art Museum in Missouri has a major collection of Beckmann's work: www.stlouis.art.museum

[above]
Max Beckmann. Photograph

[left]
The Synagogue, 1919. Oil on canvas, 89 x 140 cm. Städtische Galerie im Städelschen Kunstinstitut, Frankfurt am Main

MARC CHAGALL

PABLO PICASSO

MAX ERNST

1887–1889 Eiffel Tower built in Paris

1914–1918
Worlc War I

IMPRESSIONISM 1860–1915

1860–1915 IMPRESSIONISM CUBISM 1915–1920

1835	1840	1845	1850	1855	1860	1865	1870	1875	1880	1885	1890	1895	1900	1905	1910	1915	1920

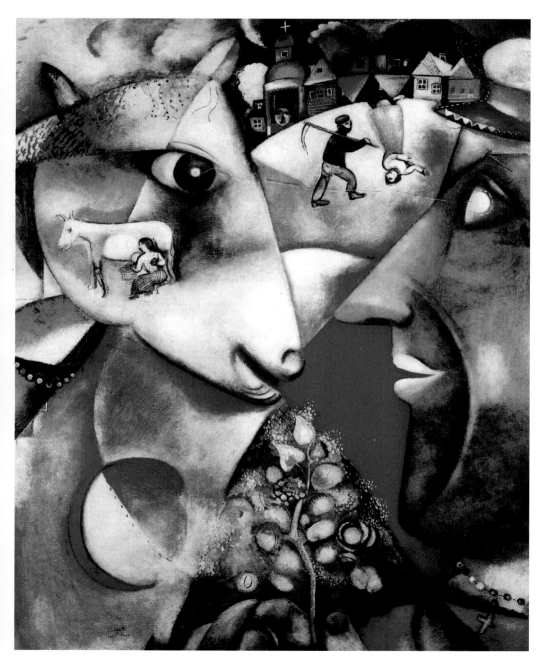

I and the Village, 1911. Oil on canvas, 192.1 x 151.4 cm. Museum of Modern Art, New York

1933 Hitler becomes Chancellor, later Führer
1937 *Degenerate Art* exhibition in Munich
1939–1945 World War II

1961 Berlin Wall built
1962 Cuban missile crisis
1973 First oil crisis

1991 Collapse of the Soviet Union

EXPRESSIONISM 1920–1940 ABSTRACT EXPRESSIONISM 1940–1960 POP ART 1960–1975

1925 1930 1935 1940 1945 1950 1955 1960 1965 1970 1975 1980 1985 1990 1995 2000 2005 2010

MARC CHAGALL

The French painter, graphic and stained-glass artist drew on the folk art, fairy tales and Jewish life of his Russian homeland to create enchanted paintings vibrant with glowing colour.

Chagall's father was a herring dealer. But Chagall himself wanted to find an occupation more suitable for his delicate hands. An occupation "that would not make me turn away from the sky and the stars, and that would allow me to make sense of my life". He wanted to be a painter.

When he had made his mind up about this, the Jewish world of his little birthplace, Vitebsk, suddenly felt alien and constricted. Chagall moved to Paris, where all the important artists of the day lived. He wanted to learn about painting by looking at the showers of colour in Vincent van Gogh's pictures, and at Cubist paintings. Like many of his colleagues, he moved into a grubby little studio near the abattoirs in Paris, where he lived in dire poverty.

Back home

Returning to his beloved Vitebsk was unthinkable, so Chagall brought his home to Paris. In his paint-ing *I and the Village* he showed Vitebsk as he had imagined it in his Paris dreams, with human beings and animals living together in harmony and con-tent. He painted happy peasants, goats, cows and blossoming trees in gentle colours and simple lines.

Chagall did finally go back to Vitebsk. He was appointed commissar for fine arts after the Russian Revolution. He married his childhood sweetheart, Bella. "I had only to open the window," Chagall once wrote, "and the blue of the sky, love and flowers came pouring in with her." And now his pictures began to show kissing couples in glowing colours in seventh heaven.

Only occasionally did Chagall lower his gaze from the stars to the dark events taking place on earth. As World War II was raging and the Jewish painter had to flee to America, he painted burning houses in black smoke or Jews escaping annihila-tion and fleeing by sea to an uncertain life. When his wife died in 1944, Chagall stopped painting completely.

Second great love

Chagall returned to France after the War. He enjoyed another great love in the Russian Valentina Brodsky, and found a way back to the lightness of his pictures. And Chagall also regained his belief in God, which he had lost through the terrible blows life had dealt him. He created wonderful stained-glass windows for many churches, praising God's Creation in glowing colours.

Green cows, red angels, daydreaming painters, soaring acrobats, women riding on cockerels and flying couples in close embraces – these are what Chagall painted with his delicate hands. "When Chagall paints," Picasso once said, "one does not know whether he happens to be asleep or awake. He must have an angel somewhere in his head." Chagall believed he had found the meaning of his life on his canvases – and, of course, also through his love for Bella and Valentina.

1887 Marc Chagall born on 7 July in Liosno, near Vitebsk
1910 Goes to Paris
1915 Marries Bella Rosenfeld and returns to Russia
1917 Founds a modern art school in Russia
1921 Teaches war orphans near Moscow
1922 The family moves to Berlin, then to Paris a year later
1937 Chagall's pictures are included in the *Degenerate Art* exhibition
1941–47 Chagall stays in America
1944 Bella dies
1952 Chagall marries Valentina Brodsky, his second love
1985 Marc Chagall dies on 28 March in Saint-Paul-de-Vence

MUSEUM AND INTERNET TIPS
Marc Chagall's sequence of pictures on the Bible is shown in a dedicated museum in Nice: www.musee-chagall.fr

[above]
Marc Chagall. Photograph by Franz Hubmann

The Lover's Heaven, 1963. Gouache on paper, 52 x 50 cm. Sammlung Marcus Diener, Basel

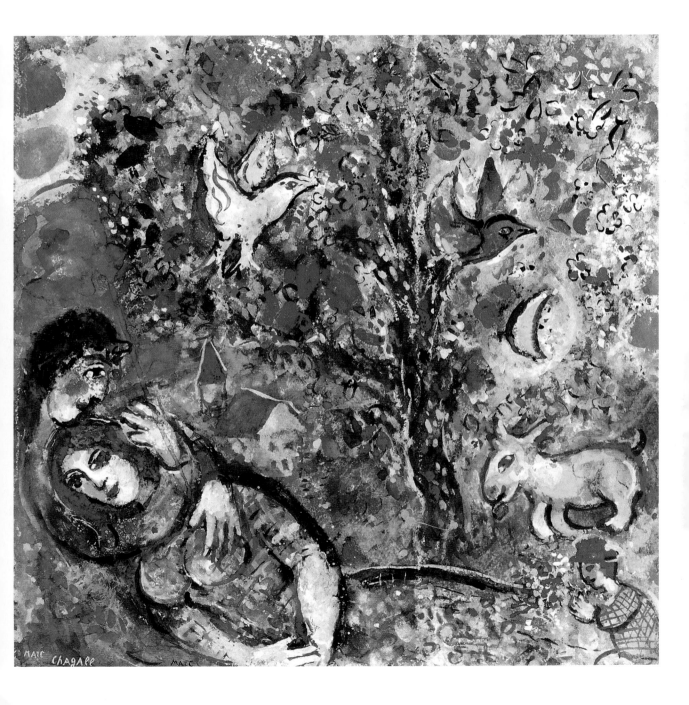

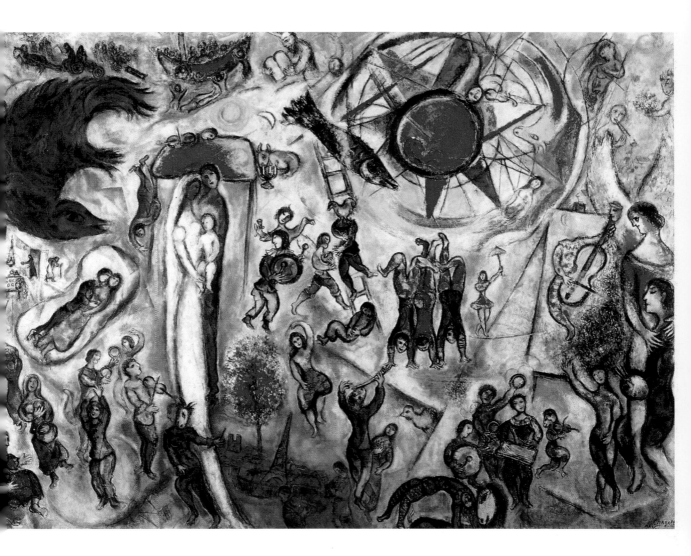

1887–1889 Eiffel Tower built in Paris **1910** Futurist Manifesto in Italy

1895 First films shown **1914–1918** World War I

IMPRESSIONISM 1860–1915 1860–1915 IMPRESSIONISM CUBISM 1915–1920

| 1840 | 1845 | 1850 | 1855 | 1860 | 1865 | 1870 | 1875 | 1880 | 1885 | 1890 | 1895 | 1900 | 1905 | 1910 | 1915 | 1920 | 1925 |

[above]
Box in a Valise, 1931–58. Leather suitcase with miniature reproductions, photography and other colour reproductions, 40.7 x 38.1 x 10.2 cm.

[below left]
In Advance of the Broken Arm, 1915 (replica). Snow shovel, wood and galvanized iron, height 121.3 cm.

[below right]
Bottle Rack, 1914 (replica 1964). Ready-made: galvanised-iron bottle rack, height 64.2 cm. Musée National d'Art Moderne, Centre Georges Pompidou, Paris

1931 *Limp Watches* (Salvador Dalí) **1955** Beginnings of Pop art

1986 Worst-case nuclear accident at Chernobyl power station

1939–1945 World War II **1969** US moon landing

1990 Reunification of Germany

EXPRESSIONISM 1920–1940 ABSTRACT EXPRESSIONISM 1940–1960 POP ART 1960–1975

1930 1935 1940 1945 1950 1955 1960 1965 1970 1975 1980 1985 1990 1995 2000 2005 2010 2015

MARCEL DUCHAMP

Ever since the Franco-American artist Marcel Duchamp signed a snow shovel and thereby proclaimed it a work of art, it has been the idea that counts, not the artistic craft. Duchamp is seen as having paved the way for Dada in New York, and laid the foundations for Object art, from which Concept art emerged.

Marcel Duchamp loved playing games. Tennis, for example, or chess. But he particularly liked playing with people's expectations. For example, Duchamp once bought a snow shovel in a New York department store and signed it on the blade. Next to it he jotted "In Anticipation of the Broken Arm" – after all, it is easy to break an arm if it is snowy and icy. Now the snow shovel was suddenly no longer an ordinary object from a department store, but had changed into an unmistakable work of art.

Found objects perfected

Duchamp later called these found objects from the department store "ready-mades". Things usually became art simply because Duchamp picked them out and declared that they were his works. Only occasionally did he make small changes. When Duchamp, still working under a pseudonym – he liked to call himself Rrose Sélavy – signed a urinal and christened it *Fountain*, because it reminded him of the little drinking fountains in New York offices, the scandal was complete. Things like that belonged in sanitary goods suppliers' windows – but in a museum? Never!

At first, only the Dada and Surrealist artists were keen on Duchamp's ideas. But when the fuss had died down a little, more and more people began to understand what he had actually been trying to show. The fact is that only in a museum or an exhibition is it possible to see how perfectly formed and elegant even a urinal can be. No one notices its real beauty in a gents' toilet. It just does its job there. From then on, Duchamp named many more everyday objects "ready-mades". Nothing was safe from him, neither bottles from the chemist's nor rubber bathing caps from the bargain counter.

As he grew older, Duchamp made little copies of his paintings, drawings, collages and ready-mades that would fit into a case easily. He wanted to create a kind of portable museum. The *Box in a Suitcase* was so sought after by collectors that

Duchamp constantly made new versions over the next twenty years, of course always adding new miniatures of his more recent work. This also meant that copies can also count as art today, just like everyday objects. They just have to be called art.

The bearded MONA LISA

All Duchamp did was take a postcard of Leonardo da Vinci's *Mona Lisa* and add a beard and an upward-twirled moustache to the mysteriously smiling woman. This *Mona Lisa* now became his work of art, for he, Duchamp, had changed it.

And when he happened to trip over a metal hook that had fallen on the floor from a fitted wardrobe, he simply nailed it down there and called it *Trébuchet* ('tripper-up'). Puzzling titles and sayings meant a great deal to Duchamp. His gravestone says in French: "After all, it is always the others who die."

1887 Marcel Duchamp born on 28 July in Blainville-Crevon
1904 Moves to Paris
1913 His *Nude, Descending a Staircase* creates a great stir at the Armory Show in New York
1915 Creates *Big Glass*, his most important contribution to modern art
1915 Goes to New York, where he influences the Dada artists. Lives partly in Paris, partly in the USA
1923 Abandons art for ten years, out of boredom
1936 Begins work on *Box in a Suitcase*
1947 Organises a Surrealist exhibition in Paris
1968 Marcel Duchamp dies on 2 October in Neuilly-sur-Seine

Object art and Concept art

Duchamp is regarded as the father of Object art. Its exponents, such as Man Ray, had, since the early 20th century, included unchanged or slightly changed found objects and everyday items in their pictures, assemblages and collages. Concept art by artists like Sol Le Witt, Timm Ulrichs or Hanne Darboven, which began in 1965, goes a step further: here, all that counts is the artist's idea, regardless of whether the resultant work was created by his or her own hands.

[above]
Marcel Duchamp, 1965.
Photograph by Ugo Mulas

MAX ERNST

PABLO PICASSO

SALVADOR DALÍ

1905/07 Die Brücke and Der Blaue Reiter
artists' associations founded

1914–1918 World War I

1933 Hitler becomes
Chancellor, later Füh

IMPRESSIONISM 1860–1915 1860–1915 IMPRESSIONISM CUBISM 1915–1920 EXPRESSIONISM 1920–1940

1855 1860 1865 1870 1875 1880 1885 1890 1895 1900 1905 1910 1915 1920 1925 1930 1935 1940

[left]
Ubu Imperator, 1923. Oil on canvas, 81 x 65 cm.
Musée National d'Art Moderne, Centre Georges
Pompidou, Paris

[right]
Grattage: *Eclipse of the Sun*, 1926. Oil on canvas,
144 x 112 cm. Private collection

1950 Outbreak of Korean War **1973** First oil crisis

1937 *Guernica* (Picasso)

1937 *Degenerate Art* exhibition in Munich **1991** Collapse of the Soviet Union

1939–1945 World War II **1960** John F. Kennedy becomes president of the USA

ABSTRACT EXPRESSIONISM 1940–1960 **POP ART 1960–1975**

| 1945 | 1950 | 1955 | 1960 | 1965 | 1970 | 1975 | 1980 | 1985 | 1990 | 1995 | 2000 | 2005 | 2010 | 2015 | 2020 | 2025 | 2030 |

MAX ERNST

In the early 20th century, many artists discovered the world that lay behind objects. Max Ernst, the most important Dadaist and Surrealist, was the most imaginative and inventive of them.

When Max Ernst decided to become a painter without ever having trained as an artist, he wanted to let other people see the hidden, mysterious world of his childhood, all the fairy-tale creatures concealed in the woodwork, the forests and the clouds. During World War I, Ernst had to enter soldiers' positions on a map, a meaningless activity. When he went home to Cologne he wanted to counter the dying caused by the War with an art that exulted in life. He founded a Dada group in Cologne with his friends Hans Arp and Johannes Theodor Baargeld. He collected bits of wallpaper, instructions and pictures from books about technology or natural history and glued them together to make amusing dream collages. So he had whales swimming through the bedroom, coaches driving across the night sky and good citizens in their Sunday best fighting with wicked serpents. Ernst thought the war had been cruel and senseless, and his buildings were intended to be senseless, but at least funny!

New painting techniques

Sometimes, as in his picture called *The Sun Wheel*, Ernst applied oil paint to the canvas thickly, and then pressed wooden planks down on it, so that he could go on to scratching around at the result with coarse palette knives and sharp, pointed objects. These grattages, as he called them, often depicted landscapes. In other cases, Ernst shook runny paint over the canvas and put a sheet of glass over it. This technique, called decalcomania, also allowed him to produce landscapes mysteriously teeming with plants and insects. Ernst called his rubbing technique frottage. Here, he traced leaves, coarse canvas or the floorboards by putting paper on them and rubbing a soft pencil over them. This made animals, heads and plants appear, as in the picture called *Forest* dating from 1927.

Native American art as a source of inspiration

It was only later, when travelling around America by car, that Ernst noticed with amazement how similar the nature there was to his sweeping rocky landscapes and jungles painted in oil. He felt particularly at home in the endless, fissured expanses of Arizona, so he settled there with his wife after escaping from Nazi Germany. On the American reservations, Ernst got to know the magic dolls and masks of the Native Americans, and he made sculptures for his garden that looked like the guardian totems and stakes of the Apache and Hopi Indians. Ernst built houses wherever he lived, including France, where he moved in 1954. And he repeatedly decorated them with bird figures, witches and monsters, which look like the messengers of a hidden fairy-tale world that was all his own and which Ernst revealed in his pictures and sculptures.

1891 Max Ernst born on 2 April in Brühl, near Cologne
1912 Decides to become a painter
1914 Has to serve as a soldier in World War I
1919 Founds a Dada artists' group in Cologne
1922 Goes to Paris
1925 Develops frottage as a Surrealist technique
1929 His collage novel *Die Frau mit den 100 Köpfen* is published
1939 Is jailed in Paris as an 'enemy alien'
1941 Moves to America for two years
1976 Max Ernst dies on 1 April in Paris

MUSEUM TIP
The Max Ernst Museum in the town of Brühl holds many early works, over sixty sculptures and an extensive collection of photographic portraits that is unique in the world: www.maxernstmuseum.de

Dadaism

After World War I, artists like Hugo Ball and Tristan Tzara organised rackety, rumpus-filled actions in Zurich, Cologne, Berlin, Hanover and New York, intended to provoke ordinary citizens and their world, which had emerged from this War. Kurt Schwitters even created a walk-in Dada world around the cut-up word 'Kommerz' (Commerce) taken from a newspaper: he built his 'Merz' houses from found objects, sculptures and collages. Other Dadaists included Marcel Duchamp, Francis Picabia and Hans Arp. They were said to have named themselves after the French children's word for a wooden horse, dada, but that, too, was made up.

[above]
Max Ernst, *Sedona*, 1946.
Photograph by John Kasnetsis

JOAN MIRÓ ━━━

PABLO PICASSO ━━━━━━━━━━━━━━━━━━━━━━━━━━━━━━━━━━━━━━

SALVADOR DALÍ ━━━━━━━━━━━━━━━━━━━━━━━━━

1886 First cars with petrol engines **1914–1918** World War I

IMPRESSIONISM 1860–1915 1860–1915 IMPRESSIONISM CUBISM 1915–1920 EXPRESSIONISM 1920–1940

1850 1855 1860 1865 1870 1875 1880 1885 1890 1895 1900 1905 1910 1915 1920 1925 1930 1935

[left]
People and Dog in Sun, 1949. Oil on
canvas, 81 x 54.5 cm. Kunstmuseum,
Basel

[right]
Blue III, 1961. Oil on canvas,
355 cm x 270 cm. Centre Georges
Pompidou, Paris

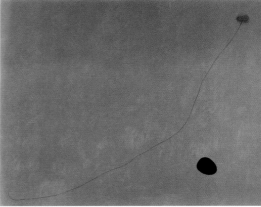

1939–1945 World War II	**1960** John F. Kennedy president of the USA	**1981** First flight by Columbia space shuttle	
1945 Atomic bombs dropped on Hiroshima and Nagasaki	**1964** USA begins Vietnam War **1969** Woodstock music festival	**1995** Christo and Jeanne-Claude wrap the Berlin Reichstag	

ABSTRACT EXPRESSIONISM 1940–1960 POP ART 1960–1975

1940 1945 1950 1955 1960 1965 1970 1975 1980 1985 1990 1995 2000 2005 2010 2015 2020 2025

JOAN MIRÓ

Leaves and eyes, flames and stars, animals and ships made up of nothing but black lines and bright colours populate pictures by the Catalan painter, sculptor and graphic artist Joan Miró. His lines, circles and dots, coming together to form more and more new dream creatures, appealed to the Surrealist artists.

Miró was sometimes asked what gave him the wonderful ideas for his pictures. "Well," he would reply, "I got back to my studio in the Rue Blomet late at night and went to bed, sometimes without any supper. I then saw things, and captured them in my notebook." At times like this, the patches on his ceiling and the light reflected from the neon signs and street lamps created a dream world of fish and cats, ladders and suns, or dragonflies with iridescent wings, of the kind that populate his painting called *Carnival of Harlequins*.

Painted dreams

In Paris, Miró met Pablo Picasso, who had helped to develop the Cubist style of painting, and whom Miró had tried to imitate in his early work. Miró made friends with Georges Braque, the co-inventor of this artistic style. The Catalan learned from Cubism that objects can be broken down into squares or circles on canvas – now all he had to was transform them back into his dream creatures. Later, when Miró had got to know Wassily Kandinsky's abstract art and Paul Klee's pictures, he invented a pictorial world of his own in which the colours and shapes float across the canvas like mobiles. Coloured animals and matchstick figures, moon figures or letter-creatures climb long ladders towards the sky. Earth's gravity cannot hold them back, ultimately they are just pure form and colour. The older he grew, the sparser his pictures became. In the end, all that remained was the blue sky of the canvas and a few dots and lines, coming together in the painting *Blue III* to form a black sun and a floating dragon in pure colour. At this time, Miró was trying above all to make the greatest possible effect with as few resources as possible: "That's why emptiness becomes increasingly important in my pictures."

The birth of the world

"One invents nothing," Miró once said, "it is all there." His pictures were already present in his dreams and in his imagination before he painted them.

Miró tried to give this dream world a glow of its own in his paintings, like a Surrealist poet in his poetry. And like a Surrealist poet, Miró gave his pictures names that made them seem all the more puzzling. *A drop of dew, falling from a bird's wing, wakes up Rosalie, who is slumbering in the shade of a spider's web* was the name he gave one of these pictures; another was called *The lark's wing circled in gold-blue comes back to the heart of the corn poppy sleeping in the diamond-adorned meadow*. Or simply *The Birth of the World*: in fact, his more than 8,000 pictures, graphic works, ceramics and sculptures are all supposed to be the birth of a new world.

1893 Joan Miró born on 20 April near Barcelona
1911 Stops working as a bookkeeper and becomes a painter
1920 Pablo Picasso receives him in his Paris studio
1924 The Surrealists take an interest in him
1926 Miró works on a stage set with Max Ernst
1930 His only daughter, Dolores, is born
1933 Miró meets Wassily Kandinsky
1941 His first major retrospective is shown in New York
1959 Takes part in *documenta* in Kassel
1983 Joan Miró dies on 25 December near Palma de Mallorca

READING TIP
Stephan von Wiese and Sylvia Martin, *Joan Miró – Snail Woman Flower Star*, Munich 2002

Absolute Surrealism
Surrealism had many faces. While artists like Salvador Dalí or René Magritte wanted to capture their dream worlds with almost photographic accuracy, painters like Miró, the French artist André Masson or the German Hans Arp presented strange forms vaguely reminiscent of human bodies. Exponents of abstract art like Wassily Kandinsky, for example, had banished objects from the canvas in a very similar way, but for different reasons. The photographic Surrealist style is called 'veristic', and the abstract style 'absolute'.

[above]
Miró in his Paris studio, 1931. Photograph

1891 End of the Indian Wars in the USA

1914–1918 World War I

1918 * Leonard Bernstein

IMPRESSIONISM 1860–1915 1860–1915 IMPRESSIONISM CUBISM 1915–1920 EXPRESSIONISM 1920–1940

1850 1855 1860 1865 1870 1875 1880 1885 1890 1895 1900 1905 1910 1915 1920 1925 1930 1935

[above]
Small Spider, c. 1940. Sheet metal,
wire and paint, 111 cm x 127 cm x 140 cm.
Private collection

[below]
La Grande Vitesse, 1969. Steel and paint,
109.22 cm x 140 cm x 63.5 cm.
Grand Rapids, Michigan

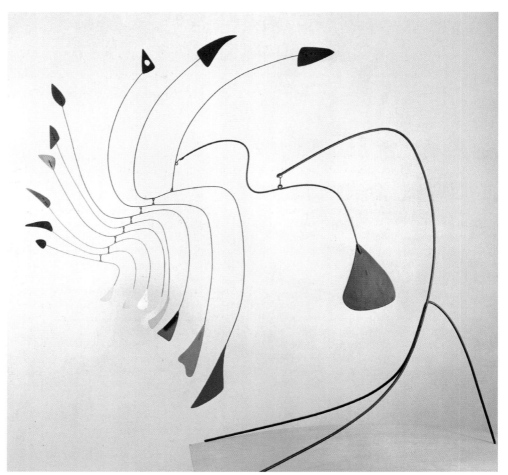

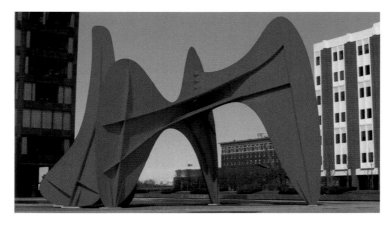

ALEXANDER CALDER

This American sculptor revolutionised modern art with the movement and colour of his sculptures. Alexander Calder became world-famous for his moving sculptures, called mobiles, and stationary constructions, called stabiles. He even painted aircraft, and celebrated his first success with a small circus.

Alexander Calder never forgot the way the sun rose off the coast of Guatemala. He had signed on to a freighter as a fireman in 1922, and was profoundly impressed by this "miracle of the universe", as he called the early-morning show. Between the fiery red of the rising sun on one side and the silvery moon on the other, Calder, who had done every conceivable job from lawnmower salesman to book-keeper, decided to become an artist. This natural miracle that he witnessed features in many of his works.

From drawing to the circus

Calder became an illustrator for a New York magazine. This work did not bring in much of a salary for the up-and-coming artist, but it did allow him to spend two weeks at a circus, which impressed him just as much as the sunrise off Guatemala. Calder had been given press tickets for the performances, and was so enthusiastic about it that he scarcely left the big top for the whole of the run. "I spent two whole weeks there, practically day and night. I could tell from the music which number was just starting," he remembered later.

Calder was so excited about the circus world that he decided to open a circus of his own. This was the *Cirque Calder*, which later achieved worldwide fame. Calder himself appeared as the ringmaster. He made his tightrope walkers, musicians, clowns and animals from wire, cork, paper and all sorts of rubbish. He moved to Paris in the summer of 1926, and was soon performing his circus acts regularly in artistic circles. All the avant-garde of the day watched the young man from America excitedly during these circus evenings: Joan Miró, Man Ray, Hans Arp, the writer Jean Cocteau. "I liked the little bits of paper best," Miró once admitted to his friend Calder. He meant the scraps of paper the artist would let down on various wires, making them look like white doves.

Moving art

Calder came to push the bounds of sculpture outwards with his great delight in experiments, and his artistic world became increasingly colourful. Empty sardine tins, coffee cans and pieces of coloured glass became equally as exciting in his hands as huge sheets of wood or metal. Calder achieved world fame with his wind-driven mobiles, which first caused a stir in the art world in the early 1930s. Metal discs attached to wires were set in motion by the merest breath of wind.

At the same time as making his mobiles, Calder screwed together sheets of metal to create his motionless stabiles, which became increasingly monumental in the 1960s and 1970s. These fantastic birds, dinosaurs and other enormous creatures still work on people's imaginations in many public squares and make the city look a little more colourful.

Constructivism

Some Russian artists showed what could be done with geometrical figures in the early 20th century. The sculptor Vladimir Tatlin and his artist colleagues El Lissitzky, Naum Gabo and Alexander Rodchenko made geometrical figures into works of art. Tatlin christened this highly mathematical approach Constructivism in 1930. The artists of the day were just as interested in technology as they were in mathematics, so they often screwed together materials like wood, sheet metal, wire or cable to form their works. While artists like Tatlin and Rodchenko placed their work at the service of profound social change, painters like Kasimir Malevich were fighting for the independence of art. Many Western artists, above all Piet Mondrian and the Dutch De Stijl group, were influenced by the Russian Constructivists. Alexander Calder was, for a time, also an enthusiastic supporter of austere Constructivism.

1898 Alexander Calder born on 22 July in Lawnton near Philadelphia
1919 Qualifies as an engineer
1924 Works as a press artist for the *National Police Gazette*
1927 The *Cirque Calder* comes into being
1931 Marries Louisa James
1932 Calder shows his first mobiles in Paris
1939 Creates a water ballet with fourteen fountains for the New York World's Fair, but it fails to work
1943 Great Calder retrospective at the Museum of Modern Art, New York
1957 Designs enormous mobiles for the John F. Kennedy airport in New York and the UNESCO headquarters in Paris
1973 Decorates a Braniff International Airlines plane
1976 Calder dies on 11 November at the age of 78

MUSEUM AND INTERNET TIPS
The Calder Foundation offers a good survey of Alexander Calder's life and work at www.calder.org
Calder's circus is now in the Whitney Museum of American Art, New York: www.whitney.org

[above]
Alexander Calder with his circus, 1929.
Photograph by André Kertész

PABLO PICASSO ══════════════════════════════════════

HENRY MOORE ══════════════════════════

JOHN CAGE ══════════════════════

1914–1918 World War I

1891 End of the Indian Wars in the USA

1929 Wall Street crash

IMPRESSIONISM 1860–1915 1860–1915 IMPRESSIONISM CUBISM 1915–1920 EXPRESSIONISM 1920–1940

1850 1855 1860 1865 1870 1875 1880 1885 1890 1895 1900 1905 1910 1915 1920 1925 1930 1935

[above]
Two Women in a Shelter, 1940–41. Pencil, wax crayon, watercolour wash, pen and ink, 20.4 x 16.2 cm. British Museum, London: bequest of Jane Clark 1977

[below]
Large Two Forms, 1966 and 1969. Bronze, height approx. 6 m. Altes Kanzleramt, Bonn

1939–1945 World War II

1960 John F. Kennedy president
of the USA

1969 US moon landing

1973 Watergate Affair

1979 Soviet Union invades Afghanistan

2001 Terrorist attacks in the USA

ABSTRACT EXPRESSIONISM 1940–1960 POP ART 1960–1975

1940 1945 1950 1955 1960 1965 1970 1975 1980 1985 1990 1995 2000 2005 2010 2015 2020 2025

HENRY MOORE

The English sculptor Henry Moore was inspired as much by the archaic sculptures of primitive peoples as by the Cubism of his contemporaries and the works of the ancient Greeks. His large, recumbent figures and mother-and-child sculptures in sweeping, curving forms can be admired in many public squares.

Henry Moore was interested in the abattoir in his home town of Castleford. The cutting up of the cattle and the curved shapes of their massive skulls fascinated him and continued to inspire him when he was sitting looking at the fissured rocks near the city of Leeds. "This rock was mighty," said Moore later about the stone colossus whose forms he liked to observe for hours on end. It was then, at the age of about eleven, that he decided to become a sculptor. He studied Gothic sculptures in churches, browsed through contemporary art magazines and admired the work of Michelangelo. At his father's insistence, Moore had to stop attending the local art college and begin training as a teacher. The young man worked in this profession for a time before volunteering for the army in 1916.

Thorough study

Moore went back to Castleford at the end of World War I and worked there as a teacher again. He grew dissatisfied with his job, and began attending night-school pottery classes. Moore became fascinated by the work of Rodin, Picasso, Alexander Archipenko and Constantin Brancusi, and began studying art. He studied the sculpture of all countries and ages in great detail. He had not forgotten his previous passion for the art of antiquity and Michelangelo, but it became more muted: "The world had been producing sculptures for at least thirty thousand years ... and the few sculptors from Greece over a period of a few hundred years no longer blind us to the sculptural achievements of the rest of mankind." After Paul Gauguin, in the late 19th century, had been the first European artist to enthuse about the free and natural creative power of the so-called primitives, he was followed by artists like Matisse, Picasso and the painters of the 'Die Brücke' group. Moore, too, was inspired as much by ancient Egyptian and South American art as he was by the wild-looking sculptures by primitive African and Polynesian peoples.

Sacred stones and famous drawings

Moore wanted to charge his stone with magic, as if it were intended for a sacred ritual. He tried to work out what the stone wanted, before making his first blow with the chisel. It was only then that the sculptor went to work. Moore felt that "the first cavity in a block of stone is a revelation".

Moore had to confine himself to drawing during World War II. He was appointed Britain's official war artist in 1940. While German bombs were falling on London he produced his *Shelter Drawings* of terrified people sheltering in the London Underground – drawings that would later become famous. After the War, he was glad to be able to resume work as a sculptor. Henry Moore became one of the most celebrated artists of the 20th century.

Modern sculpture

In the early 20th century, hordes of artists ran into the great museums of ethnology and looked with amazement at works of art by the so-called primitive peoples of Africa and Oceania. Sculptors like Constantin Brancusi and Amedeo Modigliani were uncommonly fascinated by their sculptures and masks, and Pablo Picasso also picked up countless ideas from this hitherto unknown art. The French artist Hans Arp made a name for himself with his abstract 'sculptures in the round', and the Russian Constructivist Vladimir Tatlin was famous for spiralling wooden models, while the Swiss sculptor Alberto Giacometti caused a stir with his spindly figures. Despite these numerous new movements, many European sculptors did not abandon representational work. The French artist Aristide Maillol, for example, became a master of impressive bronze sculptures of female figures. Ernst Barlach's figures went down particularly well in Germany, while Henry Moore was perfecting his recumbent figures in England.

1898 Henry Spencer Moore born on 30 July in Castleford, Yorkshire
1916 Works as a teacher at Temple Street School in Castleford
1917 Is wounded in a gas attack in World War I
1921 Begins to study art at the Royal College of Art in London
1926–39 Teaches at the Royal College of Art
1929 First major public commission, *West Wind*, for the London Underground headquarters
1940 Is appointed England's official war artist
1948 Shows work at the 24th Venice Biennale and wins the Grand Prize for Sculpture
1958 UNESCO sculpture unveiled in Paris
1986 Moore dies on 31 August in Much Hadham, Hertfordshire

MUSEUM AND INTERNET TIPS
The Henry Moore Foundation in Much Hadham, Hertfordshire, offers a great deal of information about all aspects of the sculptor at: www.henry-moore-fdn.co.uk

[above]
Henry Moore working on a sculpture in his garden at Burcroft, Kent. Photograph dated 1937

1914–1918 World War I **1929** Wall Street crash

IMPRESSIONISM 1860–1915 1860–1915 IMPRESSIONISM CUBISM 1915–1920 EXPRESSIONISM 1920–1940

1850 1855 1860 1865 1870 1875 1880 1885 1890 1895 1900 1905 1910 1915 1920 1925 1930 1935

[left]
*Face of Mae West – can be used as
a Surrealist apartment*, 1934/35.
Gouache on newspaper, 31 x 17 cm.
The Art Institute of Chicago

[right]
MaeWest Lipstick Sofa, 1937. Fabric
and wood, 92 x 213 x 8 cm. The Royal
Pavilion, Libraries & Museums, Brighton

[below]
Melting Time, 1931. Oil on canvas,
24 x 33 cm. The Museum of Modern Art,
New York

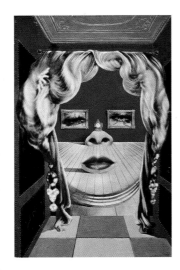

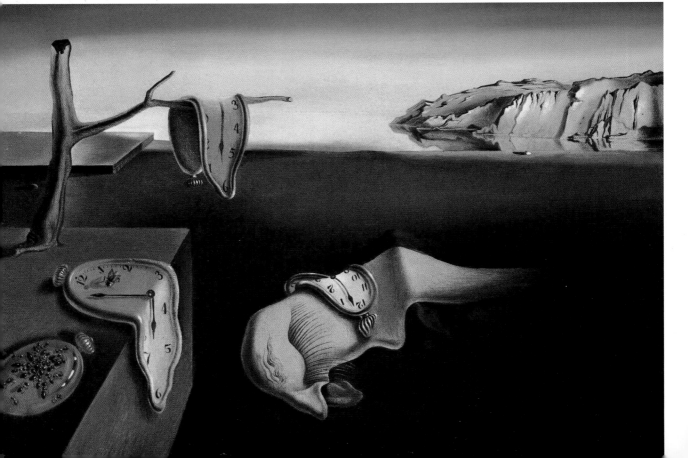

1939–1945 World War II
1952 Elvis Presley becomes popular
1972 Killings at Munich Olympics
2001 Terrorist attacks in the USA
1969 US moon landing
1991 Collapse of the Soviet Union
2003 US invasion of Iraq

ABSTRACT EXPRESSIONISM 1940–1960 POP ART 1960–1975

1940 1945 1950 1955 1960 1965 1970 1975 1980 1985 1990 1995 2000 2005 2010 2015 2020 2025

SALVADOR DALÍ

The Spanish painter, sculptor and graphic artist Salvador Dalí was probably slightly mad even as a child. He was determined to be a cook at the age of six, then Napoleon at seven. Later, he decided to be just "the genius Salvador Dalí", with a pointed moustache, always elegantly dressed – and with a lot of ideas that would cause quite a stir. Everyone, the Surrealist once said, has "a right to his madness".

Dalí's art was both mad and imaginative. He once made a telephone with a lobster as its receiver, and on another occasion he presented the public with a loaf fifteen metres long. These objects were supposed to be different from the 'normal' art of the day, and 'unreasonable' – just like the sculptures and paintings by the other Surrealists in Paris.

Capturing dreams

Dalí never painted reality – he wanted above all to make the riddles of his dreams visible in his paintings. That is why his pictures feature burning giraffes, gigantic elephants walking on stilts through the clouds, melting pocket watches suspended in trees, bowler hats, knives and railway trains floating weightlessly in the air, or groups of people in puzzle pictures turning into death's heads and back again depending on the angle from which the pictures are viewed. Some figures have open drawers in their bodies, with the core of their being hidden in their darkness. Dalí captured this inner world of dreams on canvas in a style that seems quite faithful to reality. In 1934, he painted the 'walk-in portrait' of the American film star Mae West, with a hair-curtain, sofa-lips and nose-fireplace: the furniture was 'brought to life' and reassembled as a new face that can be lived in. Dalí later reconstructed the painting in a gallery in his theatre museum.

The divine Gala

When Dalí was twenty-three years old, the Surrealist artists André Breton and René Magritte, and the poet Paul Éluard came from Paris to see him. Éluard, who had his portrait painted by Dalí, had brought along his wife, Gala. For Gala and Dalí it was love at first sight, and by the time Éluard's portrait was finished, the poet had lost his wife to the painter and the Éluards divorced each other. "Little one," Gala had said to Dalí shortly before, "we will never leave each other." And, indeed, they

remained a couple until Gala's death. Gala found a run-down fisherman's hut in Port Lligat, which Dalí extended into a labyrinth with corridors and stairs. The painter seems to have been very happy with his muse on the Catalan coast, which regularly crops up in his pictures, and later in America. Gala often appears as a goddess and saint in Dalí's later pictures, for the unconventional painter was becoming increasingly interested in religion at that time. He even showed a portrait of Gala as the Madonna of Port Lligat to the Pope, who liked it. This shocked even the scandal-loving Surrealists. In fact, Dalí kept faith with Surrealism longer than any other painter in the group.

1904 Salvador Dalí born on 11 May in Figueras
1921 Begins to study art in Madrid, but does not complete the course
1928 The Surrealists Breton, Magritte and Éluard with his wife, Gala, pay a visit
1930 Dalí and Gala settle in Lligat
1935 Breton excludes Dalí from the Surrealist group
1940 Dalí and Gala go into exile in the United States for eight years
1958 The couple marries
1971 The Dalí Museum in Cleveland opens; it moves to Florida in 1982
1972 Dalí designs wall and ceiling paintings for Gala's palace in Púbol
1974 The Teatro-Museo Dalí opens in Figueras
1982 Gala dies in Púbol
1989 Dalí dies on 23 January in his home town, Figueras

MUSEUM AND INTERNET TIPS
The Gala-Salvador Dalí Foundation was established in Dalí's birthplace, Figueras, in 1983: www.salvador-dali.org

Surrealism

Surrealism came into being in Paris as a continuation of Dadaism. The term comes from French, and means something like 'beyond reality'. Unlike the Realist painters, the artists around the poet André Breton did not want to depict the visible world, but to reveal a world that lies concealed in our dreams and nightmares. The Surrealists believed that it is possible to look into people's souls in dreams. And as in a dream, they put apparently unconnected and even absurd things together to form new combinations in their pictures. One example of this is Dalí's *Lobster Telephone*. Important Surrealists included René Magritte, Yves Tanguy, Meret Oppenheim, Joan Miró, Man Ray, Giorgio de Chirico and Max Ernst.

[above]
Salvador Dalí, November 1963.
Photograph

FRIDA KAHLO

PABLO PICASSO

JACKSON POLLOCK

1914–1918 World War I

1898 * George Gershwin **1918** * Leonard Bernstein

IMPRESSIONISM 1860–1915 1860–1915 IMPRESSIONISM CUBISM 1915–1920 EXPRESSIONISM 1920–1940

1850 1855 1860 1865 1870 1875 1880 1885 1890 1895 1900 1905 1910 1915 1920 1925 1930 1935

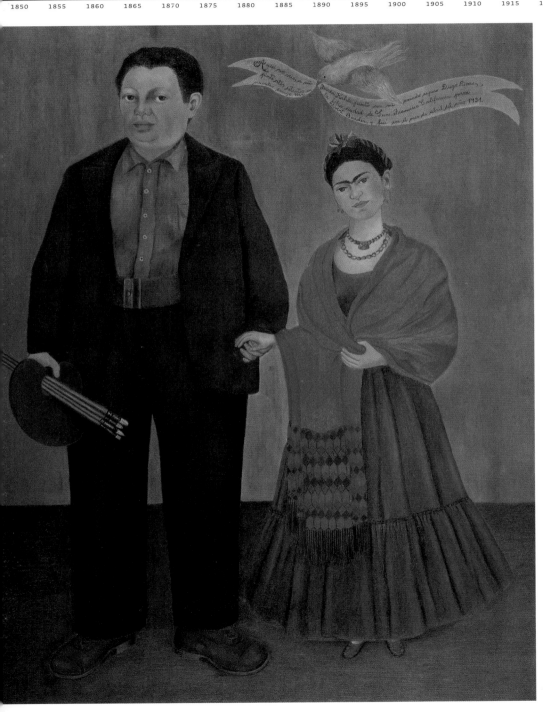

Frida and Diego Rivera, 1931.
Oil on canvas, 100 x 79 cm.
San Francisco Museum of
Modern Art, San Francisco

1937 Guernica (Picasso)

1939–1945 World War II

1962 Cuban missile crisis

1964 USA begins Vietnam War

1986 Worst-case nuclear accident
at Chernobyl power station

1990 Reunification of Germany

2001 Terrorist attacks in the USA

ABSTRACT EXPRESSIONISM 1940–1960 POP ART 1960–1975

1940 1945 1950 1955 1960 1965 1970 1975 1980 1985 1990 1995 2000 2005 2010 2015 2020 2025

FRIDA KAHLO

The Mexican painter Frida Kahlo showed mainly her own life in her pictures, a life of sadness and sorrow. Pablo Picasso, Wassily Kandinsky and the Surrealist artists admired her work. She never became a member of this movement herself, but developed a style that was entirely her own.

Frida Kahlo suffered from polio at the age of six, and never fully recovered the use of her right leg. An iron bar penetrated her body in a later bus accident and from then on the young woman was in constant paint. One day, her mother brought a mirror to her bed and pressed paintbrush and paint into her hands. And from her bed Frida began to capture herself and her sufferings in a series of unique pictures.

Frida and Diego

At the age of twenty-two, Kahlo married the much older painter Diego Rivera, who was famous for his murals glorifying the Mexican Revolution. She was always in Rivera's shadow, and this is how she painted herself in their wedding portrait *Frida and Diego Rivera*. Rivera alone is carrying a painter's utensils: a palette and paintbrushes, while Kahlo is every inch the wife. People called the oddly matched couple "the dove and the elephant". Their marriage was very passionate, but not always happy. They even divorced because the domineering Rivera began showing too much interest in other women. However, they never really got away from each other, and later married a second time. After that, they clearly got on better with each other. Kahlo became Rivera's maternal protectress; That, at least, is how she depicts things in her picture *The Love Embrace of the Universe*. Rivera is lying in her arms like a baby and both artists are resting in Mother Earth's giant hands, which also span the whole of nature. Slumbering at the foot of Kahlo's dress is Señor Xólotl, her favourite dog, whom she named after a Mexican god.

"Long live life"

Kahlo's pictures can almost be lined up as a colourful but tragic picture book of her life. There is a pencil sketch of her bus accident and an oil painting of her crumbling spinal column with the steel corset she had to wear for a long time. Kahlo portrayed her sadness in some pictures, and in others, her homesickness for Mexico. She later also painted in her wheelchair, to which she was bound until her life's end.

Many of her self-portraits show Frida Kahlo looking serious and reflective. But there are other pictures that tell of happier days and greater joie de vivre, in a lively shower of colour. A portrait of her first boyfriend, for example, a wedding picture with Rivera, or a self-portrait in the national dress of a Mexican Tehuana woman that she and Rivera so loved. Kahlo's last painting, completed shortly before she died, is a still life with cut watermelons. In the flesh of one of the melons, Kahlo has inscribed the words "Viva la vida": Long live life!

1907 Frida Kahlo born on 6 July in Coyoacán
1913 Falls ill with polio
1925 Is involved in a serious bus accident and suffers from the consequences throughout her life
1925 Begins to paint
1929 Marries Diego Rivera for the first time
1938 Has her first individual show in New York
1940 Rivera and Kahlo marry again, after divorcing the year before
1950 Kahlo has seven operations on her spine and has to sit in a wheelchair for the rest of her life
1954 Frida Kahlo dies on 13 July in her birthplace, Coyoacán

READING TIP
Hayden Herrera, *Frida Kahlo. Ein leidenschaftliches Leben*, Munich 2002.

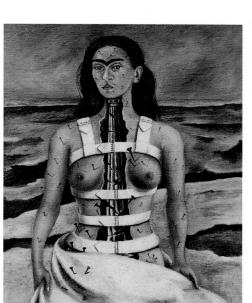

[above]
Bernhard G. Silberstein, Kahlo in Tehuana costume, 1942

[left]
The Broken Column, 1944. Oil on canvas, mounted on hardboard, 40 x 30.7 cm. Dolores Olmedo Patiño Museum, Mexico City

[below]
Viva la Vida (Long Live Life), c. 1951–54.
Oil and earth on hardboard, 52 x 72 cm.
Diego Rivera and Frida Kahlo Museum,
Mexico City

[right]
*The Love Embrace of the Universe, the
Earth (Mexico), I, Diego and Señor Xólotl*,
1949. Oil on canvas, 70 x 60.5 cm. private
collection, Mexico City

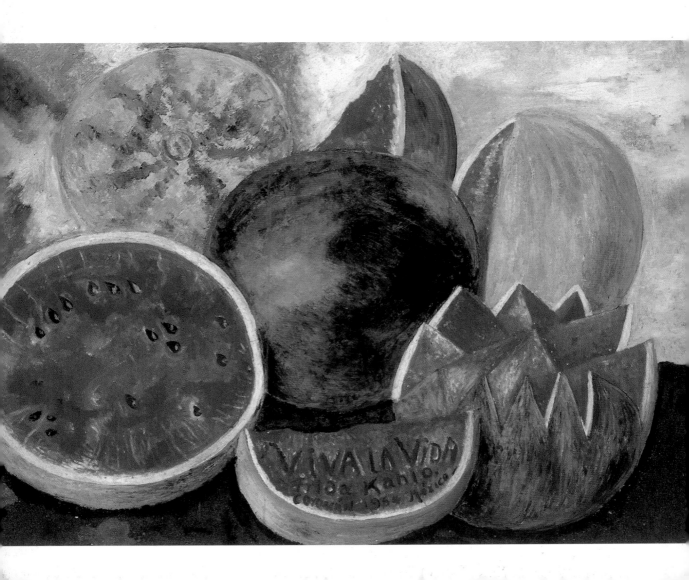

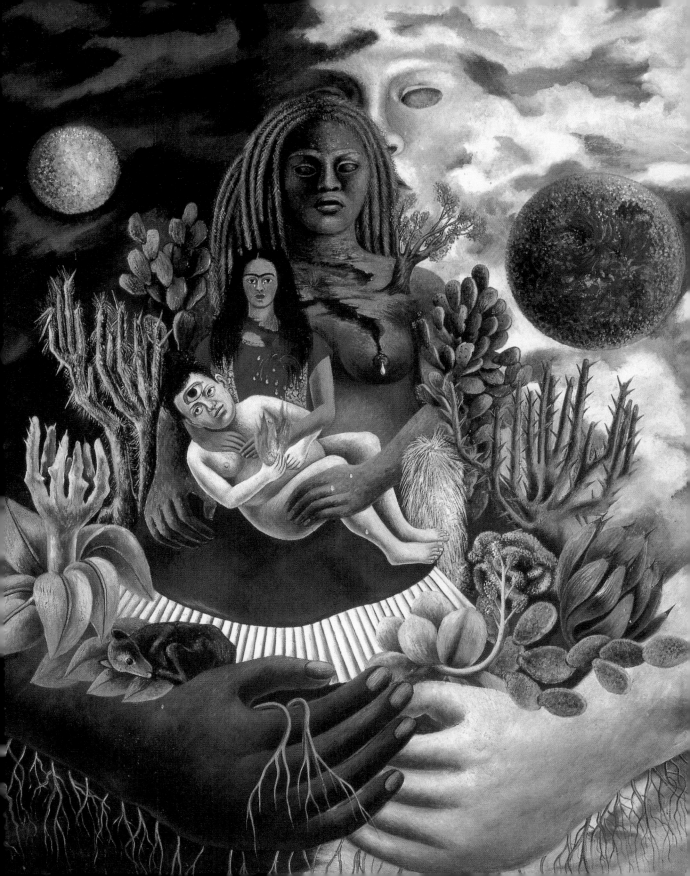

1898 * George Gershwin **1914–1918** World War I

IMPRESSIONISM 1860–1915 1860–1915 IMPRESSIONISM CUBISM 1915–1920 EXPRESSIONISM 1920–1940

1850 1855 1860 1865 1870 1875 1880 1885 1890 1895 1900 1905 1910 1915 1920 1925 1930 1935

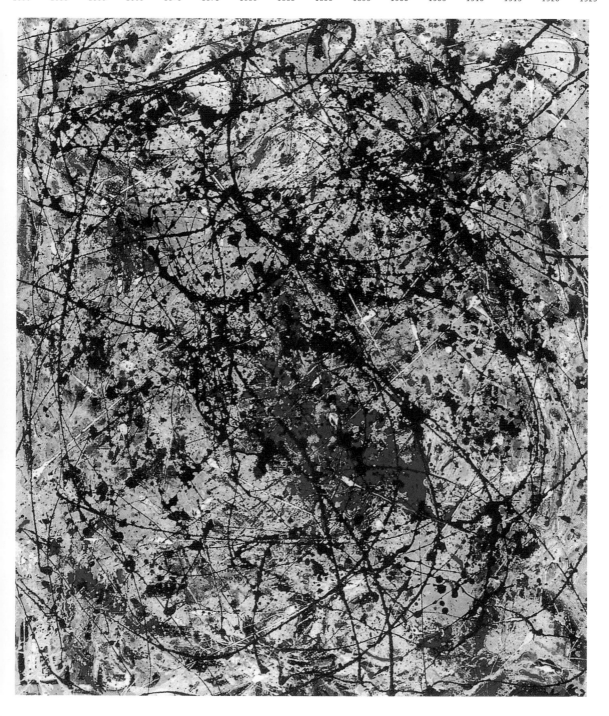

1939–1945
World War II

1952 Elvis Presley becomes popular **1969** US moon landing

1950 End of racial
segregation in
the USA

1962 Cuban missile crisis **1973** Watergate Affair

1963 John F. Kennedy assassinated

ABSTRACT EXPRESSIONISM 1940–1960 POP ART 1960–1975

1940 1945 1950 1955 1960 1965 1970 1975 1980 1985 1990 1995 2000 2005 2010 2015 2020 2025

JACKSON POLLOCK

The American painter Jackson Pollock set aside his paintbrush in order to let the paint drip on to the canvas in a pattern of coloured or black dashes, lines and blobs. This gave a boost to abstract painting. Pollock is now seen as the most important exponent of Abstract Expressionism.

Pollock was not interested in painting with a brush. He let the paint run down directly on to the canvas from above. His enormous 'drip paintings' were intended to decorate large walls, like the murals painted by Mexican artists. He was supported in this by the famous art dealer Peggy Guggenheim.

Painting without a brush

His painter colleagues mounted their canvases elaborately on stretcher frames, placed them on an easel and composed their pictures carefully. Pollock, however, did not want to paint portraits, landscapes or still lifes, but pictures that were nothing more than a picture of themselves. He chose a roomy barn as his studio and spread the canvas out on the floor. In this way he could approach it from all sides and allow the paint to flow freely. Like the American Indians who let sand run through their clenched fists to make very artistic patterns and circles at their feet, Pollock created tangled webs of proliferating lines, curves, swirls and patches in pure paint.

Pollock dripped, splashed or poured the green, yellow, red and black paint from his pots. He squeezed paint out of tubes, worked with sticks, ladles, knives and dried-out paintbrushes, scratched and wiped around with brushes, rags or his bare hands on the still wet picture. Sometimes he mixed sand or broken glass into the paint to roughen the surface. The act of painting itself, the action, was more important to Pollock than the completed picture. His style is still known as Action Painting. His picture *Number 2*, as the title suggests, is one of the world's first drip paintings. And it is, above all, a document of the act of painting as well. Anyone can study the way in which the paint got onto the canvas, every line follows one of the painter's sweeping gestures, each blob shows the force with which Pollock projected the paint.

The automatic picture

Pollock himself did not know in advance what his pictures would ultimately look like. They were supposed to paint themselves somehow, quite spontaneously, automatically, without lengthy thought and planning. The Surrealist artists had tried to do the same thing, and Pollock was familiar with their work. The Surrealist Max Ernst had once even drilled a hole in a pot of paint, then let it move round in circles, dripping paint on to a sheet of paper. But Pollock was even more ingenious than Ernst in his drip paintings. He put his idea of a new kind of painting into effect to such an extent that there came a time when he had painted everything. What could possibly be new after that? Pollock despaired at this thought, and eventually he stopped painting altogether. He was killed in a car crash a short time later.

1912 Jackson Pollock born on 28 January in Cody
1936 Attends a course by the Mexican mural painter David Alfaro Siqueiros
1943 The collector Peggy Guggenheim orders a huge mural
1943 Guggenheim organises Pollock's first one-man show
1945 Pollock marries the painter Lee Krasner
1947 Develops his dripping and flicking technique in a barn
1950 Makes a name for himself in Europe
1951 Paints only black-and-white pictures from now on
1954 Stops painting
1956 His pictures are shown at the Venice Biennale
1956 Jackson Pollock dies in a car crash on 11 August

Abstract Expressionism

During World War II, a number of American artists tried to find a new approach to painting. This led to their discovery of European Expressionism, which Wassily Kandinsky had developed into abstract art. The Americans' pictures were not intended to reproduce the real world: each picture was to be an expressive world in its own right, with its own rules, forms and colours. This movement is called Abstract Expressionism, and sometimes it is referred to as Action Painting or the New York School, as most of the painters in the movement – like Willem de Kooning, Franz Kline, Mark Rothko, Robert Motherwell and Clyfford Still – lived in New York.

[above]
Jackson Pollock in his studio.
Photograph by Hans Namuth

[left page]
Reflections of the Big Dipper, 1947.
Paint on canvas, 111 x 91.5 cm.
Stedelijk Museum, Amsterdam

1939–1945
World War II

1929 Wall Street
crash

1914–1918 World War I

IMPRESSIONISM 1860–1915

1860–1915 IMPRESSIONISM CUBISM 1915–1920 EXPRESSIONISM 1920–1940

| 1860 | 1865 | 1870 | 1875 | 1880 | 1885 | 1890 | 1895 | 1900 | 1905 | 1910 | 1915 | 1920 | 1925 | 1930 | 1935 | 1940 | 1945 |

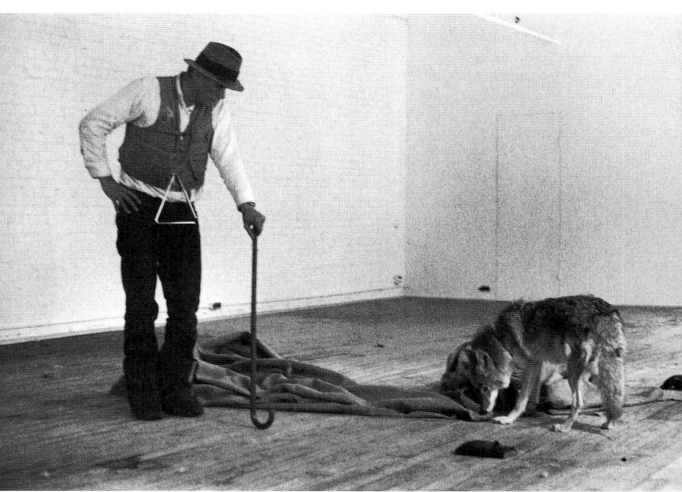

I like America and America likes me,
Galerie René Block, New York.
21–25 May 1974. Photograph by
Caroline Tisdall

Pianos and trumpets, a few firecrackers, musical clocks, an old cupboard door, interference on a television, a bucket of paint to pour over the artist's head: for many people, what the Fluxus artists were doing at their festivals or happenings seemed like circus acts or pure chaos. They played musical instruments, but with scarcely anyone really knowing how. Paper was screwed up and thrown around, paint was smeared about by the litre, and there was loud shouting, moaning and singing. American, Japanese and German artists in particular met for these festivals and happenings from the late 1950s on. They called themselves Fluxus artists. It was the artist George Maciunas who found the word 'flux' in the dictionary. It means the same as 'flow', and so suggests constant change. The best-known of the Fluxus artists are certainly the composer John Cage and his pupils Wolf Vostell, George Maciunas, Korean artist Nam June Paik, Allan Kaprow and Yoko Ono, wife of the Beatle John Lennon. Joseph Beuys was greatly influenced by the Fluxus movement.

1961 Berlin Wall built 1980 Ronald Reagan president of the USA 2003 US invasion of Iraq

1972 Killings at Munich Olympics

1973 First oil crisis 1995 Christo and Jeanne-Claude wrap
the Berlin Reichstag

1990 Reunification of Germany

BSTRACT EXPRESSIONISM 1940–1960 POP ART 1960–1975

1950 1955 1960 1965 1970 1975 1980 1985 1990 1995 2000 2005 2010 2015 2020 2025 2030 2035

JOSEPH BEUYS

This politically committed artist wanted to change society with installations in fat and felt, and pronounced that everyone is an artist. The versatile man in a hat produced work that included drawings, three-dimensional pictures and installations, and also organised happenings and published writings.

Joseph Beuys planted a tree outside his parents' house when he was only twelve. Years later, he really wanted to know what it was like and planted 7,000 trees. *7000 Oaks* is the title of the major ecological action he launched and saw through on the occasion of the 1982 *documenta* art show in Kassel. Beuys, who was a founding member of the German Green Party, saw the action as a challenge to people to do something for the environment. We should plant a tree "everywhere on earth where there is still room for one". Every citizen should be actively committed to a clean environment and a peaceful society, and everyone should be involved in shaping a gigantic work of art, the 'Social Sculpture'. That is what Beuys called our society. And that is also how we should understand that "every person should be an artist", as he once said.

Preference for fat and felt

There were two materials in particular that Beuys used repeatedly to remind us that our lives and our society are changing – indeed, allow themselves to be kneaded like a sculpture: fat, which can be shaped, and felt, which can keep us warm. His liking for these two materials stemmed from World War II. Beuys was called up for military service in 1940, around the time he was taking his school-leaving examination. He became a pilot of a dive bomber. In the winter of 1943, his 'Stuka' crashed in the Russian Crimea. His comrade was killed, and Beuys himself lost consciousness. He survived because a group of nomadic Tartars found him and looked after him. They rubbed his body with animal fat and wrapped him in warming felt. The artist never forgot this life-changing experience, and repeatedly worked with these materials. His *Fat Chair* became famous, and caused a scandal in 1964. How was placing a huge chunk of fat on a wooden chair supposed to be regarded as a work of art?

Animal stories

What Beuys wanted to do was confuse people, give them a creative boost and stimulate them into thinking about and creating the 'Social Sculpture'. He often seemed like a magician or a shaman, as he liked surrounding himself with live and dead animals. Beuys was aware of their significance in old myths and legends, and made deliberate use of them in his art. In his 1965 action *How to Explain Pictures to a Dead Hare*, Beuys strolled round the gallery with a dead hare in his arms, explained the pictures on the wall to it, launched into loud shamanist songs and poured honey over his head. During his 1974 action in New York, *I like America and America likes me*, Beuys spent five days in a room with a coyote called Little John, and kept swapping beds with it. Beuys wanted to point out that people constantly seek out objects of hatred and eradicate them, just as White Americans had done with the coyote, which the Indians worshipped. Beuys had gone to America to make peace with the coyotes.

[above]
Joseph Beuys. Photograph

[left]
Capri Battery, 1985. Yellow light bulb with fitting, lemon. Städtisches Kunstmuseum, Bonn

1901 * Walt Disney 1914–1918 World War I 1939–1945
 World War II

IMPRESSIONISM 1860–1915 1860–1915 IMPRESSIONISM CUBISM 1915–1920 EXPRESSIONISM 1920–1940

| 1860 | 1865 | 1870 | 1875 | 1880 | 1885 | 1890 | 1895 | 1900 | 1905 | 1910 | 1915 | 1920 | 1925 | 1930 | 1935 | 1940 | 1945 |

Early Colored Liz, 1963. Screen print
(acrylic) on canvas, 101.5 x 101.5 cm.
Peder Bonnier Collection

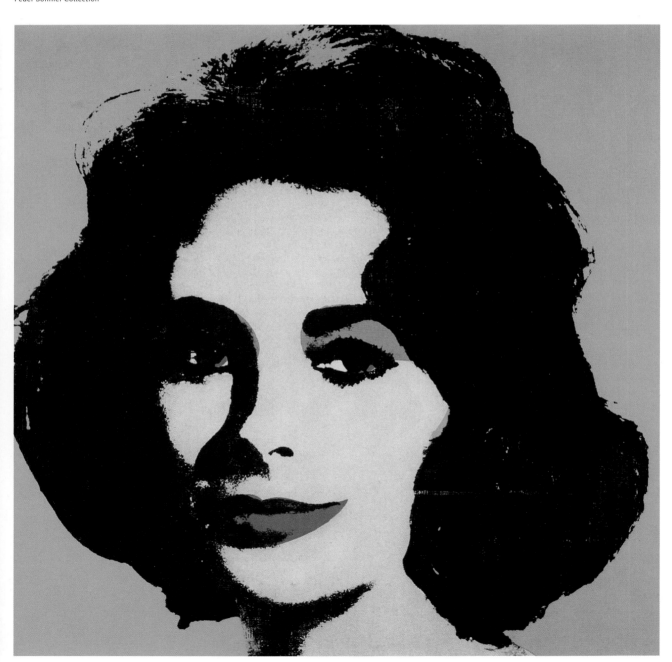

1969 Woodstock music festival

1952 Elvis Presley becomes popular

1962 Cuban missile crisis 1973 Watergate Affair

1986 Worst-case nuclear accident at
Chernobyl power station 2001 Terrorist attacks in the USA

2004 Tsunami flood disaster in Asia

ABSTRACT EXPRESSIONISM 1940–1960 POP ART 1960–1975

1950 1955 1960 1965 1970 1975 1980 1985 1990 1995 2000 2005 2010 2015 2020 2025 2030 2035

ANDY WARHOL

With his pictures of soup tins and banknotes the American painter, graphic artist and film-maker Andy Warhol brought the everyday world into museums. He turned stars into art and turned himself, the artist, into a star.

Even as a child, Andy Warhol wanted to be as famous as the politicians and film stars he read about in glossy magazines, or at least as famous as the superheroes from the comic strips. He began to paint pictures of his comic heroes Popeye, Dick Tracey and Superman in order to make a name for himself as an artist. He actually earned his living dressing shop windows for New York department stores or designing advertisements. But then, in a gallery, he came across comic-strip pictures by the artist Roy Lichtenstein that were very similar to his own work. So, to become famous, he urgently needed a new idea of his own. A female friend advised him simply to paint what he loved most. Andy Warhol therefore began to paint money. Or rather, he printed money: screen-printing green dollar notes.

Art as factory work

He made prints of cans of his favourite brand of soup, Campbell's, available in every supermarket. Or he printed on wooden soap crates and stacked these into sculptures, like the pyramids of special offers in department stores. That was really new: no one had ever before built his art around something as ordinary as a soup can, a ketchup bottle or a packaging box in this way.

Now everyone wanted to buy Warhol's pictures. To be able to meet the demand he had to employ a number of assistants. He called his workshop the 'Factory', and Warhol's pictures were, indeed, manufactured according to his instructions, as if on a factory production line, or conveyor belt, by his many assistants – just like the real soup cans or Cola bottles that featured in the prints. His dream was to produce 4,000 works of art a day. What he actually managed to produce was 2,000 in two years, which amounts to almost three per day.

The artist as pop star

Warhol's Factory did not just produce art. It was also the venue for wild parties, with the Factory's own rock group, and these were attended by important politicians, writers and actors. Warhol was now definitely part of the world of the rich, the beautiful and the famous, and he painted their portraits as well. He was particularly taken with the screen idols Marilyn Monroe and Liz Taylor, but now that he was able to read about his own parties in magazines, he sometimes behaved like a film star himself. He circulated gossip-column stories about himself, had his nose surgically altered, and wore a white wig and make-up. And if he didn't feel like going to an exhibition or the disco, he sent a lookalike, like a double standing in for a film star.

Pop art

Pop art suggests the everyday, and the Pop artists from England and the USA did, indeed, wanted to depict popular, everyday items artistically. Previously, the New York Abstract Expressionists had banished everyday objects from their pictures. Now, suddenly, film and pop stars, famous politicians, cars, road signs, cigarette packets, beer cans and flags began to appear in art, the way people knew them from fashion magazines, the supermarket or the street. Important Pop artists included Richard Hamilton, Roy Lichtenstein, David Hockney and Claes Oldenburg.

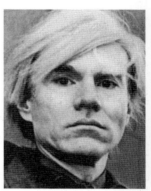

1928 Andy Warhol born on 6 August in Pittsburgh
1945 Begins to study graphic design, art history, sociology and psychology
1949 Moves to New York, where he works as a commercial artist
1952 Shows his drawings in a one-man show for the first time
1960 Paints his first comic-hero pictures
1962 Makes his first screen prints of Hollywood stars and sets up his workshop, the 'Factory'
1964 An exhibition in Paris makes Warhol famous in Europe
1968 Warhol is badly injured in a murder attempt
1968 Gets his own television show on MTV
1987 Andy Warhol dies in New York on 22 February after an operation

MUSEUM AND INTERNET TIPS
The Museum Ludwig in Cologne holds a large Pop art collection of international significance:
www.museenkoeln.de/museum-ludwig
Over 400 exhibits by the artist can be seen in his home city of Pittsburgh, in a dedicated museum: www.warhol.org

[above]
Andy Warhol. Photograph

[left page]
One Hundred Cans, 1962. Oil on canvas, 182.9 x 132.1 cm. Albright-Knox Art Gallery, Buffalo

[below]
Flowers, 1964. Screen print (acrylic) on canvas, 61 x 61 cm.
Flowers, 1964. Screen print on vinyl on canvas, 61 x 61 cm.
Flowers, 1964. Screen print on vinyl on canvas, 61 x 61 cm.
Flowers, 1964. Screen print on vinyl on canvas, 61 x 61 cm.
all: José Mugrabi Collection and Isle of Man Co.

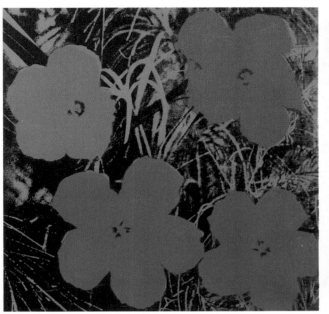

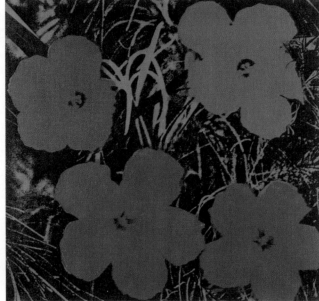

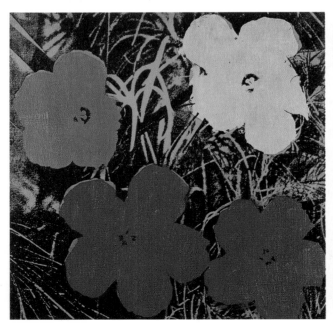

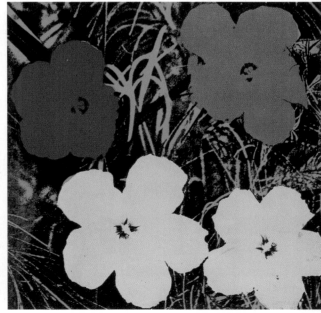

DAVID HOCKNEY

JOSEPH BEUYS

ANDY WARHOL

1952 Elvis Presley becomes popular

1901 * Walt Disney **1914–1918** World War I

1939–1945 World War II

1860–1915 IMPRESSIONISM CUBISM 1915–1920 EXPRESSIONISM 1920–1940 ABSTRACT EXPRESSIONISM 1940–1960

1870 1875 1880 1885 1890 1895 1900 1905 1910 1915 1920 1925 1930 1935 1940 1945 1950 1955

Nichols Canyon, 1980.
Acrylic on canvas, 214 x 153 cm.
Private collection

1969 Woodstock music festival

1964 USA begins Vietnam War **1986** Challenger space shuttle explodes in flight

1973 Watergate Affair **2001** Terrorist attacks in the USA

2004 Tsunami flood disaster in Asia

POP ART 1960–1975

1960 1965 1970 1975 1980 1985 1990 1995 2000 2005 2010 2015 2020 2025 2030 2035 2040 2045

DAVID HOCKNEY

The English painter, graphic artist and photographer David Hockney's colourful, two-dimensional still lifes, landscapes and portraits are close to Pop art. Hockney likes his life to be as colourful and varied as his art.

David Hockney decided to be a painter at the age of eleven. He has said that anyone who paints pictures loves the feeling of painting something with a brush full of paint, and that even now he could happily spend the whole day painting a door a single colour. Hockney has often covered great areas of his paintings with a single glowing blue, yellow or green, and then painted flowers, chairs, tables, springboards or people in front of this wall of pure colour, in smooth strokes. He learned this flat style of painting from Henri Matisse. Some of Hockney's pictures are reminiscent of empty stages waiting for someone to enter. It is, perhaps, no coincidence that Hockney has also designed many stage sets. According to Hockney, his pictures are deserted because the viewer is supposed to move around in them with his or her eyes. This is easily done in *A Bigger Splash*, one of his most famous paintings, Hockney has, occasionally, also depicted the emptiness of his own life. For example, when his boyfriend Peter Schlesinger left him, people at first also disappeared from his paintings.

Portraitist of the ordinary

Like Andy Warhol or other Pop artists, David Hockney painted everything he saw and liked in some way: 'Typhoo' tea packets, playing cards and toothpaste tubes, men showering or sunbathing by the pool, the bright but, somehow, also bleak houses of the Hollywood rich, living rooms, bedrooms and hotel rooms, oranges and orchids, his two dachshunds, Stanley and Boodgie, the ocean or the American countryside. Hockney was almost always away, travelling, in Egypt, Japan or India. The colours of his paintings changed each time, according to where he happened to be.

In his double portraits of his parents and friends, it was particularly important to Hockney to show the relationships and feelings of the couples being portrayed. In his picture of Mr. and Mrs. Clark and their cat Percy, the young married couple are not

looking lovingly at each other, but straight at the painter, with a bored expression on their faces. When Hockney painted the Clarks – he had been best man at their wedding – he sensed that things had not been right between them for a long time. And the Clarks did, indeed, divorce each other later.

An artist and his funny faxes

Hockney has always liked experimenting: he would assemble Polaroid photos into a collage, and he was able to create a whole lot of art from a single picture and with the aid of a colour photocopier. He once faxed his drawings for an exhibition from his studio to the museum in question. These copies were exhibited at the museum as 'genuine' works of art. When asked how his works should be returned to him, the painter's witty reply was that the museum could fax them back – but that would mean that they would still have them!

1937 David Hockney born on 9 July in Bradford.

1948 Wants to become an artist and shows his posters on school notice-boards

1959 Studies art in London

1960 His pictures are shown in public for the first time

1963 Finally makes a name for himself. Meets Andy Warhol

1976 Travels across the United States

1980 His hearing declines

1982 Buys a house in Hollywood

1999 Three Hockney exhibitions open in Paris simultaneously

TIP

Hockney has written a book on the tricks used by painters in earlier times: David Hockney, *Secret Knowledge: Rediscovering the Lost Techniques of the Old Masters*, London 2001.

[above]
David Hockney. Photograph

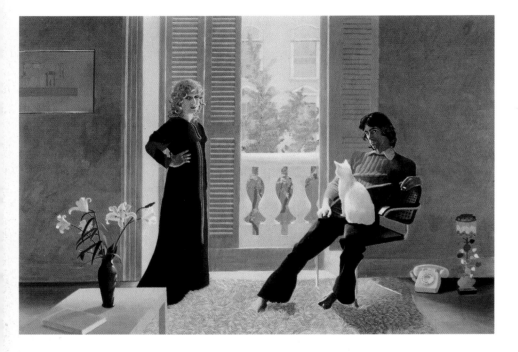

[right]
A Bigger Splash, 1967. Acrylic on canvas,
242.5 x 243.9 cm. Tate Gallery, London

[above]
Mr. and Mrs. Clark and Percy, 1970/71.
Acrylic on canvas, 304 x 213 cm.
Tate Gallery, London

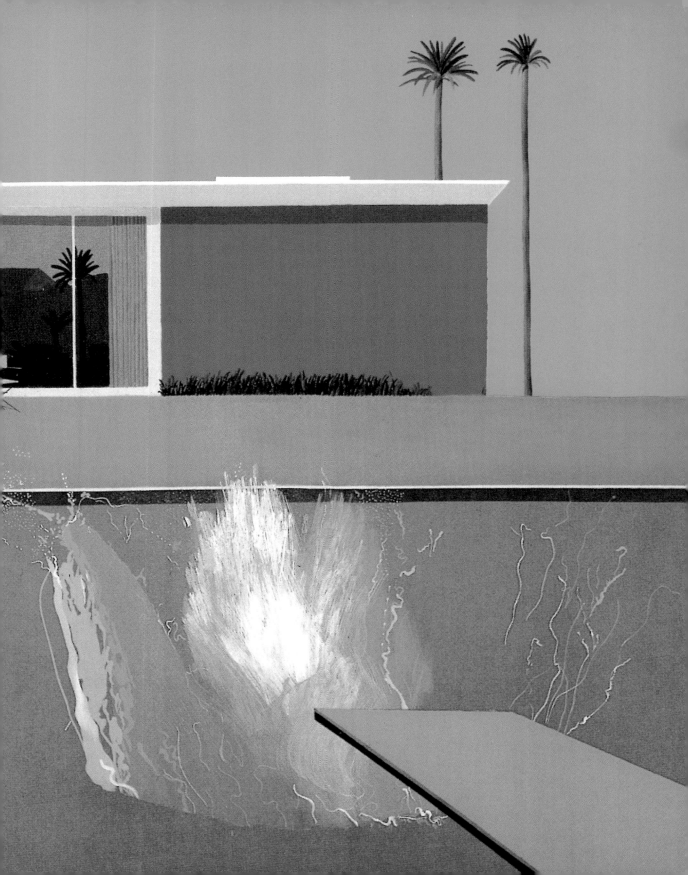

APPENDIX

GLOSSARY

Abstract, abstract art, abstract painting
Abstract means 'non-representational'. A non-representational movement in art started from 1910. Artists were interested in allowing forms and colours to work in their own right, rather in than depicting things.

Académie (Royale), (Royal) Academy
An academy is an art school. The term was also used for some societies for the promotion of science or art. The name derives from a grove dedicated to a hero called Akademos where Plato founded his philosophy school in 387 AD. The Académie Royale and the Royal Academy were royal foundations.

Action
Action, performance and happening are like an experimental theatrical or musical production. In contrast with works of art in museums – an event, or happening, takes place that exists only in the here and now. Happenings and performances draw the viewers into the action, but an action can also take place without an audience and be viewed later (for example, using photographs).

Altar, altarpiece
(Lat. *alta ara*: high altar) An altar is a place where a deity, several deities or saints are worshipped, and sacrifices brought to them. In Christian churches, altars are often decorated with pictures, or altarpieces. A winged altarpiece has panels on each side that are opened or closed at certain times, and show different images appropriate to the liturgy.

Antiquity
Antiquity is the Ancient Greek and Roman period. It begins in the 2nd millennium BC and ends with the fall of the Roman Empire, around 500 AD. Ancient art was considered particularly perfect, and was therefore used as a model by many artists and art theoreticians of later periods.

Art academy → Academy

Assemblage
(Fr.: fitting together) The assemblage technique produces a work of art by fitting various objects together.

Avant-garde
The avant-garde, as precursors of a new idea or movement, anticipate a general development, break with traditional forms and establish something radically new.

Baroque → p. 55

Bauhaus
Important school of art, design and architecture, cultivating all branches of art. It was founded in Weimar in 1919 and moved to Dessau in 1925. Clarity, functionality and practicality were the Bauhaus artists' aims. This led to the emergence of the Bauhaus style. The Bauhaus was forced to close in 1933 under National Socialist rule.

Biennale
(Ital.: every other year) Biennales are international events such as art exhibitions or film festivals that take place every two years.

Bust
(Ital. *busto*: head and shoulders image) Sculptural depiction of a person's head, shoulders and chest.

Ceramics
A collective term for fired clay products like faience, porcelain, stoneware, earthenware and terracotta.

Chiaroscuro painting → p. 51

Christian art
Christian art increasingly ousted the art of → antiquity in Europe from the 3rd century AD. It was used to adorn churches and glorify the Christian God. It conveyed the message of Christianity to ordinary people who could neither read nor write.

Classicism → p. 78

Collage
(Fr. *coller*: to glue) This artistic technique creates pictures by gluing together newspaper cuttings, scraps of fabric, wallpaper, cut-up images, etc.

Commissioned portrait → Portrait

Constructivism → p. 143

Copperplate engraving
For a copperplate engraving, the drawing is scratched in reverse onto a polished copper or brass plate with a metal graving-tool or burin. When the plate is inked the ink collects in the incised lines, which then print when a sheet of paper is applied. Copperplate engraving is one of the most difficult graphic techniques.

Copy
A copy is a version of an original work of art, usually by someone other than the original artist.

Cubism → p. 123

Dada → p. 139

documenta

documenta is a large, international exhibition of contemporary art held in Kassel, Germany, every five years.

Etching

(Lat. *radere*: scratch) In an etching, the lines for a drawing are drawn with a sharp-pointed instrument in a layer of material applied to a copper or zinc plate. This plate is then placed in an acid bath. As the coating resists the acid, the etching liquid attacks only the metal in the places that have been scratched free. The lines are then inked, and paper is pressed against the plate. The etching technique was invented about 500 years ago, and was practised by artists including Albrecht Dürer, William Hogarth, Rembrandt, Pablo Picasso and Max Beckmann.

Expressionism

Unlike the Impressionist artists, who sought to capture the atmospheric impression of light in nature, the Expressionists wanted to express their personal perceptions in painting, as the name suggests. The Fauves group in Paris demonstrated this with their exuberant colours and simplified forms (→ p. 155). Wassily Kandinsky developed Expressionism further into → abstract art. Abstract Expressionism is an American movement (→ p. 153).

Fine art

Art appealing to the sense of beauty, especially painting and sculpture. Nowadays, the term embraces all forms of artistic practice, and therefore includes photography, film architecture and design.

Free-standing sculpture → **Sculpture**

Fresco

(Ital.: *fresco*: fresh) Frescoes are executed in lime-resistant paint on lime-mortar rendering on walls and ceilings while the plaster is still wet. After they have dried, the colour pigments bond insolubly with the lime rendering, so the paint cannot flake off. Fresco painting is a very old technique, probably known even in Ancient Greece.

Genre picture, painting, depiction, scene

Genre pictures are depictions of everyday life in certain social classes. For example, a distinction is made between the peasant and soldier genres. Genre painting reached its heyday in 17th-century Dutch art (→ p. 65) and 19th-century bourgeois culture.

Gouache

Unlike watercolour, this painting technique uses opaque, rather than transparent, watercolours. The pigments are bound with rubber or vegetable adhesive and mixed with white (in the form of clay, for example). Gouache paints were used for medieval book illumination, and for preliminary studies for large paintings during the Renaissance. They were used as an independent painting technique from the 19th century on.

Graphic art

(Gr. *graphein*: to write, draw, scratch) Graphic art includes drawing or the result of a technical printing procedure (printed graphics), for example, an → etching, a → woodcut, a → copperplate engraving, a → lithograph or a → screen print.

Happening → **Action**

Historical picture, painter, painting

Historical pictures are paintings that depict a historical event. This can be a historical incident in the strict sense, but also a story from the Bible, myths or tales of gods or heroes. Historical painting was long considered the most important art genre.

Idealistic

Idealism in fine art is creating to an ideal. Realistic features are suppressed in favour of enhancing and transfiguring reality.

Impressionism → p. 99

Installation

Installations are three-dimensional works of art set up in an existing space. A great variety of materials and media can be used here.

Jugendstil → p. 109

Landscape picture, painter, painting

Nature is the central subject of landscape pictures. In early times, the landscape simply served as a background, but many pure landscapes were created in the 17th and 19th centuries in particular. But it was not until the 19th century that it became customary to paint in the open air; previously, landscape paintings were created in the studio from earlier sketches and studies.

Lithography

This printing technique developed in 1796/98 uses fatty ink or chalk on a plate made of fine-grained sandstone or zinc. The plate is then treated with acid, so that the printing ink adheres only to the fatty lines in the drawing. The areas in which the moisture is absorbed by the pores in the stone remain free.

Mannerism
(Ital. *maniera*: way, manner) Term for the late-Renaissance art style current from 1520 to 1600. Its characteristics are elongated, twisted forms and figures full of theatrical movement. Michelangelo's unnaturally muscular figures, rather like sculptures, in the High Renaissance prepared the way for this style. Important exponents of Mannerism were Spanish painter El Greco, and then the Italian artists Jacopo da Pontormo, Lorenzo Lotto, Tintoretto and Parmigianino.

Middle Ages
Term for the period between → antiquity and the modern age, which began with the Renaissance around 1500.

Modern art
Collective term for the various art styles since about 1890.

Motif
A motif (or a pictorial motif) is an object or theme depicted in art.

Nude
A nude is a depiction of the naked human body. Nude drawing is a basic subject in art training.

Object
Objects are (modern) works of art made of, or assembled from, found objects.

Object art, Concept art → p. 137

Objet trouvé
(Fr.: found object) A found object from nature or the everyday world that an artist declares to be a work of art or incorporates into a work of art.

Oil painting
This painting technique uses oil (linseed, poppyseed or nut oil) to bind colour pigments. Oil paints can be translucent or opaque, and can be applied beside or on top of each other without running into each other. This means that the finest of gradations and transitions are possible. To make an oil painting last a long time it is finally covered with a transparent varnish (for example, soft resin solutions) that is not permeable to air.

Perspective
(Lat. *perspicere*: look through, perceive clearly) Perspective representation is used to depict a three-dimensional space in a picture or drawing. To do this, so-called vanishing lines are drawn in a picture, meeting at an imaginary point, the vanishing point. The most important rule of perspective drawing is that objects that are further away seem smaller in the space than closer objects. Perspective construction was unknown in the Middle Ages. It was not until the Early Renaissance that artists had precise knowledge of perspective at their disposal, thanks to flourishing science.

Pop art → p. 157

Portrait, portraitist
(Lat. *portrahere*: to draw forth) Portraits depict particular people. A distinction is made between single, double and group portraits. They can show the whole (full figure) or part of a person (head, head and shoulders, half figure, three-quarter figure), from the front (front view, en face) or from the side (profile). Commissioned portraits are ordered from the painter. A self-portrait depicts the artist himself.

Primitive, primitive art
The expressive strength of the art of early cultures or so-called primitive peoples served as a model for many 20th-century artists and sculptors.

Printed graphics → **Graphic art**

Proportion
(Lat. *proportio*: proportion) From ancient times on, artists have sought rules to depict the proportions of human beings, determined by the relationship of the individual parts to each other and to the whole. Harmonious proportion, one that is balanced between the sizes of the individual parts, has always been an important theme.

Realism → p. 89

Renaissance → also p. 32
(Fr.: rebirth) The Middle Ages ended with the revival of the culture of classical antiquity. This epoch began in Italy in the early 15th century.

Retrospective
A retrospective – literally: looking back – is an art exhibition summing up individual phases of an artist's work, or all of it.

Rococo → p. 68

Romanticism → p. 81

Royal Academy → **Academy**

Salon
(Fr.: reception room, living room) Prestigious art exhibition

Screen printing
In this process, ink is forced through a (fabric) sieve stretched over a frame. The areas that are not supposed to print are covered with a template, and the image to be printed remains open.
In photographic screen printing, a light-sensitive copying layer is applied to the screen and exposed to light. The exposed areas are liquid-resistant and the unexposed areas are washed out of the fabric. For multi-colour printing, a new screen has to be made for each colour.

Sculpture
Sculptures are three-dimensional works of art. A distinction can be made between a work of art created from a malleable material that was originally soft (for example, clay, cast bronze), or those carved from a hard material (stone, wood). A free-standing sculpture is a work of art that can be viewed from all sides.

Self-portrait → Portrait

Series, also **Edition**
In fine art, this means a series of works of art of the same kind.

Signature
(Lat. *signare*: to mark) An artist identifies a work of art he has created with a signature – his written signature or mark.

Still life
Still lifes show still, lifeless objects and animals. The most common still lifes depict flowers and fruit, but can also feature dead game and hunting equipment, kitchen pieces or breakfast scenes. So-called vanitas still lifes evoke the transience of all things – for example, by showing wilting flowers or a death's head. This symbolic meaning for pictures was particularly important in the Baroque period.

Stucco, stucco artist
Stucco is made up of plaster, lime and sand, which is moulded and dyed and which can be painted after it has hardened. Stucco artists often created interiors with sculptural decorations in the Baroque period.

Studio
An artist's workshop or workroom.

Surrealism → pp. 141, 147

Tempera paints
Paints with watery and oily binding agents, used above all before the 15th century. Tempera paintings look harder than → oil paintings, and their surface seems duller.

Triptych
A triptych is a picture consisting of three parts.

Watercolour
Thin, transparent watercolour paints are used for this medium. Watercolour is one of the oldest painting techniques, appearing on papyrus as early as the Ancient Egyptian Books of the Dead (2nd century BC).

Winged altarpiece → altar

Woodcut
Woodcut technique involves drawing back to front on a wooden printing plate. Then all the parts not intended to be printed are cut out. The raised sections and bridges are inked and pressed onto paper.

INDEX OF ARTISTS

PHOTO CREDITS